INGRES THEN, AND NOW

'At last, here is a work on Ingres such as we no longer dared hope for: audacious, sulphurous, scandalous. Until now, Ingres has been imprisoned by his pious mythology as if by a foul swamp. The deconstruction of the artist is therefore an undertaking in the public interest, which Rifkin fulfils with a rare ingenuity. We must also note that the most despicable artist of the French school, egotistic, sexist, racist and sectarian, comes out as the hero-in-spite-of-all of this magnificently dark book. It should be its only failure!'

Régis Michel, Chief Curator at the Musée du Louvre

'This is an unusually fine and intelligent study, which will prove compelling to anyone thinking about the nature of modern art and the situation of the modern artist in nineteenth and twentieth century France. Rifkin offers the reader an array of brilliant and unexpected insights – at times focused on Ingres, at others opening out onto new ways of thinking about modernity and the fabric of modern artistic culture.'

Alex Potts, Professor of History of Art, University of Reading

Ingres Then, and Now is an innovative study of one of the best-known French artists of the nineteenth century, Jean-Auguste-Dominique Ingres. Adrian Rifkin re-evaluates Ingres' work in the context of a variety of literary, musical and visual cultures which are normally seen as alien to him. Reviewing Ingres' paintings as a series of fragmentary symptoms of the commodity cultures of nineteenth-century Paris, Adrian Rifkin draws the artist away from his familiar association with the Academy and the Salon.

Rifkin sets out to show how, by thinking of the historical archive as a form of the unconscious, we can renew our understanding of nineteenth-century conservative or academic cultures by reading them against their 'other'. He situates Ingres in the world of the Parisian Arcades, and traces the emergence of bizarre symptoms in Ingres' early work, symptoms which open him to a variety of conflicting readings and appropriations. He concludes by examining his importance for the great French art critic Jean Cassou on the one hand, and in making a bold, contemporary gay appropriation on the other.

Ingres Then, and Now transforms the popular image we have of Ingres. It argues that the figure of the artist is fixed in neither time nor place – there is neither an essential man named Ingres, nor a singular body of his work – but is an effect of many complex and overlapping historical processes.

RE VISIONS: CRITICAL STUDIES IN THE HISTORY AND THEORY OF ART
Series editors: Jon Bird and Lisa Tickner
Middlesex University

.Art history has been transformed as an academic discipline over the last twenty years. The 'new' art history is no longer new, and that widely used and useful label has come to seem dangerously over-tidy.

Re Visions responds to the arrival of new ways of thinking in art history in a series of lucid and accessible studies by authors distinguished in their fields. Each book examines the usefulness of innovative concepts and methods, not in abstract terms but through the analysis of particular art objects, ways of writing about art, and cultural institutions and practices.

Other titles in the series:

CIVILIZING RITUALS
Inside public art museums
Carol Duncan

FEMINISM AND CONTEMPORARY ART
The revolutionary power of women's laughter
Jo Anna Isaak

DIFFERENCING THE CANON
Feminist desire and the writing of art's histories
Griselda Pollock

INGRES THEN,
AND NOW

Adrian Rifkin

London and New York

First published 2000
by Routledge
11 New Fetter Lane, London EC4P 4EE

Simultaneously published in the USA and Canada
by Routledge
29 West 35th Street, New York, NY 10001

Routledge is an imprint of the Taylor & Francis Group

©2000 Adrian Rifkin

Typeset in Sabon by Taylor & Francis Books Ltd
Printed and bound in Great Britain by Biddles Ltd, Guildford and King's Lynn

British Library Cataloguing in Publication Data
A catalogue record for this book is available from the British Library

Library of Congress Cataloging in Publication Data
Rifkin, Adrian
Ingres then, and now/Adrian Rifkin
Includes bibliographical references and index.
1. Ingres, Jean-Auguste-Dominique, 1780–1867 Criticism and interpretation.
I. Title.
ND553.I5R53 2000
759.4–dc21 99-42448

ISBN 0–415–06697–2 (hbk)
ISBN 0–415–06698–0 (pbk)

À Denis

(... et je vous admire)

CONTENTS

ILLUSTRATIONS

ACKNOWLEDGEMENTS

For over thirty years thinking about Jean-Auguste-Dominique Ingres has been a focus of my intellectual life. His enigma has so diverted me that more often than not, when I have set out to write about him, I have ended up posing or answering questions that have distracted me from him or taken me altogether somewhere else. This has been a rich and strange experience, eventually alerting me to 'his' capacity to be a *différance* machine. But, at the same time, taking so long to write a book entails one in the kind of indebtedness on which even the interest payments can never be met, a sort of moral 'negative equity' – yet more a record of friendships than a burden! My father, Frank Rifkin, who died twenty-eight years ago, generously supported my first excursions to Montauban, despite his reasonable pessimism that he might not live to see the outcome – though even I underestimated by how much time he would miss it. Those remarkable scholars of a now-distant generation, Dr Helen Rosenau and Professor Arnold Noach, who shared my father's gloom, stimulated and provoked me so memorably that I still feel that most of what I do is a fragmentary and unworthy memorial for them.

In the more recent past my friends, colleagues and series editors Jon Bird and Lisa Tickner have been almost unreasonably considerate and attentive. While at Routledge Rebecca Barden's patience and commitment to the project have been quite marvellous, particularly at the point when, in a frenzy of honing, I managed to make the book almost too short for publication.

Bits or all of the manuscript have been read or heard as lectures by Paolo Berdini, Michael Camille (who put me on to the work of Serge Mourey), Gail Day, Steven Edwards, Tamar Garb, Vanalyne Green, Rosalind Krauss, Ewa Lajer Burchart, Régis Michel, Frank Mort, Molly Nesbit, Carol Ockman, Johnny de Philo, Griselda Pollock, Todd Porterfield, Alex Potts, Irit Rogoff, Kristin Ross, Andy Shelton, Susan Siegfried and Rafael von Uslar, all of whom offered invaluable and often demanding advice, though I suspect that the final result might yet be a surprise to them. I owe much to all my colleagues at the Department of Fine Art at Leeds for the stimulating environment in which *Ingres* was brought to a conclusion, though Barbara

Engh and Dana Arnold were especially generous with their support during the period that I actually completed the manuscript.

The ongoing conversations with my graduate students at Leeds and elsewhere were perhaps one of the most important resources of all, and there is not one amongst them whose work and ambition has not touched or encouraged my own. Jeremy Roe tirelessly did all the footwork for the illustrations; Simon O'Sullivan was a teaching assistant and a critic without equal.

Laura Davies helped me standardise my translations from modern and old French sources. David Pearce made the wonderful contribution of his copy of Julie Forestier's copy of Ingres' 1804 self-portrait – which the current owners refused me permission to reproduce – and David Oppedisano helped in more ways than I can remember.

As far as possible I have tried to take into account the development of Ingres literature up to the last minute before going to press, but few of these works, such as the catalogue of the recent exhibition of his portraits, have received the attention they merit. I intend no disrespect to those scholars with whom I have been unable to engage. With a few exceptions I have worked from French editions of works by authors such as Julie Kristeva or Claude Lévi-Strauss, and referenced only these editions. It goes without saying that generations of librarians and archivists lurk behind such a project in Paris, London, Rome, wherever, and my thanks at last go to them as well.

PRELIMINARY
From the bizarre to the sublime

'Qui suis-je?' ai-je demandé.

'Qui suis-je?' ai-je répondu.

La répétition est, dans sa différence, accomplissement.[1]

 Edmond Jabès, *Elya*

Il n'y a pas de parole sans réponse, même si elle ne rencontre
que le silence, pourvu qu'elle ait un auditeur.[2]

 Jacques Lacan

This is a book about what I call the staging of an artist. By this I mean the
mise-en-scène, the framing of an artist as he is figured in the histories that
precede him, as well as in those histories that he makes or that are made
around him. Hence the title, 'Ingres then, and now'. 'Then' is the historical
possibility of Ingres' emergence as an individual, 'now' is the ongoing poli-
tics of his condensation as such, the investment of value, as of values, in his
figure. 'Staging' is the elaboration of a series of overlapping frames, set-ups
or viewpoints which share some of their signs or contents, but which other-
wise are quite specific or *sui generis*. And their sharing of materials suggests
not so much a continuity of meaning as a difference within these materials,
an unevenness and instability of their signifying in histories of art.
Questions of 'who am I?' or 'what is s/he or it?', which are as likely to articu-
late the subject or being of an artist as they are the being and the subjects of
the historian, answer themselves in practices of making art or writing
history. As my two *incipits* with their three voices propose, these processes
are voluntary and involuntary, a play of intentionality and chance in the
making of a space for meaning.

 To think this through as *staging* is to allow for a certain artifice in the
configuration of statements and gestures that seem to condense moments of
historical complexity or grant a temporary distinctness to the ways in
which the threads of overdetermination knot together. And so my stages are

1

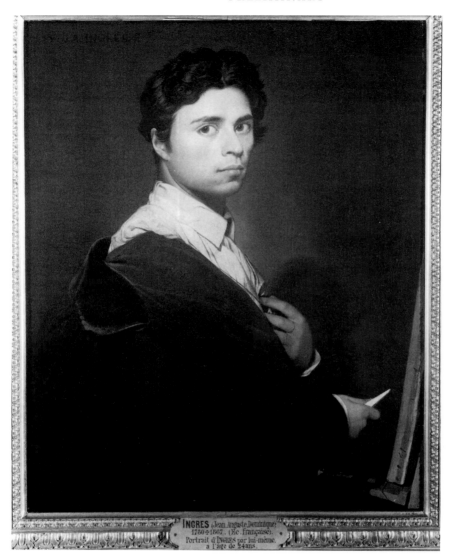

Figure 1

theoretical or historiographical images that pluralise the relations between such words as 'history' and 'art' in the already multiple significations of their archive.[3]

So if *Ingres Then, and Now* is a book about art history, its archives and its writing, then its interest in the writing of history generates a degree of

tension with its focus on an individual artist. That the book concerns Jean-Auguste-Dominique Ingres is, I hope, both its particular and especial virtue. But for all that, I will not set out to constitute his *oeuvre* as a singular temporal or thematic structure, nor will I pursue his critical reception as if it were a coherent representation of his life and times. I will rather cut across the genres of his painting and drawing, be they histories, mythologies, portraits or romances. And, disabused of the certainties of chronology and thematics, I will gather fragments and gestures from this work in order to imagine how, if we recognise their existence as many possible kinds of sign, we are enabled to re-read them and the larger sign, Ingres, that they stand for.

This book is also a rewriting; a book of rewriting and a book about rewriting as if it were a desirable achievement – as, perhaps, are Ingres' own many patient repetitions of his themes and subjects. It works on materials, written and visual, produced both by myself and by others over and through a long historical period – twenty-five years of my own life, over three hundred and fifty in the immediate history of aesthetics, or two thousand if you count the Hellenistic ur-text of French, classical aesthetics that is Longinus's *peri hupsous* or *On the Sublime*.[4]

The point is hardly subtle but nonetheless worth underlining, because the nature of duration and transformation in the history of ideas is something that a rewriting can work on and with. Not in order to reveal an immanent direction of or for intellectual history, I hasten to add. For we will here work without a telos as far as this is humanly possible. Unless, admittedly, the one permissible telos should be that of the progressive corrosion of sundry, specific teleologies. And even then it is crucial not to slip into the self-defeating finality that becomes the trap of 'total' relativity, nor for that reason to eschew the perhaps playful invention of teleologies as machines for trawling in an archive. There are two such major devices at operation throughout this text. One is the use of a continuous present for the figure of Ingres itself, a grammatical conjuration of the temporal transcendence of an aesthetic or art historical archive and tradition whose very being is invested in the necessity for such a transcendence. The other, which I will explain fully below, is the rapprochement of Ingres with E. T. A. Hoffmann as the vector for a play of *différance*.[5]

But let me touch here on the peripheral poetry of such a chance-laden encounter as that of Ingres and Hoffmann. Ingres painted the portrait of his composer friend Luigi Chérubini in 1841. In one version (Figure 2) we see the composer watched over, crowned, or even held back by a sternly protective classical muse. Far from celebratory, the image suggests disquiet and tension, its restraint enforcing an unconfident modesty or an equivocal dullness or even deafness. Chérubini was Ingres' musical equivalent, director of the Conservatoire in Paris while Ingres was in charge of the Villa Médicis in Rome. He represented the same phantasmatic integrity of history and tradition in the

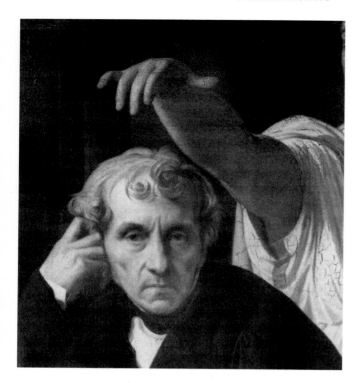

Figure 2

teaching of music as Ingres did in that of painting. Both thus lived out a strange split between the pedagogical practice of an aesthetic and the more pragmatic practice of their art — a split that we might think of as their ambivalent experience of the modern in its uncontrollable diversity.

The composer Jacques Offenbach, who dealt up the classical through the figures of comedy, everydayness and subversive ambiguity in operettas such as *Orphée aux enfers* or *La Belle Hélène*, stands for just this crazily and blissfully consummated relation between the making of art and the modern pleasure-markets of the great metropolis. He was eventually to set Hoffmann's texts to music in their most complex yet enduringly popular form with his *Contes d'Hoffmann* of 1875 — his final work and his only one to attempt a mode of conscious tragedy. But he began his Parisian career, a young Jewish immigrant, son of a synagogue musician from Cologne, as a student cellist under Chérubini, whose discipline he could not support.[6]

Claude Lévi-Strauss, whose ideas in *La Pensée sauvage* are so crucial to my construction of Ingres as a mythologised subject in Chapter 1, recounts that

his great-grandfather, Isaac Strauss, was a violinist and orchestral conductor, a friend of Offenbach's: '[W]e knew Offenbach by heart in my family; he cradled my whole childhood.'[7]

If this little genealogy is a matter of hazard rather than of Ingres scholarship, nonetheless it tells us something of the fabric of the archive, of its strangeness and dreamlike character. It alerts us to how its connective threads are not necessarily the properties of any one figure, and may never return us to a starting point. This is to remind us how, in Michel Foucault's terms, the concept of an author is a notion, one that we need, but that we must also try to set aside. For if we allow this notion to be invaded by its other, by an uncontainable otherness, its specific form might then be newly figured. Here, for example, Ingres' well known musicianship and tastes in music – Gluck, Haydn, Mozart, Beethoven – begin to refract the conditions of his own decentring rather than the character and choices of an individual. As tastes, they tell us nothing of him. As symptoms, they draw us into the archive as the unconscious possibilities and conditions of utterance.

And this leads me to understand, perhaps too late, that the world of the nineteenth century in which I try to redisclose my Ingres is, finally, that of Kracauer's biography of Offenbach, his wholly exquisite *Orpheus in Paris* of 1937. A book which, even today, remains mutely overshadowed in the glory of Walter Benjamin's unfinished *Passagen-Werk*. Yet *Orpheus* was maybe a response, the echo of Benjamin's procrastinating silence, an answer to his failure to fully voice his project. And yet the mythology of Benjamin is so imposing that I start out from him and not from Kracauer.

These coincidences are anecdotal and bizarre, uncanny reminders of the non-positivity of historical discourse, of the unsettled machinery of identification and projection in its writing. That this process of identification is absolutely fluid is a principle of this book. That this fluidity can produce an I that is a viable, discursive and transparent simulacrum of one's self or of one's desire is a matter of course. That this is history, and neither outside, above or other to it, remains only to be argued.

Finally, a few points need to be made about the writing of this book. I have adopted the right to assume that the linguistic apparatus of twentieth-century theory from Saussure to Lévi-Strauss, from Heidegger to Derrida or Lyotard, from Freud to de Beauvoir, Irigaray or Lacan, or from Lenin to Foucault or Adorno, has become a structure of the commonplace and shared apparatus of our moment, deeply entrenched in our academic vernacular. I have not, therefore, aimed to produce a text where each excursus in analysis or speculation is prefixed with a precise account of this or that particular theoretical model. In setting out to justify each theoretical or verbal usage as correct or true to its originating source – overdetermination in Marx and Freud, for example – one can all too easily fall into a mode that is neither quite that of a reader nor of a textbook. It becomes all to easy to impose closure in the space of play, or intensive argument with others' uses of

5

theoretical paradigms rather than setting them to work for the purpose of invention. I will, then, take the risk of turning my back on this kind of a dialogue with the field of critical theory, intending that the book is anyway in such a conversation. But if I do employ words like overdetermination, *différance*, origin, O(o)ther, displacement, condensation, figure, trope, aporia, etc., fairly freely, each relatively exhaustive use of a particular theoretical model will I hope be clear or supported by sufficient explanation in text or endnotes. Besides, the reader may resort to philosophical or psychoanalytical dictionaries to see that none of these words have just one meaning or structure anyway, nor only one system of meanings. To use them is to do bricolage rather than to refer to an anterior truth.

Second, some materials, whether images or thematics, will appear and reappear, looking the same, but not quite the same. This is not a wilful contradictiveness. It is a means of getting to grips with the idea of the non self-identity of the sign, but at a rather pragmatic level of historical exploration. It is also the tracing of what might be thought of as the moebian form of the archive as I have constituted it, moving round a space where repetition is achievement. Moreover, I will at times stop and start my text in a self-conscious fracturing of its more linear strategies. At two points, in Chapters 1 and 3, I therefore introduce lengthy excurses, both of which reverse the temporal logic of their narrative. The purpose of this is to dramatise or stage the historical viewpoint, my viewpoint that is to say, as irremediably a-historical and nonetheless embedded in histories that both exceed and subvert it. It is to go with anachronism as a substance of historical thinking rather than as its guilty secret, a process that I think I can call ana-historesis.[8] But that will be the subject of another book ...

NOTES

1 '"Who am I?", I asked / "Who am I?", I replied. In its difference repetition is accomplishment.' (All translations are by me and Laura Davies unless otherwise indicated.)

2 'There is no speech without a reply, even if it encounters silence, provided there be a listener.'

3 See my essay 'Art's Histories', in *The New Art History*, edited by Al Rees and Frances Borzello, London, Camden, 1982, pp. 157–163. See Jacques Derrida, *La Vérité en peinture*, Paris, Champs Flammarion, 1978.

4 Longinus, *On the Sublime*, translated by W. Hamilton Fyfe and W. Rhys Roberts in Loeb Classical Library, vol. XXIII, Aristotle, Cambridge, Massachusetts, and London, Harvard University Press, 1991 (1927). For an important discussion which has guided my own reading see Michel Deguy's essay 'The Discourse of Exaltation: Contribution to a Re-reading of Longinus', in *Of the Sublime: Presence in Question*, translated with an afterword by Jeffrey S. Librett, New York, 1993.

5 See Jacques Derrida, 'Différance', in *Tel Quel: théorie d'ensemble*, Paris, Seuil, 1968.

6 See Siegfried Kracauer, *Orpheus in Paris: Offenbach and the Paris of His Time*, translated from the German by Gwenda David and Eric Mosbacher (1938), New York, Vienna House, 1972. In fact the book was translated immediately into

French and English, the French edition containing an extra, introductory passage on Kracauer's theory of biography.

7 Claude Lévi-Strauss and Didier Eribon, *De près et de loin suivi d'un entretien inédit 'Deux ans après'*, Paris, Odile Jacob, 1990, p. 10.

8 The term is one I use to describe the work of Jean-Louis Schefer, whose *Scénographie d'un tableau*, Paris, Seuil, 1969, remains a lasting influence on my work. His writing has obviously changed enormously since then, but it continues to exemplify a method of holding specific histories and theoretical speculations in a kind of dynamic suspense with each like an analytical anamorphosis – hence my term ana-historesis. His books are too numerous to list here, but see his *Figures peintes*, Paris, POL, 1998, for an overview of his thinking, including a fine essay on Ingres, 'Ce que nous n'avons pas vu nous portons sur nous', pp. 252–258. I will explore my concept further in my forthcoming study of sexuality and poetics, *Hyperventilation: The Search for a Banal Beauty*.

INTRODUCTION
The formation of a palimpsest

[R]aphaël, en imitant sans cesse, fut toujours lui-même.[1]

Ingres, *Écrits sur l'art*

Is there anything whereof it may be said,
'See, this is new'?
It hath been already of old time,
Which was before us.

Ecclesiastes, 1: 10

Ingres is an artist whose canonical status is exceptionally difficult to pin down, and only secured at the risk of some strange and interesting violences being done to one or another of his possible histories, or stagings, as I call them.

For his first biographer, Henri Delaborde, Ingres embodies an absolute and transcendental unity of the theories and practices of art, while for the poet-critics of his day, from Charles Baudelaire to Théophile Gautier, he remains absolutely and puzzlingly ambivalent.[2] Yet generally speaking, whether for romantic poets or academic theorists and administrators, Ingres materialises a crucial fiction that structures the very notion of art's modernity in which, by 1855, he and Eugène Delacroix come to confront each other as incompatible forms of the relation between the modern and the past, and hence too of the relation between art's pasts and futures. Delaborde felt so strongly about this that, if he threw himself passionately into the production of Ingres' historiographical cult after the artist's death in 1867, he postponed his official duty to deliver Delacroix's *éloge* to the Académie indecently long after that artist's death in 1863. For Henry Lapauze, who was the first to edit the corpus of Ingres' notebooks and other writings, and to locate them within a broader history of French Academicism, the artist is the origin and only proper source of a truly French and wholesome modernity.[3] While for an artist such as Edgar Degas, an enthusiastic collector of Ingres' work, or a critic like Théodore de Wyzéwa, he epitomises the uncanny grotesqueness of the emergence of the modern in nineteenth-century art, '[t]he spicy charm of a paradox'.[4] With Robert Rosenblum, in

both his monograph on Ingres and his *Transformations in Late Eighteenth Century Art*, Ingres' modernity is inflected to become an important stage in the formation of an international visuality of the twentieth century, while in the connoisseurial philology of Hans Naëf's scholarly recension of his portrait drawings, he is the essence of a transparent social and historical documentation of his age. To make a unity of Ingres, of all these Ingres versions, entails the making of exceptions both to it and within it.[5]

René Longa, for example, in his book *Ingres Inconnu* of 1942, undertakes a presentation of the until-then unknown ink-pen sketches left by the master to his home town of Montauban, housed in the Musée Ingres. The time, 1942, is ripe for the reassertion of a backward-looking and anti-cosmopolitan nationalism in the arts, a traditional Frenchness that conjugates with the cultural politics of the Vichy state. That its renewal should be disclosed within the figure of Ingres is to the point. He stands as the symbol for the integrity of a national self that, despite its monolithic quality, is open to a serendipitous remaking without disrupting the desired flow of historical narration. And hence Longa's revelation, that, amidst the thousands of the painter's drawings which prepare us for an appreciation of his painting; which delight us with their beauty, their hesitations and inventions; which underscore our belief in truth and art at the heart of national tradition, the very substance of its transmission; here, his pen and ink sketches are to be discovered:

> Such an incursion in the drawn work of Ingres ... reveals for us an Ingres without doubt less perfect, less the great lord of the plastic arts, but closer to us, to our modern liberalism, and in that well and truly different from him that we know.
>
> Brusquely this solid classicist is revealed to us as a being who resists discipline, a sort of revolutionary who obeys only his own temperament, subject to the tyrannical empire of inspiration. And we see in him this stupefying phenomenon: the aesthetic absolutely relegated to the background, subordinated to what his agitated pen, handled without skill, is able to give him.
>
> Who would have believed it?[6]

Who indeed? In the end astonishment at the internal diversity of the figure of Ingres is precisely an *affect* of the very fetish of his imago, of its capacity to contain difference in a synthesis that redeems its parts and relieves them of troublesome contrarieties. To stumble upon an Ingres who is closer to our 'liberalism' than we might have imagined, an Ingres whose 'solid classicism' is after all subjected to his temperament, is to find a utopian identity which is also a shelter from the shocks of history. It is to foreclose the contradictions of the present through their sublimation as a stupefaction in the rediscovery of tradition. For Longa, then, in total contradiction to his

contemporary Jean Cassou, or Robert Rosenblum over two decades later, Ingres is not in any instance to be seen as a precursor of those '[b]arbarous and deceptive endeavours of certain contemporary "geniuses"'. For these are capable of producing nothing more than those agitated sketches, Ingres' first, limping but inspired and marvellous thoughts in ink.[7]

For us the issue is clear enough. Ingres' unity is factitious. But the belief in it is overdetermined. In any instance of its avowal we can recognise a congealing of symptoms round Ingres' name, projections and displacements of complex historical identifications. Very recently I watched Pierre Rosenberg, the Director of the Louvre, on a television programme, represent Ingres' contradictoriness as if it were a matter of mere curiosity – at one moment he is the paragon of all we call reaction, at another he is the source of a radical twentieth century. But for Rosenberg there is nothing to explain here, nothing at all about the workings of art history – least of all as it is played out in this great museum of colonial heritage and world tourism. The artist is a curiosity in a cabinet of curiosities, supreme exemplar of the way in which the museum occludes the traces of its own formation, even after decades of a critical art history.[8]

Yet Ingres' own highly developed apprehension of his position comes to him quite early in his career. He sees himself as an artist working in the modern world on the ground of a displaced aesthetic, yet all the more revolutionary for his attempt to redeem that aesthetic through his practice. He is a conservative and a revolutionary. He kneels before his models – Homer, Phidias, Raphael – he repeats them without aping them, and he responds to the world he lives in without for one moment succumbing to the allure of either cash or fashion. His letters and notebooks tell us this, and their publication and repeated republication repeat all of his stories as if they really did add up to his history (Figure 3).[9]

But this self-consciousness of Ingres is tightly circumscribed. It is limited by his belief that its own integrity is somehow different and set apart from the conflict produced by the hubbub of the market, the demands of the Salon, the raging of the critics; that it can be secured through the intonation or invocation of a lineage of pure artistic concepts and their embodiment in exemplary practices of art, music and literature. In terms of its most basic linguistic elements such an identification is fissured. For the displacement that is felt by Ingres, as well as by other painters of the early 1800s like Girodet, who militated against the decay of critical language, is in good part an effect of the very inefficacy of such an invocation. Despite its consoling repetition, artists such as these suffer from a gradual transition of the words of art away from the Academic to the public domain – a transmigration of meaning that we can trace back to the Salon pamphlets of the eighteenth century.[10] And, through repetition itself, they isolate themselves within the illusion of the endurance of tradition. Insist as they might on their litany, the fact of the matter is that none of its words, its semantic field, could

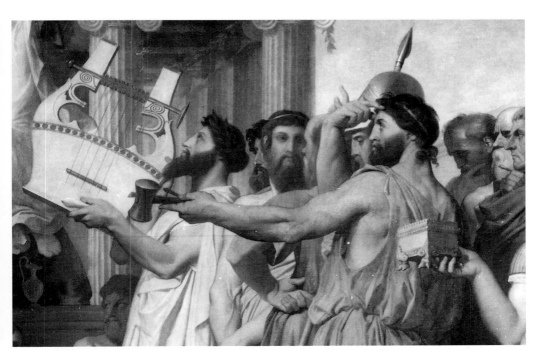

Figure 3

really be counted on to work in their favour, or satisfactorily to denote one proper practice of the arts, and it alone. As a result the expression of their opinions, be it Ingres' letters or notebooks, for example, or Girodet's polemics or teaching discourses, acquires a curious, unsatisfactory tonal range. Pedantic and angry by turn, struggling to articulate a discourse to an unresponsive public, it manifests a clumsy flatness or a baroque exaggeration, shifting from limping judgements of a banal conventionality to the most extravagant praises or denials.[11] Certain in their reference to the classical past of an Academic aesthetic, neither an Ingres nor a Girodet may be confident about how their voice is to be heard, between the silence of past texts and the babel of the present.[12]

Most obviously, Ingres pledges himself to a set of aesthetic values invested in the figure of Poussin as the most sacred of all French art, after that of Raphael as the most sacred in all of art (Figure 4). But Poussin is a dangerous motif of authority, and inevitably one of exile and alienation from the whole cultural apparatus of the French state. After all, Poussin had turned his back on France and the Royal Court, seeking a select and private clientèle of friends and faithful patrons. Poussin walked out of the court,

away from the King who fondled him like a favoured child, yet required him to do paintings beyond his ambitions, and his fabrication by the Académie as the master of its painterly protocols was a historical sleight of hand.[13] Indeed Ingres is fixated on Poussin's sorrow. On the thirty-eighth folio of his seventh *cahier* or notebook he notes this version of it:

> Poussin est persecuté en France bien qu'il y fit alors ses plus beaux ouvrages, tel le tableau du noviciat des Jésuites … ou de St François Xavier au Japon, cependant loin que ces beaux ouvrages convanquit (*sic*) ses ennemis de son grand mérite; ou fit cesser leur envie; au contraire cela ne servant qu'à les irriter d'avantage comme il y a peu de personnes capables de juger les choses, il ne leur étoit pas mal aisé de faire croire aux ignorans, que ces ouvrages considérables par leur simplicité n'étoient comparables à une infinité d'autres que le vulgaire estime par la qualité de richesse des ornemens…[14]

adding much later, in an older hand, the annotation 'chose inouie, détestable, décourageante' ('something unbelievable, detestable, discouraging').[15]

As Eugène Delacroix was well aware, Poussin's fascination lay precisely in

Figure 4

this ambivalence, in his undoing of the relation between the margin and the centre, between the absolute authority with which history endowed him and his failure to engage with authority as an institutional attainment. At the same time, to be an exile in Rome was to escape to the site of the one, true aesthetic and ideological authority of modern art. It was to live close to the *loggie* of Raphael and the architecture of Pietro da Cortona; to pursue the calm integrity of a praxis far from the noise of Parisian logos which nonetheless ratified that practice, and controlled it even in Rome through the Académie de France in Rome. Charles Baudelaire, with his deep, conflicted reservations concerning Ingres, could only regard Delacroix, in all his official success – which was in its way as great as that of Ingres – as profound if he imagined him as an exile from ordinary comprehension. Gazing at Delacroix's great ceiling decorations, he apprehended a beauty beyond common view, whilst Ingres' unhealthy, troubling look is firmly planted in a fleshly present. Both powerfully present in Paris, dominating the Exposition Universelle in 1855; in Baudelaire's phantasm the difference between Ingres and Delacroix is one between word and silence, the exclusiveness of official dominance and the exile of the authentic artist.

When Ingres seeks out and takes up his directorship of the Villa Médicis in 1834, just after the dramatic critical failure of his *Martyre de St Symphorien*, he lives out the two roles at once, as the supreme representative of the Parisian logos, yet misunderstood in exile at its principal outpost. The ambivalence of even one such problematic narrative, or mytheme of Ingres' time, is enough to shift him and Delacroix into each other's space despite their, and art history's, perception of each other as antinomic in the sense of two major, structuring tropes of its discourse.[16] Ingres' own sketch of Poussin's life in his seventh notebook shares its images of exile and outsiderness with Delacroix's published biography of their commonly acknowledged predecessor. So if Ovid in exile was one of Delacroix's most intense depictions, and Ovid is hardly one of Ingres' poets, their shared desire for Poussin undoes this difference. And Ingres' notes for the subject of Medea, a painting he was never to make, reads like a caption for Delacroix's finished work (Figure 5):

> toute enflammée de jalousie regardant de mauvais oeil en travers ses petits enfans et machinant je ne sais quoi d'horrible. Car elle tient une épée et les pauvrets sont autour d'elle qui se rient ne sachant rien de ce qui doit arriver, mais regardant tout seulement au glaive que leur mère a entre les mains ...[17]

Such positioning, this shifting historical topology, will concern us throughout my book. It is not then an account of the artist's work. Nor is it an account of his life, though it is one of his times – understood as a series of temporal spaces whose order remains perhaps to be apprehended for a

13

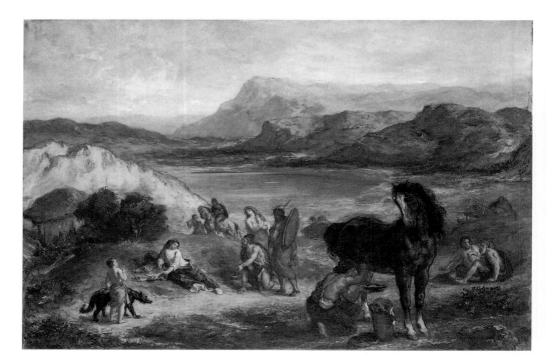

Figure 5

moment, but never fixed. Nor is *Ingres Then, and Now* an attempt to deal
with the ever-more thorny and inexhaustible questions of art and context,
yielding up new iconologies of his great works.[18] But it is a book that wants
to engage deeply with these art-historical problems. It is very much both-
ered with the ways in which tracing this artist as a figure in the history of
art can enable us to understand some details of where we are up to with our
discipline; how we choose our methods and positions, how they configure
our horizons and the dimensions of our knowledge, how they are overdeter-
mined by configurations outside of our intentions. Ingres might in this
respect be our Lacanian mirror, turning the hermeneutic back to us as gaze.

For this art history, then, as it tracks through the staging of the artist
Ingres between different periods of art's history, I will not try to secure any
kind of monolithic paradigm for a concept such as that of modernity, nor
will I try to disperse those which exist already.[19] I intend neither to reject
nor to work with the lineages of the modern that run from David through to
Manet, certainly not as a visual and literary canon that entrenches forcefully
determined loci of attention for a contemporary art history. Loci, that is,
which through their attraction of historical attention mutually confirm

themselves as origins or half-hidden strata of what is of today, or of what has only just passed in the urgency of contemporary art. Instead there will be moments when what might be thought of as a canon changes its accepted profile, while leaving commonly accepted definitions of modernity as if intact. Here we will be looking at the troublesome coexistence of different materials within a single narrative trope, of which the antinom Ingres-Delacroix began to be established by 1824, when critics like Anthony Béraud reacted to Delacroix's first major impact at the Salon, and Ingres' *Voeu de Louis XIII* lay in wait as an alternative paradigm to romanticism (Figure 6). And by an obvious inversion, there may be a shifting modernity which is never quite the same as any of its possible canons, – a conceptually rather than iconically invested modernity, that is to say, which loosely coincides with our differing viewpoints of its always partial materials. For Ingres this

Figure 6

is crucial, precisely because he is deployed in so many narratives of modernity, as a fountainhead of abstraction or as a weapon against abstraction, as modernity's other or the sign of its polymorphous perversity. To understand the coexistence as well as the contrariety of these positions requires the conceptualising of the modern to be left quite open ended. And, as a consequence of this, the hypothetical negation or transcendence of the modern that has come to be named as the postmodern is defused in its potential to predestine an ending, possibly through the rendering of Ingres' aesthetic enigma as a condition of the modern, *always and already*.

If rewriting is the book's method, then this is also because my purpose is mimesis. In feeding off tiny elements, paragraphs, sometimes only phrases, of theories whose importance for our field is well established, I do so not to generate a newly coherent synthesis, nor to engage in an undirected eclecticism, but to make the fields of theoretical reading relatively transparent. But in so doing, I attempt to re-enact something of what I see as Ingres' own problematic, but atheistically, without pretending to imitate his profound belief in the unity of his 'project'. So my book enacts a series of mimetic procedures with concepts and histories in their duration and reoccurrence. It does so consciously as a disabused imitation of its subject, the painter and draughtsman Jean-Auguste-Dominique Ingres, 1780–1867, to whom I feel closer now than ever I might have imagined. This is an unforeseen departure from the original idea of the work, which was to demystify the way in which individuals and institutions invent, deploy and reinvent the figure of the artist to write or to project themselves an image of their 'I' out of or on to this figure. Over the years this critique from 'without' has come to be replaced by an engagement from within. It is now a deliberated projection of what art histories are, or might wish to be, into the artist. It is a remystification, or at least a number of bids at achieving it, yet critically.

My argument ends up by becoming wantonly aporetic, or rather pathseeking, in the sense explored by Sarah Kofman in her little book *Comment*

s'en sortir (1983). In her initial discussion of M. Detienne and J.-P. Vernant's *Les Ruses de l'intelligence* Kofman elaborates the relation between various meanings of the word 'poros', a path, an expedient, a way out, and its specific sense as maritime or watery:

> Poros dispels the darkness that reigns in the night of the primordial waters by opening up 'the ways through which the sun can bring daylight and the stars trace in the sky the luminous paths of the constellations'.[20]

That is to say, in a state of aporia – 'all kinds of difficult situation, with no way out' – that calls for techniques, mechanics, ruses and expedients of arriving at determinacy, limit or direction, 'crafty intelligence' engages in a process of navigation rather than one of resolution, of sophistry rather than of logic. Anne Cauquelin in her recent book *L'Art du lieu commun* discusses these same principles of sophistry from a rather different angle, emphasising the procedure of social argument which runs through the repetition of the phrase 'and if ... and if'. Valorising a mode of the production of sense which is both pragmatic and philosophically grounded in a way that Platonic idealism would wish to circumscribe, but which escapes Platonic circumscription, Cauquelin points to the involuntary complexities of artistic gesture.[21]

And if this too is somewhat like the way that a number of artists appear to work in Ingres' time, even at their most rigorously academic, it offers a point of induction from method or theory to a framing of something of the social and economic complexities of the Napoleonic period that is not only a matter of markets, institutions and 'events' but one of aesthetic aporias, unanswerable conundrums that artists deal with, in and as a practice. This was in some ways a new, but neither a natural or universal condition for artists, given the uneven development of systems of patronage, institutions and forms of taste. But a condition it was. And this is why we cannot accept either Ingres' Platonism at its face value – his inscription of Homer as the model for all true art – nor his pragmatism as Platonism's idiosyncratic other. To do so would be to return us to René Longa's frenzy as, realising the dangers of the informality he has discovered, he breaks the link between Ingres and contemporary art:

> The aim of the elevated aesthetics lesson given by Ingres must not be sidestepped and used to mislead people. Here we may repeat with M. Henry Lapauze: 'Ingres was horrified by sophistry; so let the sophists clear out of his way.'[22]

Of course I will not remove my sophistry from Ingres' path. For, if nothing else his condition resembles our own, our problematic knowledge of

artists in a self-critical art history that nonetheless transmits a belief in art's monstrous importance. And if the play between those artists' puzzles and ours makes possible a 'poros' of our own, then our relation to them is critically structured. And then, from being a cold regard on the sign 'Ingres' and on Ingres' signs, this text has become an attempt to imagine their spaces parabolically, as something that we might need to imagine, in part as a series of framings or stagings that distinguish this artist from any other, let us say, Edouard Manet or Louis Barye, in the decades immediately following the author's death at the hands of Barthes or Foucault. Once I would never have said that 'Ingres est un grand peintre', for example. Now I would say that he is 'très grand', even, for the beauty of his strange and inconsistent textuality.

The stages of Ingres which I will offer are few but, I hope, in their manner exemplary. Many others would be feasible. Carol Ockman's resituating of Ingres within a series of theoretically and historically *feminine* spaces from the *abjection* of Julia Kristeva to the social world of Pauline Borghese and the artistic practice of Cindy Sherman is precisely such a transformation of his mise-en-scène, as is the lesbian framing of Wendy Leeks.[23] Richard Wollheim's, in his *Painting as an Art*, situates the complexities and oddities of a number of Ingres' spatial constructions and visual narratives through the use both of the classic Freudian reflections on the role of the father and the post-Freudian or Kleinian concept of projective identification. In doing this he infers a particular relation between biography and theoretical structure drawn from the Oedipal narrative of psychoanalysis. Yet, while it must be understood as a significant attempt to render apparent anomaly into complex signification, this seems to me to remain within a staging I want to refuse – that of psychobiography.[24] While for me psychoanalytic concepts such as that of the symptom, the fetish as a substitute for the lost object, or overdetermination, are all important, the way in which a 'normative' psychoanalytic narrative might unfold in the individual to generate forms of expression in his work have been eschewed as useful explanatory procedures.

Norman Bryson's figuring of Ingres as enjoying a privileged site at the end of a tradition, his tracking of the painting into the strange unconscious of bourgeois desire as Benjamin represents it in the *Passagen Werk*, and his consequent radical re-aestheticising of the work, is closer to some of my own directions, though I find that we often enough reach quite contrary conclusions.[25] The aesthetician Jean-Pierre Mourey, in his book *Philosophies et pratiques du détail: Hegel, Ingres, Sade et quelques autres*, comes the closest to my own theoretical investigations over recent years. In particular he uses the early thinking of Julia Kristeva to engage in a deft and subtle reading of the detail as a visual symptom in Ingres' painting. Glossing and citing Kristeva's words, he writes:

> The fine form of representation, of memory, of the sign is fractured;
> the totality of the object given to you is broken and invested in

fragments (colours, lines, forms) ... The order of representation, its thetic are fractured, displaced by 'another order', one of disorder, fragmentation, dissemination. It destroys the totality, order and unity of form, of scene, of fiction.[26]

And, Mourey rightly insists, we must distinguish between the fragment which '[i]s the residuum of a lost body or of a past time, which the form *still allows to be imagined*', and the '[p]rocess of fragmentation, of pulverisation which *destroys* form, unity, totality'. Thus we can understand how the fragment is not a nostalgia in Ingres' work, but a process of making visible in which Ingres' voluptuous body-line undergoes distortion in '[e]xalting its general line' (p. 78). A process which, Mourey argues, in a wonderful conceit of the juxtaposition of Sade with Ingres, is to be distinguished from the detail or the fragment in Sade's writing, which is rather a point of frenzy and disruption.

Yet our undertakings remain very different. If Mourey's analysis confirms the aptness of Kristeva's poetics to Ingres' work, my reading of her mapping of the choric, the thetic and the negative enables me to find an analogy for the historical archive. An analogy through which a psychoanalytic poetic can attend to the particular possibilities and conditions of visuality, that are Ingres' paintings for example, as a series of discontinuities and only partially or contingently coherent effects. The significance of detail may turn out neither to transcend nor to exceed the totality of the image; but rather to escape it, to lead us to a force of determination which may not necessarily return us to the image from which we set out as a unity possessed of greater significance than its fragments. To insist on this, I have suggested, is to configure an archive as one made up of the possibilities and conditions of figuration, historically accumulated and generalised, highly specific, long-lasting or relatively transient. As Kristeva notes of Stéphane Mallarmé's statement, 'Everything comes down to Aesthetics and political economy', aesthetics and political economy appear to share a common domain, '[i]nsofar as they hold to the logic of production; the latter of capital, the former of language'; and to have a separate one, society and the subject, '[w]hich complete each other in the process'.[27] It is this concept of the archive that I call 'chora', following Kristeva's neo-Platonic naming of the semiotic babble that underlies all sense; and it is the painter's scheme or gesture that I think of as thetic, as the cutting of the archive through an intention which can never be fully identical to itself, and which manifests the incoherence of the underlying babble or babel despite itself. The negative, to travesty the complexities of Kristeva's work, is neither denial as a conscious response, nor repression, nor the middle part of a dialectical argument, but it shifts between these and other possible meanings. In thus shifting, the negative opens up or may be identified with the space of poesis as a symptomatic discourse. To look at a painting through this poetics is

strangely like listening, hearing the faltering of a tone, a half-masked intake of breath, the muddles and lapsuses of speech, the unexpected effects of intended juxtapositions in a formal discourse. The object of attention is to hear the archive, not to call on it as the body of evidence, as if it were incontrovertible in its eventually discoverable truth.[28]

It is interesting, then, to note that conventional Ingres scholarship, that of Daniel Ternois, Hans Naëf and, more recently, Georges Vigne, Gary Tintorow and others, has unswervingly clung to its narrow philology even at a certain honourable and quixotic cost to its object of attention. Currently the careful reassessment of the Ingrian corpus is leading to a disattribution of whole areas of the master's work. The background of the *Portrait de Granet* goes to Granet himself, the near entirety of the Roman sketch-books, once so beautifully exhibited and published by Naëf, to a hypothetical 'Master of the Little Dots', while the reflection of a window in the back of M. Bertin's chair is ascribed to an assistant. These last two items touch me, as I have something of an epistemological nature to say about both the Roman drawings and the reflection (Figures 7 and 8). I am not at all sure that I agree with the observation that the former must go to an anonymous artist, from whom Ingres must have obtained them as a source of reference, and who should be called 'Maître des petits points' – after the tiny marks that often betray the hesitant use of a *camera obscura*. Indeed hesitation could be entirely an effect of Ingres' lack of familiarity with both the subject and the form of landscape, and some of the 'spatial tearings' seem more typical of his hand than they do of an optical device – the argument is open. Either way, these drawings represent *his* Rome, as I call it on p. 54 below. The desire for scholars to strip them from the oeuvre needs to be understood symptomatically – perhaps as representing the impasses of intensive, philological interrogation of a single oeuvre, but certainly indicative of a theoretical incapacity to escape the fetish of the author. As for the latter, the reflection, which I discuss at some length in Chapter 3, Ingres marks it in quite ferociously in his first drawing of his subject's seated pose. If, as Vigne recounts, the decorative artist Dutanhofer really did have to repaint it several times at Ingres' insistence, the reflection's importance for the master as an essential aspect of the whole image seems to be underlined rather than undermined.[29]

Figure 7

Figure 8

My first chapter, *Ingres and the Arcades*, schemes the world of Walter Benjamin, his nineteenth century, with Ingres rather than Baudelaire at its centre. It needs a gloss of its own. This rather perverse exercise in antinomy tries to explore some of the dimensions of a commodified culture that are sedimented in a form of art work that most definitely tries to set itself apart from the general mode of commodity production. The chapter title therefore implies an argument, a polemic with the image, the idea of the nineteenth century that tends to weigh most heavily in recent narratives of art and literary history. This idea of modernity is obviously not the unique property of the social history of art in the manner that we have come to practise it over the last three decades. Nor is it the discovery of a deconstructive turn in the re-reading of the literary canon. On the contrary it is shared by all kinds of conservative and radical approaches to both the disciplines of art and literary history and was in a sense already invented by Baudelaire before subsequent scholarship would take him at his word and spin modernity around them.[30]

The nineteenth century that unfolds itself around the problematic modernity of a Baudelaire or a Manet is a habitus for many forms of academic discourse. Whether such artists are to be appraised for the quality of their formal innovations in the production of word and image or for their revelation of brushmark and prosody as themselves representational and symptomatic, they are used as a means of privileged access to the nightmare world of the capitalist commodity. Situated on the bleak side of capital that commodifies everything human, body and soul, they provide the central axis of a modern that for a century and a half has been a dark, confining yarn of the tragedy of urban life. But, in this very complexity, their narrative is a striking statement of the desire for the security of a canon on the one hand, and, on the other, for a bewitching fluidity of meaning. It seems as if the flight from fixity of meaning that alone darts just ahead of the commodity is itself too disquieting if it cannot be returned to a completed work.[31] Norman Bryson has, as I suggested, made an interesting attempt to fit Ingres into this Benjamin-like space, seeing Ingres' portraits in terms of the bourgeois desire to trace identity in the decor and bibelots of the modern interior. Though this is achieved at the expense of some slippage between bourgeois and aristocratic appearances, taking the essentially aristocratic portraits of the Restoration as if they were middle-class images of the Second Empire, the anachronism itself points productively to the problem of quite where Ingres' work belongs in the modern.

Now this modern itself has histories, a history of its becoming, its becoming accepted, of its institutions, inscriptions into very different levels of literature and academic studies. And, although Baudelaire and Manet are the quasi-natural materials of these histories, it was, of course, Walter Benjamin who was to become their presiding theorist. It was he who begot our most treasured tales of a modernity wrought through the fragments of

the new industrial city and, what is more, a textuality that has provided the surest link between the marxist and the post-modern. It is, then, this textuality that is the nineteenth century of the arcades, the nineteenth century of Baudelaire, Manet and Benjamin; of the arcades as a sufficient representation of a desire for our nineteenth century to be the origin and the other of our own pleasure in the commodity of art. Consumption and fragility, prostitutes and the instabilities of urban space, the strange and estranging confusion in the changing orders of the public and the private that are the arcades and the department stores, the febrile gesture of the gambler, the ragpicker's limp, and, their mutually redeeming preservation in the Poet's irony and the prehistoric confusion of the Theoretician's notebooks (Figure 9):

Figure 9

> Paris is the city of mirrors ... The women here see them-
> selves more than elsewhere: from this comes the particular beauty of
> Parisiennes – before a man might get a look at them they have
> already seen ten reflections of themselves.[32]

Somewhere in the *Passagen-Werk*, in the section *Painting, Modern-Style, Novelty*, (S 7a, 1) Ingres figures as an author. Benjamin quotes his vigorous rebuttal of the proposed reform of the École des Beaux Arts in 1863, his hasty, long-after-the-event barricade against the entry of industry into art – 'Maintenant on veut mêler l'industrie à l'art. L'industrie! Nous n'en voulons pas. Qu'elle reste à sa place et ne vienne pas s'établir sur les marches de notre école ... !'[33] Perhaps this flat-footed definitiveness made Ingres uninteresting for the theory of the commodity. But where do those dull, barely reflecting mirrors of his fit into the nineteenth century of the arcades? Is it simply a matter of social distance – these countesses, *Mme de Senonnes*, 1815, *Mme d'Haussonville*, 1845, turned their back on those mirrors that also reflected bourgeois man (Figure 10)? Though *Haussonville* went on display along with all the other commodities on the Boulevard Bonne-Nouvelle in 1846, and was thus exposed to the *flâneur*'s gaze only a stone's throw from the Passage des Panoramas. And why, anyway, should there be such a distance between Ingres and this Paris, why should the words of my title sound so badly together? After all, the year that he came to Paris to study with David was the year before the first of the great Arcades, the Passage du Caire, was opened, and his lifetime spanned theirs from birth to the early period of their social and economic decline.

This difficulty in siting Ingres in such a nineteenth century intimates that despite its glamour, it does indeed have its disappointments and frustrations. Not least these may be attributed to us, to the fetishistic nature of our own attraction, our entrapment by it. The academic rite of passage that calls for a tussle with Manet's *Olympia*, the establishment of lineages and

21

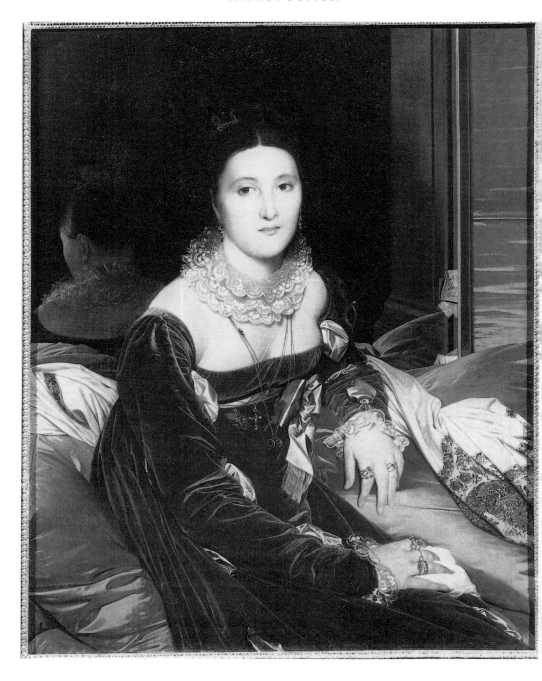

Figure 10

inflexible teleologies of a 'subversive' modernity, the overcrowding of signs, texts, images, in which the destruction of already-established meanings is set in motion by the need for space as much as by any theory of meaning as such. In this light our heroes, these three men, Baudelaire, Manet, with his curl of lemon-peel reality in the *Déjeuner à l'atelier*, and Benjamin, may eventually be understood as the tropes of a long evolving, complex, richly versioned allegory of modern life. Courbet was more prescient, perhaps, than ever he or we had imagined in his *Atelier*, in representing the living Baudelaire as already such an allegorical figure. Rather than as a poet writing, we see a reading figure, a text-maker poring over text.

In the perspective of the Arcades, then, the canon of the century is radically shifted from anything that might have been imagined by Charles Blanc or Henri Delaborde, or later, Henry Lapauze, to mention just three eminent Ingristes. All of these had their conception of the modern, of tradition, innovation and progress, and saw their relation to it as in some way passing through Ingres. In Blanc's *Grammaire des arts du dessin* this *passage* becomes intellectually central to French aesthetics, inflected with a subtle and complex understanding of the artistic transformations of industrial society. Often unreasonable, intolerant, academic in the worst sense – recall Delaborde's treatment of the dead Delacroix – these men are readily stereotyped by bohemian mythology as the living caricature of an oppressive establishment, and Ingres along with them. For, as we have already indicated with Longa, they undo the problem of the avant-garde by presenting their hero as the 'always was' of modernity, as the 'ur-modern' of a Degas, Maurice Denis or Picasso. As an after-effect of all this their nineteenth century has found itself but little space in the twentieth that is mapped out by the critical romance of the commodity fetish.

Broadly speaking the social history of art, understood as a discipline based in a generally marxian mode of analysis, with its materials drawn the good side of the real as of the metaphoric barricades, has fallen for this. So, with some recent exceptions I have noted, Ingres gets slotted in, whereas Manet or Courbet get one monograph after another. Where there is the white male gaze, there might be one of Ingres' nudes. Where there is question of the colonial other, his Orient might figure this important theoretical discovery, and so on. Leaving Ingres in these fragments, his queries to modernity enmired in their enslavement to Tradition, a new art history has very largely starved the terrain of his historicity. And, by the same token, has deprived itself of working through the potential for historical plurality of modernity itself. The school of writers devoted to Ingres' cause, from Delaborde to Rosenblum and Bryson, who nonetheless goes beyond this, points to a lack at the heart of the philosophy of the modern. And yet brings us little nearer to a more extended, deeper view of the evolution of sometimes separate and sometimes intertwining theories of language, representation and meaning. Let me say that this is not a carefully disguised

plea for yet another reworking of Academic art, or even for a widening of the canon to reconcile conflicting stories of modernity in a single straitjacket. I want to enjoy the guilt of some of my own accusations, to engage in a reading of Ingres which might seem quite Ingresque in its perversity.

So, in framing this piece of work, to find modernity a new place in Ingres, some resort to an arbitrary eclecticism appears pardonable. Hence the matter of E. T. A. Hoffmann. Searching in the index of that classic of punctilious investigation, Norman Schlenoff's magisterial *Ingres: ses sources littéraires* (1956), I solicited a missing name. I was not sure which. Only that it had to be one whose presence would help neither to solve nor to accentuate the fraught non-question of the romantic and the classic, for example. A name able to slip between the binary slippages of the modern, conservative in form, socially radical, radical in form, socially conservative, and so on. The missing name in the 1830s, the one which is not a literary source for Ingres, but which was pre-eminently present in Parisian cultural life, was E. T. A. Hoffmann. That is to say, the name of a German writer whose resonance is archetypically the Paris of the Arcades, or of that version of the nineteenth century, yet at the same time who sounds in Kracauer's *Orpheus*, that critical other to Benjamin's writing on the city. A writer and musician whose name conjugates nicely with the word Arcades, the world of flickering identities, just as that of Ingres does not. Suffice it to note here that my exercise in the arbitrary structures two chapters of this book, reading together the separate histories of Ingres and Hoffmann until they coincide – as we will see.

Now it is true that Benjamin hardly plays more with the name Hoffmann in the *Passagen-Werk* than he does with that of Ingres. Yet when he does so, it is in connection with the key figure of modernity that is the *flâneur*, one entry below an extract from the *Grand dictionnaire universel* outlining the *flâneur*'s addiction to the changing *étalages* of the Boulevards.[34] That is to say, on the side of industry. Hoffmann too is part of that nexus of German romantic culture gathered around the figure of Jean-Paul Richter, nowhere more important for Theodor Adorno than in his critique of Benjamin's essays on Paris, and so an integument of critical discussions of the modern.[35] Moreover Hoffmann belongs unproblematically to the world of modern life, to the philosophically speculative, aesthetically cosmopolitan and endlessly ironic circles of the *Revue de Paris*, the *Revue et Gazette Musicale de Paris* – some of the earliest translations of his work appeared in them – and the *Revue Musicale de Fétis*. That is, to the world of Berlioz, Bellini, Liszt and the Docteur Véron, a world where Ingres makes his marginal appearances as friend, as portraitist, as a man of musical taste and even some practical accomplishment as a violinist. It is this marginality that will hold our attention now. For it is here that we can begin to read the instability of Ingres' signs and the sign Ingres. And to see how the stability that Ingres wants to secure for his signs can be only at the constant risk of his ambitions for their purity. The Romantic side of Ingres lies here then. Not in his genius, but in

the complexity of a semiotic space that now includes a writer who was not, who could not have been, one of his *sources littéraires*, but whose presence produces one possible axis of meaning. But a writer who systematically invokes elements of Ingres' own ego-ideal, Gluck, Mozart, Rome, the century of Louis XIV. Such is the rationale for Chapter 1.

Another theme, developed in Chapter 2, *Académie*, deals with the ways in which an artist might be thought of as prefigured by a tradition of representation and the historical institutions of artistic production, and with how he represents himself through this system of practices and ideas into which he is born. This is important because it enables us to materialise the image or myth of Ingres the academic, Ingres the monolith, realising himself only in a set of knowledges that are themselves contradictory, conflicting, historically complex and rather lumpy. This builds out from my 1983 article 'Ingres and the Academic Dictionary'.[36]

Chapter 3, *A filament in the tissues of modernity*, sets out to trace the concept of avant-gardist negation as a framing for Ingres' painting, but within a context of a French cultural progressivism not readily assimilated to our habitual modes of post-Frankfurt theorising. Here unexpectedly the figure of Jean Cassou holds centre stage, and his relation to French Hoffmannism and its acceptance of culture's uncanniness allows me to insert my gay seeing of Ingres as a further disturbance of historical proprieties.

But before entering the concept of the Arcades, and in conclusion of this foreword, it will be useful to map out one of the paradigmatic elements of Ingres studies, the matter of his *Cahiers* and the editions of his writings. I will do this because it sets in place the philological and biographical fundamentals of Ingriste studies, while the reader may refer to other books for an exhaustive account of his life and works.

From very early in his career Ingres keeps a series of notebooks. This is well known, basic, like his violin. He is a wordy artist and a musical artist too. Ingres' notebooks are to scholars what his violin is to more popular parlance, a surrounding of him, and an inner gestalt that we sense in his life and works. These are his ten *Cahiers*, conserved in the Musée Ingres in his hometown of Montauban. Edited more or less in full, first by Lapauze and then by Schlenoff, our first glimpse of them is in that maimed and highly selective collection that Delaborde appended to his ur-biography of the artist in 1870 as 'pensées d'Ingres'. This medley has remained the basis for most subsequent compilations and has so become a vernacular of Ingrisme from its most popular to its most elevated forms. I will very largely stick with it myself. Except insofar as it is useful to think about that which neither Lapauze nor Schlenoff thought necessary to relay to us – the look of the pages. To see them as something more than a philological and palaeographic nuisance to be cleared up in a clean, decent and chronologically accurate true-text of the artist's thought, is to open a crack to hearing the artist's thought, his 'and if ... and if'.

25

Anyway, these notebooks are the place where he writes things out that he is reading, sometimes as a faithful copy, at other times in précis or even as if he had thought something up himself, in his own words. In fact it's not utterly unlike fiddling on a violin, following a score, varying a key, retrying, improvising a few bars. Yet if antiquity and exemplary modern texts are like a score, it's something of a Cageian score, a graphesis that demands no single realisation. So, these are words from the accumulated texts of an artist's culture at the end of the Enlightenment and the *ancien régime*, and at the beginning of a revolutionary social world that we think of as becoming systematically bourgeois and modern. Ingres therefore begins to make his notebooks more or less at the outset of the 'modern episteme' in Foucault's sense of the word 'modern', and their fragmentary suspense between denoting and classifying seems to fit the moment well. He is a modern individual. In the notebook entitled *Pline et la Grèce*, under the heading 'Lecture' he notes that:

> Pliny the Elder read with his pen in his hand, making notes and extracts; he never missed doing this because, he said, there was no book that was so bad that there was not something good in it.

Most of the notebooks are lists of subjects for painting, and so represent the eclecticism of a culture in which an artist reads precisely for this reason, to have subjects to paint. The model was provided by countless dictionaries and encyclopaedias of the eighteenth century, of which the Comte de Caylus provided the artist's exemplar in his *Tableaux tirés d'Homère et de Virgile*. This was an urbanely patronising attempt to educate the poor, hard-worked artist in the right pathways without taking up his time ploughing through too many highly literary texts that were anyway above his status as a reader. A close, comparative reading suggests that Ingres sticks with Caylus' model, yet does a lot of his own reading too. He wants to do it right, as of his own right to live a cultural ideal, albeit he never reads in Greek or Latin.[37] Ironically eclecticism is nonetheless sustained by the classical precedent of Pliny's reading method, the citing of which is intended to overcome the impurity of the present day. For if to adopt Pliny is to fulfil the prescription to imitate the ancients, it is also to open a space to difference, to risk the discovery that the good one finds is not always quite the same as the good that one expected to turn up. In this sense too Ingres replicates the vicious circularity of Academic antiquarianism, which, even as it tried to classify the precedents of modern art in an exclusive genealogy from Antiquity to itself, opened up a space of difference and the relativity of values in its very awe facing the grandeur of the archeological record.[38]

The formula 'there is nothing so bad that there is not something good' becomes an involuntary and open-ended liberality, elaborated around one single instance of the rhetorical and aesthetic rule that it is good to imitate

the ancients. Reading Pliny as if one were Pliny reading seems so secure that, in its fetishistic certainty, it wards off the selfsame vision of difference that it actually allows. This primary and founding instance of what I will call the 'classical gesture' in Ingres, is, then, the very drifting to that other structure of classical philosophy, named aporetics or sophistics. This is quite unintended, but opens out to the navigation of the everydayness of being-an-artist. Such a gesture itself then is the site for the emergence of the archive, the unconscious disturbance of poetic rules that is the history of their production as of their undoing.

In some parts the notebooks are more literary in their allure. And in one instance, that of *Number 9*, represent a sustained reflection of Ingres on himself and his situation through the collection of exemplary texts of all possible kinds, opinions and notes, made over a period of forty years. Were we to decide to read them as the record of a fractured, modern subject, eminently individual, post-feudal, yet haunted by the past and the problem of making it over into the present, the case could readily be made. If he intends his work, his painting, to be like these notebooks or drawn out from them, to be an exemplary locution of certain deposits of pictorial, and with it historical, social and political value, then, alas for his peace of mind, none of the signs he uses are able to mean quite what his locution or visual realisation requires of them. As we will see, their histories, presents and futures are so crowded with use and pullulating presences, with utterance and counter-utterance, that to write or to paint them out was not so much to secure meaning as to disturb it. The margin between a pure classical gesture and a complicated, half-formed commentary on the complexities of artistic production was indistinct.

Let us note here how haunting was this problem in a world where, to follow Georges Bataille's insights developed in his *Manet*, art as a process of figuration was still largely dependent on a social history that preceded its coming to replace religion and other mysteries as a source of value.[39] Ironically a classical gesture could entrain its source, the past, only at the expense of turning into kitsch – I anachronise the concept quite deliberately, while looking at the sketch of Ingres' *Apothéose de Napoléon* ceiling for the Hotel de Ville (Figure 11). Or at the cost of ironising its very sources. Here I think of one of the most accomplished classical gestures of any of the arts of the mid-century in Paris. It is the moment in

Figure 11

27

Berlioz's opera *Les Troyens* when Cassandre sings 'Les Grecs ont disparu …', a perfectly achieved rhetoric that reinvents Gluck's imagined reinvention of Antiquity – Ingres' own, axiomatic musical exemplar – on an axis that exquisitely confounds the taxonomies of 'romantic' and 'classic' through the simultaneous reinvention of affect both in and through the musical formality that points only to mystery and absence.

This is something Ingres aspires to do in his *Apothéose d'Homère*, to represent the affect of a given truthfulness, the Greek, if at the mercy of his own indecision or ignorance on the one hand and the palimpsest of history on the other. For the *Homère* is one of those images that Ingres reworked to the very end of his days, shifting his artists, poets and musicians around, without resolving whether origin is merely an effect of present, the rejigging and reprioritising of the figures a politics of universality, individual preference or cultural expediency (Figure 12). But with Berlioz at what another expense! For if the Greeks have disappeared, the very condition of the utterance, it is only to return as destroyers, inside their wooden horse. The founders of the 'western episteme' reduce Troy to ruins only to set off the *Aeneid*, the founding narrative of Rome. And this in a single gesture of Cassandre that invokes all at once the incompatibility of the narratives of Antiquity as surely as they had rubbed shoulders with each other in the Revolution of 1789 and its failure to resolve them into a unitary narrative of republican nationhood. Universality, as Marx well knew, is here dressing up nothing more than the acting out of different selfs and their interests. Turning this back into art, and no more than that, Berlioz's opera remained unheard, at least until the terrible significance of his defeat, or triumph, could be culturally inaudible – London, 1969.

'It doesn't hurt', sings Cassandra, after the Greeks have triumphed, as she stabs herself with this Tacitean phrase. But it did hurt, the culture of the 'western episteme'. When Aeneas enlists his troops to Dido's cause on his arrival in Carthage, it is to crush the Nubians, the black inhabitants of Africa. The narrative of Rome passes through this moment, just as it will return to the destruction of Carthage itself, confounding the enslavement of Africa with its own ideal image. The affect of Berlioz's music is an intimacy with this hurt as the repressed substance of an ancient aesthetic as it passes through history. Ingres' *Odalisque à l'esclave* may do again or may undo this hurt or offer it for a different kind of enjoyment; necessarily different, as it hardly invokes an origin. It hopelessly conflates aesthetic singularities with each other, with the Other: the dictionary of Moorish ornament, the exotic fabrics of the *étalages* of the industrial exhibitions and the shopping arcades, industrial pattern books, which between them, in a proper order are art's sources, but in another order are its Other (Figures 13 and 14). So if it is the after effect of an origin, this origin is one in which the western episteme might already have confused itself in the registers of its potential others. I will come back to this in Chapter 1.

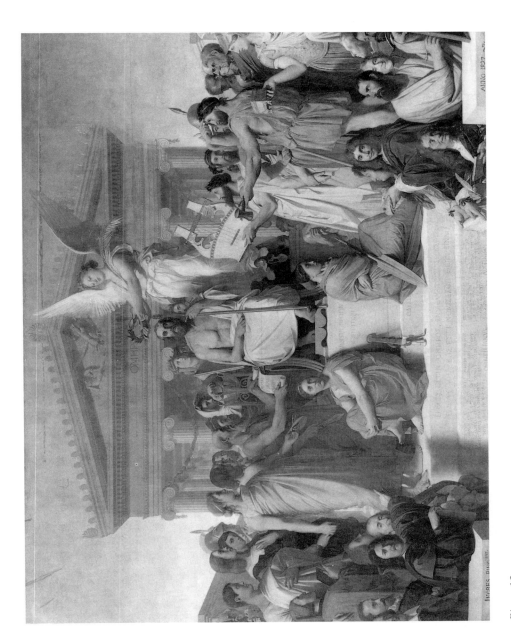

Figure 12

Figure 13

At the same time the ever-present weakness of the episteme and its classical *gestuelle*, again located in the Aeneid, marks Ingres' work in 1814 in his *Virgil Reading* and its subsequent variants. Amongst these complex and shifting morphologies of a single moment that Ingres works, we can trace, as perhaps the sole element of stability, the silence that befalls the classical discourse at the very moment where its flight from origins brushes against its possible actualisation, the point at which its appeal becomes an effect, in search of an affect.[40] Virgil inscribes across the whole future that which cannot be spoken, the moment he renders into allegory, and Ingres' representation is of that which cannot but be repre-

Figure 14

sented, but as representation's aporia. This is what Stephen Bann calls the moment of naming, of the enunciation of the sole force for the evasion of history, of the projection of some thing beyond its ruins, some thing which, if it is not yet origin, is at least more than the present merely is. And yet this image and the present haunt each other at the level of the seen itself, as the family of Augustus and the families of modern life merge into each other in Ingres' anxious eye (Figures 15, 16, 17 and 18).

Of course this is speculation. It would be nicer to give *Virgil Reading* a name of some kind – it is 'not realism' or it is 'romantic classicism', though it is far from clear that it is not 'about' the reality of representation or that its investment of classicism with affect is conditioned by the same kinds of social forces and rhetorical procedures that drive the 'romantic' – which could probably be demonstrated if we worked around a suitable nexus of texts and market analyses. But hence the purpose of this text, of mine. To make these readings against the accumulation of the artist's gestures, in the space between the contemplation of a gesture and its enactment.

The surface of Ingres' notebooks resembles this problem, which is also a problematic: how to remain clear, how to escape aporia when it is the condition of the artist's knowing. Especially in the densest amongst them, the supposedly most personal *Number 9*, texts and periods of text elbow with each other, as the artist fills and scribbles and re-notes, in contiguity and partial superposition. Trying to write on a page where text is declaration and memory, noting the value of something quoted half a century before, as if it was what one had thought, and now, still, is what one does think, this writing in itself, in its self-defeating occupancy of the paper, fabricates slippage, the metonymy and the metaphor that make meaning, but also in the form of their combination, make poetry as readily as rules. If we were to read the notebooks as a theology and commentary, this too could make some sense. I could imagine, but generally will resist, picking up threads that lead to Walter Benjamin or Emmanuel Lévinas on the ethics of the subject. But at least here are the symbolic fantasies of the unitary subject, the artist's sense of being I, and a He which is also someone other's I in the discourse that they spin around him. Not just Delaborde writing as 'I' and 'thou' or 'I' and 'he' concerning Ingres, but, in his projection onto Ingres, as 'I' and 'I'. (Which is perfectly Rastafarian in the end, if the repressed slave is here to make a triumphant return.)

Here Ingres' early memorialists, Henri Delaborde first amongst them, grappled with his notes as if it were a purely textual matter. A matter of clearing the interstices of mismeaning, to establish the master's essential thought. It was they, Delaborde and Blanc, who first systematised an I in his he. They found an I for themselves and for their institutions, the Académie Française and other cultural apparatuses of state, the Gazette des Beaux-Arts and the Academic funeral orations, in the he that they gave the name of Ingres. For them, Ingres stands, above all, for the 'unity' and 'solidity' of

Figure 15

Figure 16

their national tradition of French art. A tradition that through its unity is able to recuperate the significance of artistic practices and production from the shock and transforming effects of historical change. Or it defines art, true art that is to say, as an activity that folds back upon itself as the means of generating its own processes of change. If art is true, it is the same, however different one art-work will look from another. What it is is always fully present. In his *Homère* Ingres tries to commit this metaphysic to a single image of itself, to engage in a gesture that will reveal it as 'always and already' a history in and for itself. He does this on the ground of his own disparate production that stands in such striking contrast to the

Figure 17

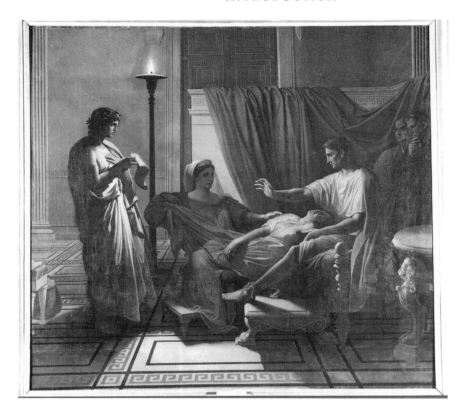

Figure 18

ideal of the *Homérides* that even his own attempt to approach it becomes in itself a replacement for the thing. If we were to make a dictionary of hands posed on knees in Ingres' work, thighs posed on cushions and arms of men and women posed on the arms of chairs, or any other combination of human postures, the worlds of *Virgil Reading*, *Lucien Bonaparte et sa famille* or the *Famille Forestier* or even *L'Age d'or* would fold into each other in a radical confutation of difference, of genre, style or historical times, so that we too might find ourselves dupes of the desire for wholeness or seduced by such an unintended or unexpected achievement of transcendence.

NOTES

1 'Raphael, through constant imitation, was always himself.'
2 Henri Delaborde, *Ingres: sa vie, ses travaux, sa doctrine, d'après les notes manuscrites et les lettres du maître*, Paris, Plon, 1870. Charles Baudelaire, *Curiosités esthétiques; L'Art romantique*, Paris, Garnier, 1962. Théophile Gautier, *Les beaux-arts en*

Europe (1855), Paris, 1855 and 1856. For Ingres see First Series, Cap. XIII, pp. 142–166. Also Gautier's *Portraits contemporains: Littérateurs, peintres, sculpteurs, artistes dramatiques*, Paris, Charpentier, 1874, pp. 280–290. Delaborde maps out the foundations for almost all future Ingres scholarship in his naming of three principal bodies of source material, namely Ingres' notebooks and loose-leaf jottings, his letters to his intimate friends, and notes taken by other parties in his studio sessions. In the face of this heterogeneous and fractured material Delaborde sets out the thread that binds them and reduces inconsistency – see his *Ingres*, pp. 4–5.

3 Henry Lapauze, *Les Dessins de J.-A.-D. Ingres du Musée de Montauban*, Paris, Imprimerie Nationale/J. E. Bulloz, 1901; *Le Roman d'amour de M. Ingres*, Paris, P. Lafitte, 1910; *Ingres: sa vie et son oeuvre (1780–1867), d'après des documents inédits*, Paris, Georges Petit, 1911. For discussions of Ingres as a conservative totem see Lapauze's introduction to *La Renaissance de l'art français et des industries de luxe*, 4, May 1921; Christopher Green, *Cubism and Its Enemies: Modern Movements and Reaction in French Art 1916–1928*, London, Yale University Press, 1987; Kenneth Silver, *Esprit de Corps: The Art of the Parisian Avant-Garde and the First World War, 1914–1925*, Princeton, New Jersey, Princeton University Press, 1989; Romi Golan, *Modernity and Nostalgia: Art and Politics in France Between the Wars*, London, Yale University Press, 1995. For a specific analysis of the linguistic structures of this process see my article 'Ingres and the Academic Dictionary: Ideology and Stupefaction in the Social Formation of the Artist', *Art History*, Summer 1983, pp. 154–170. For the broader historical and theoretical context of Ingres' Academic/linguistic conditions and the forms of knowledge appropriate to the early modern artist, see Tom Holert's unique and important book, *Künstlerwissen: Studien zur Semantik künstlerischer Kompetenz in Frankreich des 18. Und frühen 19. Jarhunderts*, München, Fink, 1998.

4 T. de Wyzéwa, *L'Oeuvre peint de Jean-Dominique Ingres*, Paris, Gittler, 1907.

5 Robert Rosenblum, *Transformations in Late Eighteenth Century Art*, Princeton, New Jersey, Princeton University Press, 1967; *Jean-Auguste-Dominique Ingres*, New York, Abrams, 1967. Hans Naëf, *Die Bildniszeichnungen von J.–A.–D. Ingres*, 5 vols, Bern, 1977–1980. For an exhaustive list of Naëf's many articles see *Portraits by Ingres: Image of an Epoch*, edited by Gary Tintorow and Philip Conisbee, New York, Metropolitan Museum of Art, 1999. Indeed this volume, the catalogue for the eponymous exhibition, constitutes the most up-to-date survey of Ingres scholarship and offers the most comprehensive bibliography of the artist.

6 René Longa, *Ingres inconnu*, Tours, Rombaldi, 1942, p. 30.

7 Ibid., p. 36.

8 The locus classicus of this discussion is Carol Duncan and Allan Wallach, 'The Universal Survey Museum', in *Art History*, vol. 3, no. 4, December 1980, pp. 448–469, and their earlier 'The Museum of Modern Art as Late Capitalist Ritual', in *Marxist Perspectives*, 4, Winter 1978, pp. 28–51. See Carol Duncan, *The Aesthetics of Power: Essays in Critical Art History*, for her 'The MoMA's hot Mamas', pp. 89–107. In my gay parable on Ingres (see Chapter 3 below), I rather perversely take up her insight that '[w]hat is true in the street may not be so untrue in the museum, even though different rules of decorum may make it seem so', p. 206. See also *Museum Culture: Histories, Discourses, Spectacles*, edited by Daniel J. Sherman and Irit Rogoff, London, Routledge, 1994. Sherman's fine essay 'Quatremère/Benjamin/Marx: Museums, Aura, Commodity Fetishism', pp. 123–143, is especially germane to my arguments throughout this book.

9 See Ingres, *Pensées*, Paris, Éditions de la Sirène, 1922; *Écrits sur l'art: textes recueillis dans les carnets et la correspondance d'Ingres*, preface by Raymond Cogniat, Paris, La Jeune Parque, 1947; *Ingres raconté par lui-même et ses amis*, vol. 1, *Pensées et écrits du peintre*, Geneva, P. Cailler, 1947; vol. 2, *Ses contemporains, sa postérité*, Geneva, P. Cailler, 1948. Both from the series *Les grands artistes vus par eux-mêmes et leurs amis*, under the direction of Pierre Courthion with the collaboration of Pierre Cailler.

10 Here, as for later discussions in Chapter 2, see the classic works of André Fontaine, *Les Doctrines d'art en France de Poussin à Diderot*, Paris, 1909; Jean Locquin, *La Peinture d'histoire en France de 1747 à 1785*, Paris, Laurens, 1912. And then Thomas Crow, *Painters and Public Life in Eighteenth-Century Paris*, London, Yale University Press, 1985; Richard Wrigley, *The Origins of French Art Criticism, from the Ancien Régime to the Restoration*, Oxford, Oxford University Press, 1993; Robert Darnton, *The Business of Enlightenment: A Publishing History of the Encyclopédie, 1775–1800*, New York, Belknap, 1987; Bernadette Fort, 'Voice of the Public: The Carnivalization of Salon Art in Pre-Revolutionary Pamphlets', in *Eighteenth-Century Studies* I, 22:3, 1989, pp. 368–394. All of these are concerned with the development of a new public sphere for the languages of politics and culture, and its drift away from limits defined by the economic and cultural apparatuses of the Monarchy.

11 See Anne-Louis Girodet-Trioson, *La Critique des critiques au salon de 1806*, Paris, Firmin-Didot, 1807, an anonymous pamphlet correctly attributed to Girodet but not included in Coupin's collection of his writings. This long versified attack on the critics reappropriates the language of art for a specifically Academic domain of discourse, precisely trying to recuperate it from the public sphere of its diffusion. For his sententious teaching language see, for example, his address at the *Séance Publique de 1816* of the Académie, Paris, Bibliothèque de l'Institut, '[T]he obligatory route of study, Gentlemen, necessitates the perfect knowledge and judicious application of principles: this is the thread which must guide the artist in the labyrinth.' See Anne-Louis Girodet-Trioson, *Oeuvres posthumes de Girodet-Trioson, peintre d'histoire, suivie de sa correspondance, précédée d'une notice historique*, edited by P.-A. Coupin, 2 vols, Paris, J. Renouard, 1929. For the most significant discussion of Girodet and his production as a figure by Coupin, see Thomas Crow, *Emulation: Making Artists for Revolutionary France*, New Haven and London, Yale University Press, 1995. On Ingres' reaction to the criticism that there was something gothic in the portraits of the Rivière family, see Susan Locke Siegfried, 'Ingres and His Critics, 1806–1824', PhD dissertation, Harvard University, 1980. This remains a matchless resource and remarkable analysis, but see also the same author's 'The Politics of Criticism at the Salon of 1806: Ingres' "Napoleon Enthroned"', in D. D. Horword, J. L. Conolly and T. Parker (eds), *The Consortium of Revolutionary Europe, 1750–1850: Proceedings*, vol. 2, Athens, Georgia, 1980, pp. 69–81. But Ingres' absolute puzzlement at the word 'gothic', first registered in his letter to his intended father-in-law, M. Forestier, is already justified in Delaborde, *Ingres*, p. 32. The dossiers of the Commission for the Dictionary of the Académie contain records of the elaboration of a definition for each word.

12 In addition to the above discussion see my 'History, Time and the Morphology of Critical Language', in *Art Criticism and Its Institutions in Nineteenth Century France*, edited by M. Orwicz, Manchester, Manchester University Press, 1993, pp. 29–42; and one of the most innovative and complex attempts to represent academic theory and its imagery, Régis Michel, *Le Beau Idéal, ou l'art du concept*, Paris, Réunion des Musées Nationaux, 1989.

13 For a complex and scholarly rethinking of the French Academic tradition see *Révue d'Esthétique*, nos 31/32, 1997, *La Naissance de la théorie de l'art en France, 1640–1720*, especially Thomas Puttfarken's essay 'La reconstruction de la pensée de Poussin par les théoriciens de l'Académie', pp. 132–147. Bernard Teyssèdre, *Roger de Piles et les débats sur le coloris au siècle de Louis XIV*, Paris, Bibliothèque des Arts, 1957, remains the most comprehensive single survey of the origins of French Academic aesthetic conflicts, while Annie Becq's *Genèse de l'esthétique française moderne: de la raison classique à l'imagination créatrice* (1984), new edition Paris, Albin Michel, 1994, is the most detailed chronological history. For a more intellectually reflexive and complex attempt to think through the significance of the classical aesthetic in the early modern period, see Jean-Marie Schaeffer, *L'Art de l'âge moderne: l'esthétique et la philosophie de l'art du XVIIIe à nos jours*, Paris, Gallimard, 1992. See Bellori's account of Poussin in Paris in his life of Poussin, found in Giovanni Pietro Bellori, *Le vite de' pittori, scultori e architetti moderni*, edited by Evelina Borea, introduction by Giovanni Previtali, Turin, G. Einaudi, 1976; Eugène Delacroix, *Essai sur Poussin, (20 April 1828)*, préface et notes de P. Jacquillard, Geneva, Cailler, 1966. A fascinating and important account of the complexities of the linguistic and narrative forms of French academic art and Poussin's painting as an origin for the problematics of nineteenth-century painting can be found in Claudine Renée Mitchell, 'The Problem of the Representation of Time in French Painting 1860–1875, with Particular Reference to History Painting', unpublished PhD thesis, University of Leeds, Department of Fine Art, 1985. Also the late Stefan Germer's *Kunst – Macht – Diskurs: Die intellektuelle Karriere des André Félibien*, Münich, Wilhelm Fink, 1997, embodies a new approach to the period, opening up an extraordinary reassessment of the historical archive of French Academic discourse.

14 'Poussin was tormented in France, although he was doing his finest works there, such as the painting of the Jesuit novitiate, or of St Francois Xavier in Japan. Yet these fine works, far from convincing his enemies of his great merit or putting an end to their envy, served, on the contrary, to irritate them further. As there are few people capable of judgement, it was not difficult for them to make the ignorant believe that these works, significant for their simplicity, were comparable to a host of others that the masses prize for their richness of ornamentation.'

15 Montauban, Musée Ingres, *Cahier 7*, my transcription.

16 See Andrew Shelton, 'The Critical Reception of Ingres's Portraits (1802–1855)', in Tintorow and Conisbee (eds), *Portraits by Ingres*, pp. 496–521, for a significant current assessment of the overall question of Ingres' reception.

17 'all inflamed with jealousy, looking menacingly across at her little children and plotting something horrible for she is holding a sword and the poor little things are beside her, laughing, knowing nothing of what is to happen, but simply looking at the blade that their mother has in her hands ...' (*Cahier 2*, folio X).

It is worth noting the extent to which this scene is paradigmatic of the borderline between sublimity and propriety in aesthetic thinking by the end of the eighteenth century.

18 Nor do I propose any fresh hermeneutic or new means for explicating art's many orders of meaning such as a newly definitive or speculative iconological reading of one of Ingres' paintings, in the way, for example, that Manet's and Degas's have been interrogated. See for example *12 Views of Manet's Bar* (The Princeton Series in Nineteenth-Century Art, Culture, and Society), edited by Bradford R. Collins, Princeton, New Jersey, Princeton University Press, 1996; *Dealing with*

Degas: Representation of Women and the Politics of Vision, edited by Richard Kendall and Griselda Pollock, London, Pandora, 1991.

19 Henri Lefebvre in his *Introduction to Modernity* (Paris, 1962), translated by John Moore, London, Verso, 1995, suggests a complex and decisive model for the making of distinctions between concepts such as those of the modern and modernism long before the debate on the postmodern was to take place. Nonetheless, see my essay 'Long Running Histories of Modernity: An Essay in Postdating', in M. Iversen, P. Barker and P. Hulme (eds), *Re-reading Modernity*, Manchester, Manchester University Press, 1993. In this essay I referred to the writing of Anthony Béraud, an important critic of the Restoration and, in the *Annales du Musée*, an author of early polemics against romantic painting and the Stendhalian position on the Salon of 1824. In 1827, writing on Delacroix in the *Annales*, he had this disabused comment on the word *romantisme* to add in a foot-note to his text:

> we are here using a word which, deep down means nothing at all; but, to express myself more adequately, I would have to develop my thinking and do so at length; anyway, there is something about certain words that is like those old paper monies in Russia, which the government put in circulation to meet temporary needs, and which everyone used without being able to say exactly what their value was.
>
> (*Annales du Musée*, Paris, au bureau des Annales du Musée, 1827, p. 70)

This sense of a wasting or a wanting of meaning in a word, whether of established usage such as the words of the Academic discourse, or of recent currency like *romantisme*, is important for my argument concerning Ingres or Girodet and their sense of depossession. It symptomatises their difficulty in confronting the commonplaces of contemporary cultural phenomena while linguistically belonging to them. We will return to this throughout Chapter 2.

20 Sarah Kofman, *Comment s'en sortir*, Paris, Galilée, 1983, p. 18.

21 Anne Cauquelin, *L'Art du lieu commun: du bon usage de la doxa*, Paris, Seuil, 1999. See, for example the passage on the *Technicien du discours*, p. 31 ff. and p. 180 ff., for a reading of the relation between the sophistic *doxa* and the Kantian aesthetic in German romanticism in conceptualising the contradictions of early nineteenth-century aesthetics.

22 Longa, *Ingres inconnu*, p. 36.

23 Carol Ockman, *Ingres's Eroticized Bodies: Retracing the Serpentine Line*, New Haven and London, Yale University Press, 1995. Wendy Leeks *The 'Family Romance' and Repeated Themes in the Work of J.-A.-D. Ingres*, PhD dissertation presented at the University of Leeds, Department of Fine Art, 1990, and her 'Ingres Other-wise', in *Oxford Art Journal*, 9:2, 1986, pp. 29–37.

24 Richard Wollheim, *Painting as an Art*, London, Thames and Hudson, 1990; see Chapter 5.

25 See Norman Bryson, *Tradition and Desire: From David to Delacroix*, Cambridge, Cambridge University Press, 1984, especially pp. 101–113 for Ingres' *Napoléon* images and pp. 163–175 for the Senonnes, d'Haussonville and Moitessier portraits. In echoing the title of Walter Friedlander's *David to Delacroix*, translated by Robert Goldwater, Cambridge, Massachusetts, Harvard University Press, 1952, Bryson not only takes up a tradition of art-historical narrative, troped through the shift from the French classic – David – to the French Romantic – Delacroix – as the form of an epoch, but he resitu-ates it in the frame of a critical modernity. In a sense Harold Bloom, *The*

Anxiety of Influence: A Theory of Poetry, Oxford, Oxford University Press, 1997 (2nd edition), and Walter Benjamin become the newly latent content of this tradition – a move already marked out in Bryson's earlier *Word and Image: French Painting of the Ancien Régime*, Cambridge, Cambridge University Press, 1981.

26 Jean-Pierre Mourey, *Philosophies et pratiques du détail: Hegel, Ingres, Sade et quelques autres*, Paris, Champ Vallon, 1996, p. 100. It is hard to overestimate this chapter as a contribution to the symptomatic understanding of painting in general and Ingres' in particular, while his final discussion of linear details in Ingres, pp. 159–166, is disappointingly narrow and formalist.

27 Julia Kristeva, *La Révolution du langage poétique. L'avant-garde à la fin du XIXe siècle: Lautréaumont et Mallarmé*, Paris, Seuil, 1974, p. 516.

28 Ibid., pp. 67–70, for the thetic and aesthetic *signifiance*. Also pp. 104–110 for a discussion of negativity especially germane to my assertions here. I am citing from the French edition of this important book because the translated version is only of the first, more theoretical section. In refusing the reader the possibility to see through the complexities of Kristeva's detailed speculations on the specifics of poetic analysis, it distorts and undermines her whole enterprise and the complexity of the levels of relationality between language, psychic drives, historical conditions and philosophical systems.

29 For George Vigne's summary of his thinking on these matters see his essay 'Ingres and co.: A Master and His Collaborators', in Tintorow and Conisbee (eds), *Portraits by Ingres*, pp. 523–542. See Hans Naëf, *Ingres: Rom*, Zurich, Manesse Verlag, 1962.

30 See the wonderful passage of inventing this alluring modernity in T. J. Clark, *The Absolute Bourgeois: Artists and Politics in France, 1848–1851*, London, Thames and Hudson, 1973, Chapter 5, 'Delacroix and Baudelaire'. For an overview of Baudelaire studies see Claude Pichois and Jean Ziegler, *Baudelaire*, Paris, Fayard, 1996, and André Ferran, *L'Ésthétique de Baudelaire*, Paris, Nizet, 1968.

31 See my discussion of Benjamin, Adorno and their play of difference over the nineteenth century, 'Total Ellipsis: Zola, Benjamin and the Dialectics of Kitsch', *Parallax*, 2, 1995, pp. 101–113.

32 See Walter Benjamin, all my references drawn from the French edition of the full text of the *Passagen-Werk* (Frankfurt, Suhrkamp, 1982), *Paris, capitale du XIXe siècle*, Paris, Cerf, 1989, p. 352.

33 'Now they want to mix up art and industry. Industry! We want none of it. Let industry stay in its place and not set itself up on the steps of our new School.' See L. E. S. J. de Laborde, *De l'Union des arts et de l'industrie*, Paris, Imprimerie Impériale, 1856.

34 Benjamin, *Paris, capitale*, p. 572.

35 See this correspondence in *Aesthetics and Politics*, London, New Left Books, 1977, translated by Ronald Taylor with an afterword by Frederic Jameson, p. 110 ff.

36 In *Art History*, Summer 1983, pp. 154–170.

37 Tubières de Grimoard de Pestels de Lévis, Comte de Caylus, *Tableaux tirés d'Homère et de Virgile, avec des observations générales sur le costume*, Paris, 1757, and see Norman Schlenoff, *Ingres: cahiers littéraires inédits*, Paris, PUF, 1956, for the best account of Ingres' classical reading.

38 When we look at Caylus in his volumes of *antiquités* we see how the quantity of objects, problems of periodisation and classification almost always exceeds judgement, and how he comes to admire Egyptian building for its own grandeur rather than as a mere precedent for that of Periclean Athens.

39 Georges Bataille, *Manet* (1955), Geneva, Skira, 1994, is one of those remarkable points of condensation in the histories of modernism, a book which discretely transforms the nineteenth-century admiration of Manet into a complex theory of meaning. I am indebted to it throughout this book.

40 See Stephen Bann's remarkable essay 'Les Temps voilent l'antiquité', in *Corps de la mémoire*, Toulouse, ARPAP, 1995. I find this little piece, along with Mourey, amongst the most congenial of all the writing on Ingres to have appeared during the long gestation of my own *Ingres*. I have refined Chapter 2 in the light of Bann's discussion.

1

INGRES AND THE ARCADES

The rejection of the ideal of classicism is not the result of the
alternation of styles or, indeed, of an alleged historical temper-
ament; it is, rather, the result of the coefficient of friction in
harmony itself, which in corporeal form presents what is not
reconciled as reconciled and thereby transgresses the very
postulate of the appearing essence at which the ideal of
harmony aims. The emancipation from this ideal is an aspect
of the developing truth content of art.

T. W. Adorno, *Aesthetic Theory*

Homère et Phidias, Raphaël et Poussin, Gluck et Mozart ont
dit en réalité les mêmes choses.[1]

Ingres, *Écrits sur l'art*

One of Ingres' best-known, clumsy and
winningly facile judgements on his great prede-
cessors is his comment on Rubens, a painter
whose place in French art as both court artist
and rival of academic classicism puzzles him not
a little:

> chez Rubens, il-y-a du boucher; il y a avant
> tout de la chair fraîche dans sa pensée et de
> l'étal dans sa mise en scène.

> (there is something of a butcher's display in
> Rubens: above all there is fresh flesh in his
> thinking and something of the butcher's
> counter in his mise en scène)[2]

'There is something of a butcher's display in
Rubens.' Rubens makes Ingres see fresh meat

Figure 19

41

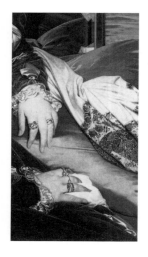

Figure 20

and theatre – flesh in his way of thinking, and the butcher's slab as his staging for it. Baudelaire shares Ingres' response; in *Les Phares* he wrote of Rubens as a 'pillow of fresh flesh'. If Ingres renders Baudelaire at once both anxious and admiring, then it is perhaps on account of his magisterial absence of freshness and purely marmoreal sensuality. Indeed, in Ingres even pillows are strange; the golden silk cushions of *Mme de Senonnes* seem to be lit in reverse, with highlights in their hollows and folds, resisting imitation of the sitter's flesh (Figure 20).[3]

Graphic, obvious, a little vulgar; in his approach to Rubens' fleshy nudes and vigorously muscled bodies, Ingres straddles the roles of a professional artist and the amateur or commonplace viewer, whose supposed voice we hear in the Salon pamphlets of the early nineteenth century, and which make such cruel fun of him in his first displays. The coarseness of his reaction perverts his lofty intentions, pinpointing his oddity as a figure for aesthetic integrity. Rubens' bravura and lavish colour certainly impress him as a spectacle of technique, invention and display. But as an artist whose paragons are Raphael, Mozart and Gluck, Ingres' pondered reaction cannot but be negative; there may, at all costs, be nothing to learn from Rubens. And Ingres' students must turn their gaze from his canvases in the Louvre. This scission of potential affect from aesthetic value is one made easy by the Academic conventions for the separate evaluation of colour, drawing and composition that go back to Roger de Piles and, ironically, the temporary triumph of the Rubénistes in the Académie under his stimulus.[4] The very viability of measuring an artist's right to be accorded a determinable quality and hence to a proper and decorous affect in terms of separation and recombination of colour, line and composition guarantees as much.

But if Ingres is defending the Phidian, Raphaelesque or Poussiniste ideal of knowingly *composed* beauty against this dangerous, libidinously staged abundance, his comment is surely made without conscious irony. For what is the butchery in art, if not the very classical aesthetic that rubénisme had once displaced in the Académie, and which Ingres voices to himself in his notes?

> Strictly speaking Greek statues surpassed nature only insofar as they brought together all those beautiful elements that nature but rarely encompasses in a single subject.[5]

Whatever *did* become of the remnants of those bodies which have sacrificed their one perfect arm, leg, nose, breast or penis to be combined by the calculating artist in order to produce the perfect imitation of nature?

Inadequate, maimed, war-injured, legless or armless wrecks of an aesthetic of plunder, the bodies desecrated by idealism's unreasonable demands should certainly look more like studies of fragmented corpses by Géricault than the Venus de Milo's elegant amputations. Should we imagine the name *Boucher* hidden in Ingres' meaty fears of Rubens, a displaced insistence on his own role in the regeneration of the French school? Perhaps a fear that the great David's rococo teacher has passed down a contamination to him, Ingres, David's great student?

In reprimand for his obtuseness, let's ask what there is 'chez Ingres', what it is that escapes through his formulation of Rubens' savagery or stall-holder's aesthetic? One answer could be the missing syllable from the word *étal*, a verbal currency available to Ingres:

chez Ingres il y a de l'étalage.

'In Ingres, there's something of the shop window.' The phrase is my own, and I find that it makes adequate sense both of the Phidian ideal with its assembly process of perfect parts, and of the fussy look of Ingres' paintings, even at their most painstakingly simple – the *Grande Baigneuse* itself is brimming with materials, of which painterly glazes and virtuoso effects are not the least abundant. Jean Cassou in his *Ingres* of 1947 is entirely seduced by this when he writes of how, in the flat, lightless juxtapositions of the painter's work, 'Ingres still has to discover, after his exaltation at the beauty of contours and local colours, the diversity of materials.'[6] And *étalage* helps to name the way in which, at different points of his life's work, he is so anxious to display his talents and to assemble the fragments of his capacity to shift between incompatible registers of representation from the heroic to the anecdotal, the observed portrait drawing to the more abstracted schemata of classical gestures.

Ingres is forever fiddling with the way things are to look, and this fiddling is not quite the same as preparatory work, though it might well coincide with it – as indeed René Longa realised. Ingres seems as if uncertain about the subject of his paintings. And though he himself insists that it is good to repeat a fine work – 'On m'a fait observer, et peut-être avec justesse, que je reproduisais trop souvent mes compositions ... Voici ma raison' ('It has been pointed out to me, perhaps with justification, that I reproduce my compositions too often ... This is the reason why') – each repetition tends to shift his relationship to the theme, unfolding the endless proposition that is 'and if ... and if'.[7] Consider, for example, the minutiae of his adjustments and reassemblages through his lifetime reworkings of the figure of the *Grande Baigneuse*, alone or in company, the themes of *Virgil Reading the Aeneid*, *Paolo et Francesca*, *Antiochus et Stratonice* or *Roger et Angélica*. Figures as important as Virgil himself in *Virgil Reading*, Francesca's spouse or even Stratonice, enter and quit the frame from version to version,

or drift from one plane to another. Types of body also find themselves in one setting after another, transformed from oriental majesty to Grecian sensuality – again, think only of the versions of *Virgil Reading* or of *Antiochus*, or the nude who is here the *Odalisque à l'esclave* and there the nymph *Antiope* in all her fleshliness. Think too of that uncompletable exposition of the Phidian ideal that was the *Homerides* itself, at once one of his most public works, twice over displayed in the Louvre as the copy on the ceiling and as the original canvas on the wall, and also his most private, his last drawing to be worked on before his death. In each reconsideration Ingres' treasured history of culture and cultural values is disordered and transformed. Which musicians, artists or poets are to be included, and who will have the right to

Figure 21

look at whom, to articulate the most directly their descendance from the poet, their closeness to Raphael or Racine? Blind Homer at the origin of art presides over the purety of his heritage as a chaos of indecision, of alternative arrangements, of a disconcerting profusion of choices (Figure 21).[8]

I want, then, to underline a relation and a homology between *étalage* and the Phidian ideal of the perfect choice that has a specific allure for a reading of this historical period and the texture of Ingres' little judgements on Rubens and other aesthetic matters. Such a relation is, roughly speaking, one between an unconscious or an archive of the everyday, which is identifiable with the increasingly merchandise-like quality of art itself and of its markets on the one hand; and, on the other, the duration or atemporality of a deliberated, Academic discourse on art's making that escapes from or represses this condition through its own recourse to the claim of a pre-modern origin. Ingres, as we have seen, practises an incantatory or magical repetition of this discourse which, typically, he sets in opposition even to the reality of his own work as a painter. The repetition of the antinomy portrait↔history painting is in this sense a fetishistic acknowledgement of his fractured practice through the disavowal of its fracture at the level of incantation. Underlying this relation which resembles that of a conscious/unconscious system of interferences is the homology of the Phidian ideal with that of consumer choice, or the eye's choices in the increasingly dense visuality of the modern city – amidst which art is one item amongst so many as well as itself multiplicitous in the Salons.[9] And, perhaps, it is here in art produced and trapped in the meshes of commerce, that we should seek the phantasmatic imagery of the interaction between the eternal and the ephemeral, rather than in the detached and disembodied gaze of the *flâneur*. Baudelaire's mistake in his insistence on Constantin Guys as the bearer of this revelation – that the eternal may be wrested from the ephemeral – lies in his own projection of marginality into an artist and an

oeuvre whose relative insignificance met his needs without challenging his aesthetic.[10]

Moreover the shop window's combining together of all that is best in a society of increasingly industrial fashion, a society where a Balzac writes for *La Mode* and, eventually, the Expositions Universelles invite a plenary identification with the commodity, the Phidian principle of choice might as well result in a perfectly dressed bourgeoise as in a finely proportioned statue.[11] In an image like *Mme Moitessier* (1856) we seem to have both. We know the date of the completion of *Mme Moitessier* from the style of her cap alone. A correspondence of 1937 between Martin Davies, who purchased the painting for the National Gallery, and the Director of the Victoria and Albert Museum mulls over how the tracing of modish fabrics in Second Empire Paris enables us to pinpoint this woman's relationship with Ingres down to his last chance to complete her in a befitting style of dress. Over the eleven years of her painting, or her ageing, we could speculatively measure the yards of fashionable cloth that have been cut, sewn and thrown away; the trimmings bought, applied, and discarded after a season or a sitting at the most. What a singular effacement of the passage of the present through human gesture is this classically modelled image, copied from the *Hercules in Arcadia* or some other Pompeian model! Yet which is, in its singular form, neither more nor less than the state of fashion, Autumn, 1856, transience objectified (Figures 22 and 23).[12]

Importantly, Ingres seems here to have got Baudelaire's reading of Guys back to front, and ends up with the ephemeral inscribed across the endless and all-inclusive outline of the conventionally timeless that is the classical model or referent. And this is not because he does not belong to the world of Guys and Baudelaire. Rather it is because he does in the closest and most restraining of biographical attachments, in an even more totalising proximity than they.

When Ingres came to Paris to study in David's studio in 1797, the very first of the great Parisian Arcades, the Passage du Caire, was under construction. The bourgeois shop-window was just beginning to match and then succeed aristocratic modes of provision and spectation, in that fine series of emotional and economic microdramas later to be condensed and memorialized in Balzac's *César Birroteau*. This is to say that the Paris to which Ingres came and to which he aspired, and which he left after nine turbulent years for its symbiotic antinom, the unchanging city of Rome, was a city in a state of transformation hardly less spectacular than that of the 1850s and no less complex. Not least the confluence of ideological and economic forces produced by the Napoleonic war economy and social order reinvented and eased the relations of the consumption and production of art into a series of ever more convoluted and endlessly differentiated connections.[13] At the same time Ingres' attachment to the world is structured through the ways in which he acquires the conventions of a classical rhetoric on the one hand,

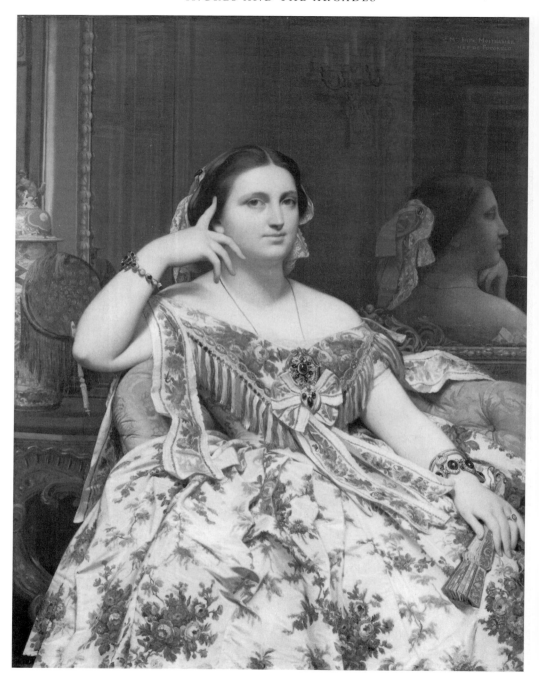

Figure 22

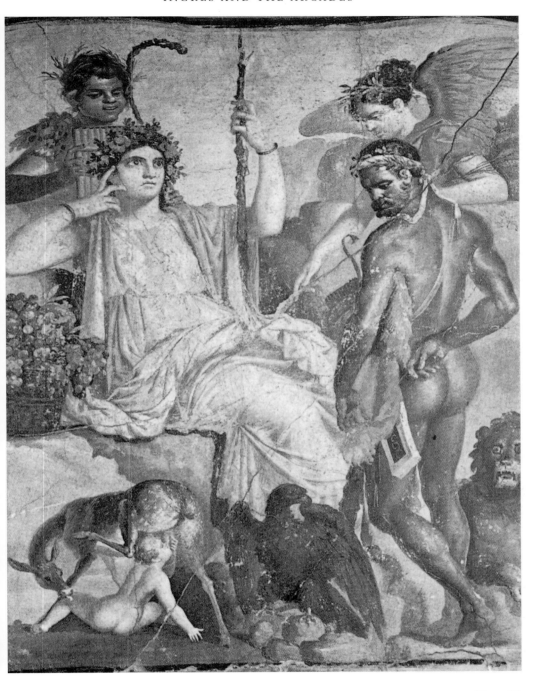

Figure 23

and his urgent desire to quit the little society of provincial, artistic commerce into which he was born on the other.[14] A redemption to be effected precisely through this supposedly timeless rhetoric's sublime powers, which Parisian art education now only uncertainly represents, not least because of its buffeting and marginality in another and more powerful commerce of the modern city.

This rhetoric, which is a basic condition and the equipment of anything above the median of bourgeois education, deeply informs the work of a Baudelaire or a Delacroix. It does so with a more developed linguistic knowledge than that of the relatively ignorant and ill-bred Ingres, who learns by rote, copies out page after page of Pliny, reads translations and fancies himself close to Homer or to Virgil.[15] Yet with Ingres this rhetoric never serves to conjure up the immediacy, sensuality and indelible presence of some imaginary referent inside the contemporary orders of locution. It refuses to serve as the index of a utopian potential of the present. Rather, he recuperates it from its death or loss, to strange effect as we are beginning to perceive.

On the contrary, the classical figure emerges as an overwhelming nature in a poem such as Baudelaire's 'La Vie antérieure', with its inhabiting of memory constructed out of archeology, marine landscape and oriental sexuality: 'J'ai longtemps habité sous de vastes portiques / Que les soleils marins teignaient de mille feux ...' ('For long I have lived time beneath huge porticos that the sunlight over the sea tinted a thousand hues ...'). Or, in that rockily dystopian landscape for national struggle of Delacroix's *Greece expiring on the ruins of Missolonghi*, it fleshes a modern and committed political romanticism. While again, the Homeric or Racinean text spins out the unbroken cord between the modern city and the classic myth in Baudelaire's great invocation of 'Le Cygne', 'Andromaque, je pense à vous ...' ('Andromaque, I think of you ...'). Here the poet himself becomes the grieving widow of all that certainty which dies in a present of total allegory. In these three examples Baudelaire and Delacroix carefully reinvent the classic with a fluency that is an effect not just of their schooling, but also of a self-consciously contrived and conceptualised modernity. While Ingres' architectural schema, especially at their most archeologically learned and up-to-date such as those of *Chérubini* or *Antiochus*, all too literally resemble shopping arcades or railway stations, letting the present into myth and ancient history despite his careful reconstruction of the past. Ironically, this suggests that Ingres' wholehearted insistence on the integrity of his myth is close to true melancholia, identifying himself fully with the lost object, while Baudelaire is infinitely capable of a wholesome mourning – through which the present and the past are redeemed from each other's threat in newly invented figurations (Figures 24 and 25).[16]

But there is not an end to it! Ingres, on the contrary, and perhaps as a result of his *parvenu*'s objectification of the rhetorical procedure, experiences

Figure 24

Figure 25

his world through the most remote system of meta-linguistic apprehension, the level of the code of codes, like reading Pliny as if one were Pliny reading. '[C]aressing things with the tip of his finger-nail' is how Jean Cassou puts it, finding an exquisite image for Ingres' mode of intertwining distance and proximity.[17] Intimacy with art is not inside the present, but before it, yet in a space that is not quite the space of history; more the space of origin, which is before history and contains stories of art's beginnings as well. Yet this sense of intimacy with origin imagines itself natural and as if without a code, misconceiving its rhetorical abstractness as an unmediated honesty or truth to nature on the one hand, and its proper representations on the other.

It is the quite specific dependence of Ingres' method on an enclosed institution, the Académie, and the way in which he unselfconsciously reworks something already reworked as if this were natural, that alerts us to its mythic character. It looks like a system of procedures that Claude Lévi-Strauss termed 'pensée sauvage'. 'When myth', Lévi-Strauss writes, 'is repeated, the individual listeners are receiving a message that, properly speaking, is coming from nowhere; this is why it is credited with a super-natural origin.' With Ingres, then, discourse swings between the strictly mythic – that is the belief in a single origin and the need to exercise the rhetoric which surrounds it and flows from it ... and the formal abstraction that the application of myth's rules make of his practice in the present. In *La Pensée sauvage* Lévi-Strauss suggests the possible form for an insight into this strange configuration:

> Finally, primitive art is opposed to learned or academic art: the latter internalises the execution (of which it believes itself master) and the destination (as 'art for art's sake' is itself its own end). As a consequence, it is driven to externalise the opportunity that it asks the model to offer: this thus becomes part of the signified. In short, primitive art internalises the occasion (as the supernatural beings

which it likes to represent have a reality independent of the circum-
stances and timeless) and it externalises the execution and the
destination, which thus become part of the signifier.[18]

To think through this we have to take Lévi-Strauss himself at an unex-
pected angle, and try to locate Ingres in the second part of his binary
opposition. Of course in doing this it must be clear that, as with any
Straussian binary, the two poles are conceptual oppositions that serve to
structure an infinite series of slippages and ellipses, and that to see Ingres as
inhabiting the 'primitive' is not to consign him to improbability, but to find
a metaphor for the condition of the academic at the historical moment of
Ingres' mental formation – this is a matter we will examine further and
rather differently in the next chapter. Insofar as he dreams of paying homage
to the 'timeless ... supernatural beings', whether they are artists like
Phidias, Racine or Raphael, or concepts such as 'truthful imitation', that are
the formal units of academic discourse, his making of this dream as a
painter's practice in effect subverts the academic effacement of that making,
transforming it into a mode of self-expression. Despite his rhetoric, that is to
say – 'Ce qu'on appelle "la touche" est un abus de l'exécution' ('What one
calls "touch" is an abuse of execution').[19] In effect this lapsus constitutes his
surface as a space of the *étalage* of painterly signs and of the fracture of his
system, exactly as its mythic character interacts with his conditions as an
artist. In this, despite himself and the look of his paintings, their execution
comes to signify in ways other than he himself expects, 'he thinks that he
has mastered it'. It signifies rather in the way that we expect Delacroix's to
do, as the expression of what we call a temperament, but all the while
looking as if it were a meta-discourse on the subject in the image rather than
an embodiment of the artist who makes it. *Pace* René Longa and his prede-
cessors, Ingres' 'temperament' is not something hidden or surprising, but a
conditional *fiction* of all his work.

Delacroix too can be shifted into this discussion of Lévi-Strauss, by route
of the ethnologist's approach to music, myth and language in the *Overture* to
The Raw and the Cooked – again at the risk of turning the text away from his
intended aesthetic. When Lévi-Strauss writes of *musique concrète* as breaking
the relation between the sounds it collects and sense images which might be
their origin, he claims that it then also breaks the first level of articulation
of all or any language, and which in music is traditionally embodied in 'the
hierarchical structure of the scale'. If *musique concrète* '[used] noises while
retaining their representative value, it would allow it to set up a system of
signs through the bringing into operation of a second articulation. But this
system would allow almost nothing to be said'.[20] While we may wish to
argue with Lévi-Strauss's both narrow and overgeneralised association of this
dead end with what he calls 'abstract art', it does suggest a striking parallel
with a figurative art that claims to represent the *fougue* of nature at the level

of the mark, and to invest in this mark the artist's identity. Thus the myth of romanticism would be that it expresses the individual as a signifier of 'man' in his relation with 'nature', whereas in effect it breaks that relation either in embedding its expression in a form without a meaning (only possible via an articulation of all three levels), or in indexically pointing uniquely and solely back to its author. I want to engage these speculations not to reallocate Ingres and Delacroix to newly fixed positions, but to point to the methodological problematic of deciding quite was what happening at this moment, and within what conception of an archive for the painting of the first half of the nineteenth century.

For with Ingres it is this remarkably elaborate mismatch between the present and a desired mode of locution which opens him to a kind of Kristevan analysis, allowing us to pull back into the visual articulations of the early nineteenth century the concepts such as the thetic, the choric and *signifiance*, etc., with which she analyses the poetics of its closing years. Reading his gestures as lapsuses or as faulty intentions, as a kind of despite of his desire, Ingres' archive is that which escapes or overdetermines these gestures while it disturbs the very details of their execution. Structurally, in Ingres and the idea of Academic practice that he avows, the most strictly 'primitive' mode of thought and the most formally autonomous turn into each other through the mediation of institutions and markets, and their turning process is the place for mapping the symptoms of a possible history of art. And so, at the same time, Ingres as an archive of modernity is sign of its fundamental unevenness, his looking back opening the space in which his present – our present, for that matter – may emerge.

The peculiarity of Ingres' attachment to such conventions, and the capacity of this attachment to function as the site of its own undoing, might be thrown into relief by looking at his devotion to the city of Rome. Formed in his period as a student and as a young, professional artist between 1806 and 1824, and renewed during his intendancy at the Villa Médicis from 1834 to 1841, it is framed by two significant reactions to the city. One is his self-assertion in finding and succumbing to a powerfully real, material Rome that the training of David's studio had never prepared him for. His own Rome, which he discovers just as David had done so long before, is made over into his own image, separating himself from an hypocritical academicism that fell so short of the values it espoused. The other, as I have already indicated, is the perception of Rome as the site of Poussin's exile, and hence as a source of a certain purity, the purity proper to a practice of art that engages in 'true imitation'.

But Ingres' Rome, unlike his Paris, is a matter of visual record (Figures 26 and 27). If the capital of France is figured only through its people and their interiors in his portraits, drawn or painted, the public Rome that appeared in fantasmatic reconstruction in David's Sabines, for example, is recorded by Ingres both as ruin and as present in an unassuming and obses-

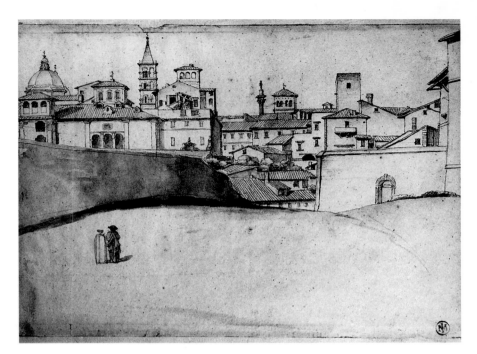

Figure 26

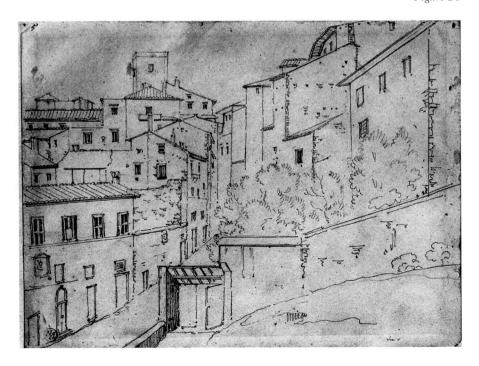

Figure 27

sional topography.[21] Spaces open and close in alleyways, rising and falling lines of streets, garden pathways of the Villa Médicis and more general views and architectural ensembles of an extraordinary rhythmic elegance and simplicity of construction. But while it would be uncalled-for to see these drawings as an advance on de Chirico's Ferrara, nonetheless they offer a radical and puzzling emptiness. This is to say that while they care neither to note nor to notice the human vivacity of the city, which after all is one of its great historical titles, more often than not they are busy drawings. Busy with marks of the city's surface – there are stones, bricks, carved acanthus leaves, trees and bushes, long and broken lines of roofs, the curves of bridges, an endless texturing that comes to look microscopic, not unlike an early light-made image. But they are busier still through their odd elision of any orders of difference between these various things, their position in space and their effect as pencil marks, in their common reduction to a seductive texturing. Invariably empty of human life or the more empty for its formality and sparseness, even in views that overlook the routes and spaces of human circulation, there is no specific mode for people in these drawings, no place at the level of the pencil's mark. What might this be, if it is not the price that the present has to pay to the past, to hold in place a space that is inseparably myth and actual? The present that is Ingres' own work and presence in the city guarantees the image of Rome as outside time, as if he is trying to hold in place a subject that is him and it. And when Ingres does paint scenes from Rome, ancient or modern, *Virgil Reading* or the papal ceremonies of his day, it is to the city's archeologically imagined or real *interiors* that he turns, while the city of the drawings haunts only a handful of his portraits as a background. The Rome of these drawings is a secretive and private subject defended against impurity; it is a thought of Ingres, an interior image, an ego-ideal *strictu sensu* – 'Une instance du moi prenant à sa charge les fonctions attribuées jusque-là à cette "conscience morale" qui permettait au moi d'évaluer ses rapports avec son idéal.'[22] Rome, he writes in 1835, is no longer what it was:

> Tout s'abâtardi; mais malgré cela, les têtes sont de toute beauté, les ouvrages de l'art antique toujours sublimes; le ciel, le sol, les fabriques, admirables, et, par-dessus tout, Raphaël éclatant de beauté, un être vraiment descendu chez les hommes: ce qui, cependant, fait qu'en somme Rome est encore supérieure à tout. Paris vient après.[23]

So impurity in plenty it had encountered, nonetheless protected by Raphael's triumph over time.[24] Aesthetically or socially, the Rome of 1806 or 1834, the dates of Ingres' two arrivals there, could only be the equivalent of the Rome of the seventeenth century, that antinomy to the Parisian court from which Poussin had beaten his retreat. And to Directoire Paris, where

the young Ingres comes from Montauban; to Imperial Paris that he leaves in 1806 to take up his long-delayed prize sojourn; to Louis-Philippard Paris and its politics of art in 1834. And to which, in effect, pursued by his over-whelmingly negative critical reception at the Salon of 1806, and then 1834, he now also appears to have come as a refugee – albeit that he in his turn finds his friends and connections, patrons, students and admirers.[25] If this accretion of historical effects is so essential to Ingres as a subject then, by 1806, his becoming such a subject is haunted by the conflicts and inconsistencies of his moment. Take the person of P.-J.-B. Chaussard, for example, radical of the French Revolution, publicist, critic and, in the end, provincial grammarian.[26] In 1798 he had carried the colours for David in the controversy over the *Sabines*, defending its morality and historical veracity, while in 1806 he was in the front line of serious and influential critics who were to flay Ingres in his attempt to win acceptance and to impose himself at the Salon.

Superficially, Chaussard was on Ingres' side of things. In the introduction to his notorious serial volume on the Salon, *Le Pausanias français*, he sets himself firmly against the market for art as a commodity, rapidly produced to flatter viewers. He praises ancient sculptors for the sheer length of *making* they put into their work with such vehemence that, forty years later, we might wonder if Ingres is still hearing him as he delays the completion of *Mme Moitessier* for over a decade. In Ingres' working life she is almost an equivalent to the *Olympian Zeus* in that of Phidias as Chaussard recounts it in his introduction to the *Pausanias*. But shared signs are not simply the semiotic recognition of common or agreed experience. By the same token as they are shared they are necessarily split. And they crumble away into diverse fields of connotation, the plural modes of reading of such a newly emerging and fractured public – as Roland Barthes has so powerfully shown in his famous essay 'The Death of the Author'.[27] A split within a sign is now much more than a disagreement or a conflict of judgement, as it might have been in a *séance* of the old Académie of the *ancien régime* where a self-electing élite met to expound, sometimes to expand but generally confirm the defining terms and supreme parameters of artistic practice. It is rather the register of a multiplicity of discursive effects that strip away the very notion of a common meaning, that forcibly *exogamise* the sign into other or counter-discourses, exchanging stability for plurality. And, as for the representation of Rome in the contemporary world, Ingres and Chaussard have no more in common than they do over Ingres' intentions in his painting, either in 1806 when he tries to get things right or in 1856 when he no longer does.

For Chaussard presents a Rome which is neither that of David's *Sabines* nor that of Ingres' drawings. In his volume *Héliogabale* of 1797 Rome is well and truly peopled, not with the heroic protagonists of revolutionary virtue, nor the accidental figures that pass by in the long contemplation of a street, but with a scandalous eroticism which, in its populist story-lines, simplifies

the work of a Sade or a Laclos. Closer to the Directoire novels of Ingres' greatest enemy of 1806, the all-powerful overlord of the arts Vivant Denon, Chaussard's writing refigures Rome and historical narrative through the consumer mores of his moment, exploiting genres of discourse for a literary market-place without any frustrating or regretful sense of the incompatibility of genres.[28] On the contrary Chaussard's Imperial decadence defies any of the model rules for historical writing such as we might find in Condillac, Condorcet or other great models of the French Enlightenment. For Condillac such a period as that of Heliogabalus might be one across which the careful historian should accelerate the pace rather than choose to stall in lurid anecdote.[29] Do we need to know that the Emperor's mother preferred sex with common men – 'le peuple est l'objet de ses passions' ('the people are the object of her lust')? And Chaussard's story-telling certainly exceeds the narrower proprieties of the condensation of historical detail around the accurate establishment of date and order in the antiquarian and connoisseurial histories of, let us say, numismaticians, where the chronologies of coins and of dynasties confirm each other to make up an historical fact. While these too might have had a political or theoretical agenda, Chaussard's Rome blatantly belongs not to the classical ideals of Republic or of Empire that it nonetheless exploits, but to a literary appetite of his day. Ironically his Rome is closer to the scandalising East of Delacroix's *Sardanapale,* painted three decades later, representing another murderous ruler in his final *jouissance* of power.

With Ingres we also find a practice that flows easily enough across the whole range of genres that his patrons wanted of him, and at the Salon of 1806 he is at pains to show off his versatility. But his lifelong refrain to the effect that of all these genres, only one among them, the historical, is of any real value, erodes any sense of the strange logics that nonetheless bind his work. The more so as his insistence is extreme. It was the completion of the *Antiochus*, which was at least a little history, and the small Odalisque, that made him complain of doing dwarfs in the place of giants – '[j]e ne les termine que par respect humain et pour tenir mes engagements' ('I only finish them out of personal respect and to honour my commitments').[30] For Chaussard the making of a drama is opportune, and while one of the dramas that he makes is *Héliogabale*, another is his cruel treatment of Ingres in 1806. He switches names easily, now Publicola, now Pausanias, and this unsettles the heroism and purity of the ancient world as origin in favour of a post-revolutionary political or commercial masquerade. It is in this sense that Ingres' Rome, as a sign of his own longings, is already polluted, always and already, even as he idolises it for its purity. In a moment we will look in more detail at how this contamination is a condition for many of the crucial signs in Ingres' discourse – I will have recourse to Chaussard again when we look at the figure of C. W. Gluck. But for now, I would like to dwell longer on this culture of *étalage*, of the commercial display of talent, that figures Ingres and his enemies.

How, then, might we close in on this idea of a relation with the everyday-ness of the modern in Ingres' paintings, as an accumulation of visual orderings that are his responses to an artist's situation? In part by grouping together his works with something of the clumsy diversity with which he produces them, respecting the incompatibility of genres and the ambitions invested in them. The discrepancy between the 'dwarfs' and the heroic works, understood as an integument of imagined identity, of identifications and dis-identifications with markets and procedures, histories and relations, becomes a sign not so much of the artist's diversity, as had been commonly assumed, but of an improbable consistency.

If writers have often enough noticed the exacerbated element of eclecticism in and made up by Ingres' mediaeval and historical subjects, artistic or literary anecdotes, they have tended to overlook the possibilities of this curious assemblage of bodies and objects in space, of images as a series.[31] Distorting each other's presence in their space, their oddity may indeed be attributable to some essential tension in Ingres' parental relation to decorative art or in his attitude to the nascent mediaevalism of the time. But seen, intertextually, as a new way of ordering objects, they might be thought through my dispositif of *étalage*. A dispositif which is denied by Ingres, yet which is also an archive of his work, perversely cathected through the Phidian ideal. As I have suggested, three, four, five decades after Chaussard savaged Ingres' early portraits at the Salon of 1806, Ingres' legendary slowness seems to respond to that critic's regret for the lost integrity of ancient art, for a time when artists took all the time necessary to complete a work: 'Jamais je ne me hasarderais à montrer, encore moins donner à graver, une chose faite vite, pas plus que je ne voudrais une mauvaise action' ('I would never risk showing, still less have engraved, something done quickly, any more than I would desire a bad deed').[32]

Mme Moitessier's lengthy period of production is more of a design for working at a tangent to that which the work directly concerns, for evading representation at the level of being literal. The subject's little daughter grows up and is removed from the canvas. Incidentally this enables Ingres to give Madame the pose of the figure from the Pompeian *Hercules*, as she no longer needs to fondle her offspring at her side. But, at the same time, the quotation is actually distanced from its source, where indeed the child Telephos is visible in the foreground suckling at the feet of Hercules. The temptation to line up Ingres with Hercules, and the child as the missing term in a classical tableau which includes the artist and Mme Moitessier his goddess, is quite enticing. In a sense Ingres would be waiting for the child to grow up before he could fully possess her mother. Psychoanalytically this loss of her phallus-substitute would account for *Mme Moitessier*'s exceptional formlessness and Ingres' extreme difficulty in locating her in space. We could begin to think of this portrait as a regression behind the mirror-phase, which, after all, is Ingres' secret ambition in his repetition of the classical gesture.

But in willing this, the making of the work opens Ingres to chance, fashion, change and to chasing the market for all those things that are art's antinomy. And as this work is in the market-place, the very peculiarity of his method, understood as an astutely viable imposition of rarity, suggests how slowness adds value to his status.

I don't want to make too much of this, nor to make a direct comparison between just *this* artist's work and the carefully orchestrated displays of a Parisian Arcade. Only to point to a possibility of a crossover between historical veracity and the narration of events on the one hand, and isolated and decorous display of objects on the other, such as to suggest the grounds for a *dispositif* of classification embodying different patterns of formal articulation of and for consumption. For a consumption, this is to say, that includes historical story-telling in books like *Héliogabale* or *feuilles-volantes*, things in shop windows, and paintings themselves in the Salons, but sometimes also seen in shop windows, an item amongst many even if one that is rather superior; as if the *Enseigne de Gersaint* had become not a sign that were a painting, but painting that is sign. If, implicitly, the pursuit of this argument leads us to link the nature or possibility of intertextuality itself with the general framework of modernity, then that makes good sense. We have already seen how the internal splitting of a sign is a dispersion in and into the textures of a new sociability rather than a difference of opinion, a mistake or an individual failure to attain accuracy.

Be that as it may, let us take just two of the clumsiest of all Ingres' small consumer paintings, the *Henri IV jouant avec ses enfants* and *La Mort de Leonard de Vinci* (Figures 28 and 29). It is possible to argue with Wollheim that the peculiarities of the spatial manipulations are, assumed together with comparable instances across Ingres' career, to be taken seriously as desired effects. They cannot be the outcome of an error or an incompetence, but represent the very surface of the painting as a site of conflict, difference with and energetic indifference to the rules of correct organisation that are the proclaimed principles of the aesthetic training that he has undergone. Yet we might need to go further than this hermeneutic *ad hominem*, of desire as invested in this individual and his projective identifications, towards understanding a sense of both the mystery and the indifference of objects, of which paintings are exemplars and which they represent.

Or, in the case of *François 1er*, as he clutches the dead body of Leonardo, his sword stays quite straight as it is outlined while it nonetheless evenly lies in the non-parallel plane of each of the visual elements it traverses. In effect it twists, as it is still quite flat: *moebian*. This exaggerates the distinctness of the sword as object from an ensemble in which its presence is purely decorative, or of no more importance than the formal decorum of historical accuracy; that is to say indifferent. What matters is not where it is, but that it be there, as a given of the narrative's specificity, and it then asserts itself as separate in equality with all the other objects, fabrics, gestures, physiog-

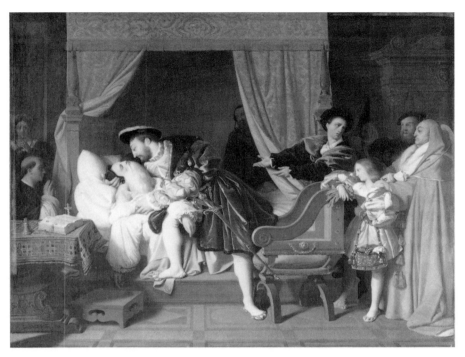

Figure 28

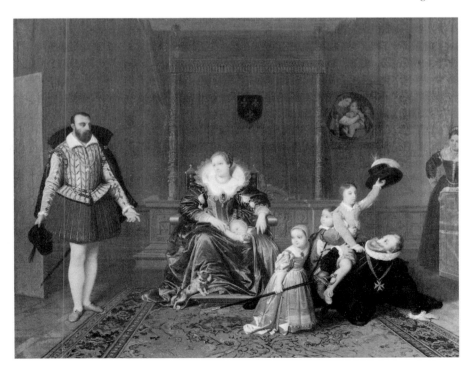

Figure 29

nomies and expressions that make for this specificity. In its twisting the sword defeats the savant disposition of foreground and background, rendering them too equal in narrative attention. While in the *Henri IV* a similar nominalism destroys space in favour of the simple narrative schema,

[(AMBASSADOR) – incidental activity – (KING PLAYING)],

throughout which each element partakes of the same twistings as François' sword. In very small and cluttered paintings like these, which invite a peering-in, the paradigm of *étalage* is easy enough to recognise; this juxta-position of an ensemble of invitations to consume, in which the ensemble and the parts both play an equal part in the release of delectation. Yet in a less figuratively loaded image, such as the later and much larger *Voeu de Louis XIII*, the Virgin and the King also escape each other entirely in their contest for spatial equality and autonomy; signs from different histories and kinds of history that can no longer be brought coherently together, even within a specific ideological programme, so much have they become a matter of choice, of position, of the twist and turning of appearances.[33] Is this a becoming objects of subjects, a lay death of religious and secular histories rather than their revival? And, by the same token, and becoming subject matter of objects, differently from the old still-life? This is to say, a rendering of the materials of art uncanny within those very techniques of representation and rules of decorum that are wrought to secure their ulti-mate stability. And to take a further example from one of his much-repeated themes, the Chantilly version of *Paolo and Francesca*, we have only here to note the oddity of the light – 'amongst these pleasures light plays no role at all'[34] – and its play between objects. In effect there is no light source in the regular pictorial sense, but rather a confusion of light and surface such as we see in a backlit colour transparency. The strange luminescence of the walls and floor, which also show through Paolo's tumescent neck and lips, orders a vision in which the terms of general and particular are confounded in a set of contradictory and contingent relations barely contained by the clarity of the story line. Now you see it all, the whole luminous sheet of background, now you see only a part as if it were not even a part, but as much or more than the whole, in its curious autonomy. The swelling throat and nacreous floor differentially share a libido the workings of which are revealed in spite of the painterly technique of effacement. Its raw, directing presence is unex-pectedly sparked in uncanny details like the shadow – if a shadow may fall *on* the light – of Paolo's straining foot. The flow of libido in pictorial form and semantic structures, coming up against the blockages of art's rules, gives rise to overlapping and only partially coinciding charges or affects (Figure 30).

By now it is appropriate to pick up and to unpick the trope of Hoffmann in my examination. The reason for this, I have to underline, is twofold. First,

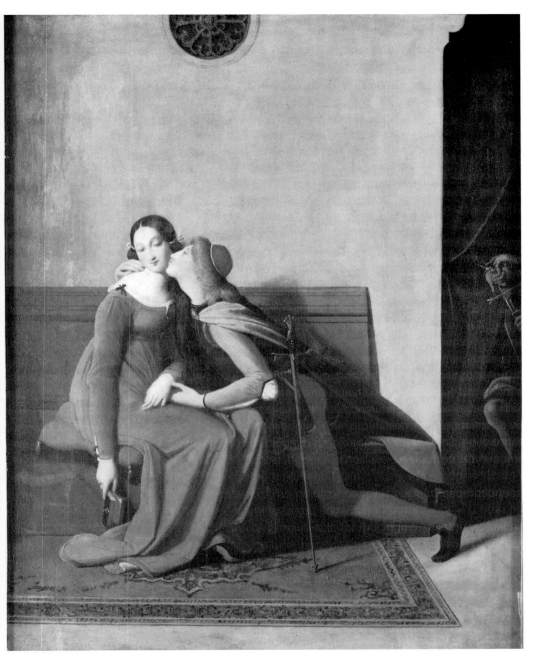

Figure 30

61

there is the coincidence of Ingrisme and Hoffmannism in the figure of Jean Cassou. Cassou is to become one of the principal vectors of Ingres' 'radical-ness', as we will see in Chapter 3, and his phrases already cited by me seem to register some strange presence in Ingres' work without treating it as an exception, as did Longa, for example. And second there is the significance of Hoffmann for the development of modern cultural theory through the impact of his *Sandman* on the work of Freud and his theory of the uncanny, which is of almost unlimited interest for modern cultural studies.[35] Thus 'Hoffmann' is for me a dialectical image or a conceit, the confection of which precipitates a certain possibility of the ordering of things through the coalescing of a historical figure and a theoretical concept.

By a happy coincidence, Ingres' uncanny distortions chronologically coin-cide with the diffusion of those that are to give rise to the theory of the uncanny in Freud – the stories of E. T. A. Hoffmann, which will literally overwhelm a section of the Parisian cultural elite at the end of the 1820s as they are translated in the *Revue de Paris*, the *Journal des Débats* or other significant cultural and political organs.[36] Yet if this was a cultural scene against which Ingres sets his colours, then despite this it resonates in and contaminates his practices, and no more so than through those figures and figural spaces to which he resorts for a sure footing, for a securely monosemic gesture.[37] Clearly Ingres' most complete and systematic attempt to resolve this problem of modernity is the *Homerides* itself, a painting completed on the brink of Parisian Hoffmann-mania. And the portrait of *Chérubini* might be thought of as a later attempt to hold the same line. Between these two paintings the line needed to be held, nowhere more urgently than in those musical paradigms bearing such names as Haydn, Mozart or Gluck which are reassigned to the complex values of romantic aesthetic theories. In 1836, while Ingres was at the Villa Médicis, Stéphane de la Madelaine proclaimed in the *Revue et Gazette Musicale* that the Prix de Rome (for music) was a dead letter:

> The prize is worthless, the journey noxious, the pay good only to waste on the distractions of your sinecure ... The prize is worthless because the only reward worthy of an artist's work is the distinction of success. Only the public weaves lasting crowns, not coteries (these exist in the Institut de France as elsewhere), given that 'for being immortal one is no less human'.

Amongst other things this was a polemic in militant favour of a modern market as the proper location for renewal, originality and youth in the face of a musical and artistic establishment that now looks more and more like one of the *corporations* of the *ancien régime*. If Ingres fled to Rome after the débacle of *Saint Symphorien*, it is exactly because the public refuses to weave him a laurel wreath, and he seeks refuge in the sociability of an older *côterie*

which he, an assiduous and attentive director, will organise in his own image. In Rome he goes on to paint *Antiochus*, the dwarf, which will win him proper, *public* laurels on his return to Paris in 1841, as it treads so finely the borderlines of an exotic classicism and a wholly modern romanticism of frustrated sexual passion. It confounds categories as only a dwarf may do; as an overwrought and introspective subversion of contending forms of art which, in its refinement, activates the viewer's gaze that a giant would have subdued.

The unreal problem of Homer's heritage was one that Ingres was never fully to resolve. Even Homer's conventionally agreed blindness makes strange his role as dominating figure for the visual. It rings as uncannily as Virgil's silence in Ingres' other most compelling vision of classical enunciation. Théophile Sylvestre, Jean Cassou and Norman Bryson have indeed all remarked on Ingres' mastery of silence in the *Grande Baigneuse*, the way in which it compels us to listen for the flow of water. We might go further to think of Ingres as himself being mastered by a short-circuiting or deadening of sense. The heritage of Homer, which is first and foremost an aural tradition, however much one might wish to insist that he is 'father of all the arts', is dumb exactly at the point of its most vocal imagining in *Virgil Reading*. The blindness of the poet himself in the *Homérides* does not record a fact of history, but enables Ingres to re-enact an originary blinding, one which here protects Homer from the vision of the chaos he has engendered in Ingres' mind. With Ingres the parallel of painting and poetry, that already strange and essentially rhetorical, eighteenth-century concordance of the arts, withers an aesthetic figure before its eventual rebirth in the imagination of a Stendhal or a Baudelaire, just as the artist tries to render it in paint.[38] The uncanny effect of this withering in Ingres' art is that his greatest nude, the *Baigneuse*, turns out to be a painting rather more 'about' sound than vision, an allegory of aesthetic disorder conceived as harmony. Indeed, we can begin to think about Ingres' desire for truth of vision, the careful effacement of pictorial technique, and the enactment of proper imitation as a field of sharp interferences and discords, which we will hear if we listen carefully to his painting. For these interferences are hushed and in the detail.

So, if we argue that the essence of Hoffmann and Hoffmannism too lies in the efflorescence of sometime discrete objects and forms of narrative in what was once each other's space, of a dangerous interference and off-setting of narrative and sub-narrative to produce an excess of meanings, then we can begin to think of this as an analogy for the condition of Ingres' signs.

Some suggestions: In Hoffmann's *Mlle de Scudéry*, translated and published in 1828, the age of Louis XIV is fractured in a dark narrative of secret, impassioned criminalities that foretells the romantic serial novel and predicts Paris as the city of the *friche* and gutter. Scudéry herself plays a role in the story out of all proportion to her historically permitted status as a

mere excess or embarrassment to the achievements of her age as Boileau had defined them. The *Grand Siècle* takes on the murky depths of the modern city and the great style of the court a seedy but sensually charged and obsessional skullduggery. *Don Juan* steals the figure of Mozart from its established, rich yet calmly conventional sublimity – '[n]otre Raphaël en musique' ('our Raphael in music') Ingres calls him, for the blackest of tales of the transfixing fear of death and of the Other as death. Donna Anna captivates the narrator in her singing, but in singing herself to death, haunts him as an impossible sublimity of such dark and bitter music. While in Hoffmann's story about Gluck, *Gluck, Memories of 1809*, this second, major instance of a classical immortality turns into the uncanny immortality of the ghost. Moreover here he is condensed as a seminal formulation of the crazy artist, his spectre a nightmare vision of ineffable creativity, rather as he had already appeared in André-Ernest-Modeste Grétry's memoirs, where the memory of the real Gluck turns out to be about as mad as Hoffmann's fiction.[39] In this Gluck's great historic role as yet these are not unique effects, or rather they accompany a general unfixing of Ingres' signs. In *La Revue Musicale* Victor Schoelcher, a few numbers away from Hoffmann's *Chat Murr*, depicts Mozart's *Don Juan*, Ingres' adored masterpiece, '[c]hef d'oeuvre de l'esprit humain' ('masterpiece of the human spirit'), as being like 'one of those cathedrals they call Gothic' in its combination of an 'imposing ensemble' with the hiding away of 'a thousand exquisite embroideries' in its most 'profound corners'. Berlioz himself, writing on *Le Carnaval à Rome et à Paris* confounds Raphaelism with a descriptive apparatus that echoes Hoffmann's *Princesse Brambilla* rather than academic *pifferari* – 'Mirate! Mirate! Voilà notre fameuse Vittoria, cette Fornarina au petit pied (pas si petit) ...' ('– ! Here is our famous Vittoria, that Fornarina with the little (not so little) feet ...'). Immanuel Kant is invoked, reviewed, discussed as the source for a *Germanic* revision of the very concepts of taste and beauty, while the Germanic, the French and the Italian musical modes are set in an endless interplay as to how they become precipitates in the practices of art, destabilising a Haydn or a Mozart. And between these seething forces of aesthetic speculation Ingres is implicated through the figure of Franz Liszt, whose portrait he is to draw, through anecdotes about his heroes and his friends. And as he writes:

> La musique! Quel art divin! Honnête, car la musique a aussi ses moeurs. L'Italienne n'en a que de mauvaises: mais l'allemande!

> (Music! What divine art! Honest, because music has its manners too. Italian music only has bad ones, but German!)[40]

his own musical allegiances trap him unwittingly in the Germanic web of fantasy and sublimity spun in Hoffmann's writing.

Where in the light of this, in my nineteenth century of the Arcades, may we put this image of *Chérubini*, who seems to have so little to do with them (Figure 31)? Who sits so horribly ill at ease, a miscast stereotype in a world of infinitely subtle mysteries, an unequivocal frown in a social whorl where faces are rarely the index of a truth. We may note a marked degree of stress in the painting. There is the desolate slippage between two quite different possible orders for the representation of an artist. A statue for a public place, allegory and muse, her timeless gesture sagging above a scene of disjointed domesticity – the Artist in his chair, the artist, who, whether he likes it or not, is already, thanks to the historical anomalies of art, a crucial character in the allegory of the modern. There he sits, as modern in his grimly tailored suit as any steam engine in an industrial fair, starving artist in his garret, or *fille de joie* in the Rue Notre-Dame-de-Lorette. And there she stands, a grim reminder that the most difficult thing of all to accomplish in this industrial mid-century was a fully confident, and therefore unambiguous, classical gesture. Just as she pulls the master into one public space, of Academic recognition, he pulls her into the abstract intimacy of the portrait. Her arm is like the broken balance of a scale as their spaces seesaw in the conundrum of art's values. A modern allegory, one critic remarked, even though Ingres hopes to construct a symbol. I suspect that Ingres realises this aporia of past and present, and has to find a vision of it, just as did the greatest of all romantic artists, Hector Berlioz. He unequivocally devoted much of his career to reconstructing the work of Gluck or reinventing it – Gluck, that crowning glory of neo-classical reconstruction for whom Cherubini stood as a living, if depleted heritage.[41]

Gluck – the divine Gluck in Ingres' commonplace opinion, though oddly in his final tribute he spells it *Gluk* (Figure 49, p. 153). He repeats the judgement often enough, though without the detail that might enable us to see quite what it means for him, as distinct from any other writer saying much the same thing in the pages of *La Revue Musicale*. Any number of artists, critics, musicologists, believed that Gluck was the great renovator of music. Joseph Ortigue, for example, writer for the *Ménéstrel* and successor of Berlioz at the *Journal des débats*, believed that while Mozart was the Racine of Music, he preferred Cherubini's requiem to Mozart's 'faulty' one.[42] The battle between the advocates of Piccini and those of Gluck in the 1780s, between their conflicting paradigms of operatic virtue, was perhaps the most significant re-run of the battle of the Ancients and the Moderns as was to be seen in the eighteenth century. More important for the generality of public taste in all probability, than Vien's reform had been for painting; and mapping at the level of a more popular consumer than that of art the formative elements of Ingres' critical vocabulary.

P.-J.-B. Chaussard himself believed fervently in Gluck – but in an excitable and highly coloured prose that foretells the Mozart of Victor Schoelcher or the *Phares* of Baudelaire. In his massive, anecdotal essay of

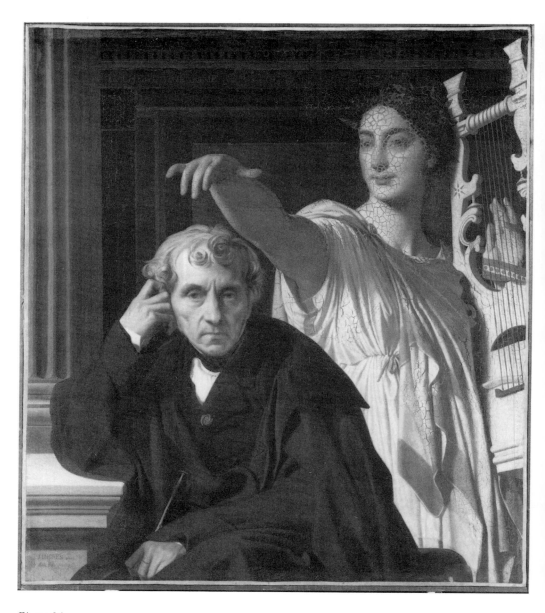

Figure 31

1799, *Le Nouveau Diable boiteux*, he casts Gluck as the master of a kind of proto-romantic expressivity, of the transcendence of colour and conflict over any single-minded purity:

> those hesitations, the tumult, that constraint, that brilliance, that restraint, that contrast of all the movements of the heart, that fickle Proteus who coils into a thousand forms, in short those infinite nuances of which the verses of Racine, for this reason so difficult to express, are an example ...[43]

Ingres echoes Chaussard in 1821 when he writes that, were he to write a requiem, he would attempt '[d]es hurlements, des effets d'orchestre à la Gluck' ('groanings, orchestral effects à la Gluck').[44] Chaussard and Ingres appropriate Gluck as a sign in their elaboration of cultural ideals even though their work of critic and artist confronted one another in the impossible aesthetic politics of the Salon of 1806.

Thus, when Ingres finishes his *Apotheosis of Homer* in 1827, where the great renovator is to figure amongst the Greeks, Gluck was anything but an uncluttered sign. '[H]e takes us back to the theatre of Athens when we listen to his masterpieces' was how Ingres put it, typically inserting a trope of origin, so that his appreciation is itself the effect both of a convention and an absence that ratifies its utterance.[45] In 1829 Gluck was made even stickier by the publication of Hoffmann's story *Gluck, souvenirs de 1809*, translated by Loève-Veimars in the *Revue de Paris*, followed by his *Don Juan* in September. To attach oneself to Gluck was no guarantee of being understood as the master of a calmly crafted aesthetic, any more than to admire his personality was to assure others of your own sanity. And, as we have just suggested, Mozart was no safer in Hoffmann's *Don Juan*, where the crazed, dead soprano/Donna Anna haunts the terrified narrator; nor the Grand Siècle itself in his *Mlle de Scudéry*, first published in French in Geneva in 1828, a night-time tale of Louis XIV's Paris so dark and sinister that all the rules of literary and social propriety are utterly perverted; nor Rome in the *Princesse Brambilla*, translated in 1827 in the *Revue Germanique*, this eruption of the uncanny, where ancient and Renaissance Rome become invisible behind the mystery and multiplicity of carnival.

So what then of Chérubini, Gluck's supposed successor, destined to inscribe his lessons in the curriculum of musical education in France for the twenty years that he reigned as head of the Conservatoire de Musique? His musical relation to Gluck was not fundamentally in doubt. Delacroix certainly concurred with the broad outline of Ingres' judgements – as I have said, they were rather commonplace – though he, Delacroix, did see Chérubini as lacking the depth that should really enable him to transcend the rhetorical competence he could claim to have inherited from Gluck. But who is this Chérubini in the portrait? What had he done? A *Medée* in 1797,

that must surely have affected Ingres, who plans an image of this anti-heroine in his notebook, choosing, as we have seen, the same moment that Delacroix actually painted. And equally, a *Lodoïska*, a major success in the Revolutionary genre of 'escape opera', a fantastic story of historical mystery, love, war, loyalty and deliverance marked by any combination of late eighteenth-century aesthetic ideas except those of respect for the unities. A work which, in its own times and its own terms, was a remarkably achieved commodity. Yet of the operas produced in Paris that year, 1799, it was Méhul's *Stratonice* that was to mark Ingres for his working life, not *Lodoïska*. In the one case as in the other it was their tendency to overlap the mythic with the most exaggerated conception of domestic passion that appealed to Ingres. And taken in its parts, as a collection of characters and their postures of passion or desire, the *Antiochus* fits beautifully into the high epoch of the *vignette romantique* (romantic book-illustration).[46]

For Ingres, perhaps, this Chérubini that he painted was like a mirror, in which he could see himself idealised in his opposite number at the head of the Conservatoire. Constantly erring in the market for commodities, portraits, little drawings for simple gratification, Ingres produced while Chérubini remained relatively silent. Indeed he seems only to listen, recalling Courbet's Baudelaire who reads, as well as Ingres listening for Greek theatre when hearing Gluck. And, in the as-if mirror, that restraining hand of the classical ideal, that oh-so-longed-for imaginary perfection, holds the composer back from an aesthetic error as surely as she crowns him. But she restrains him from an aesthetic error of romanticism that could only be evaded if the Great Revolution itself were to be forgotten, and with it the composer's history. Chérubini's uneasy officialdom is part of the historiography of France, of its radical and complex inflections in the Restoration and the Louis-Philippard régime. One critic remarked on the Tricolour architecture.[47] But far from being the colours of the Great Revolution or even the July Days, this décor registers their etiolation. It fades them off into an archeologically correct and current version of Grecian polychromy, which, as we have come to expect with Ingres, once more hopelessly compounds the mythic and the domestic.[48] We could call this a demetonymising of the past, a rupture of its allegorical potential in Ingres' desire to create a symbol – but ending up another allegory, despite itself.

Shortly after seeing a version of this portrait Chérubini died. Ingres, according to the story published in the *Revue et Gazette Musicale de Paris*, another journal of the avant-garde he so abhorred, is perturbed by the silence of his reaction when he unveils it to him in his studio, and by his friend's precipitate departure on seeing it.[49] He was not to know until after his colleague's death what his true feelings had been, that he had composed a canon in gratitude for the accolade. The story is bizarre. Chérubini, Gluck's heir, returns as music only weeks after his death, as fantastically as Gluck, or Mozart's Donna Anna in Hoffmann's tales. When critics noted the bizarre

aspects of Ingres' work what they really witnessed was his normality, and that to subscribe to Gluck or to any classical sign for that matter, was to subscribe to one's own pollution in the circumstances of early nineteenth-century cultural invention. What is truly bizarre in the whole story is how it reveals for us Ingres' belief that you can use a talisman to ward off yourself, which, simplistically, you have mistaken for an Other, long before Rimbaud was to sanctify this projection.

It is this reversibility of expectations that now leads me to think Ingres as an industrial sort of artist; it is the next most unexpected fate for him after his coupling with Hoffmann, and the two are in some ways related.

In 1855, as is well known, Ingres and Delacroix confronted one another at the Exposition Universelle. At the heart of the great fair of commodity culture, this wild, experimental taxonomy of all the possible universes of industrial production, the French organisers solved a problem that they understood the British to have ducked in 1851. This was to find a single form or figure of the national identity, one rooted in a type of physical production, but beyond the instrumentally narrow interests and purposes of any individual commodity, either alone or in its proper class or series. This national object was painting in general, and its summit was the painting of Ingres and Delacroix. Courbet underlined the point by showing his paintings outside the gates. In Kantian terms, if the exclusion of Courbet was a judgement of taste, the choice of painting as a symbol was a thoroughly categorical or synthetic judgement. But Ingres resists and continues to resist L. E. S. J. de Laborde's great report on the London show of 1851, *De l'union des arts et de l'industrie*, which expounds the principles that lie behind the categories of 1855. The sawing sound of industrial aesthetics put Ingres' teeth on edge, and even if it placed his form of work at the pinnacle of human thought, he wants art to pay nothing of the price for industry's proffered honours. Recall Benjamin's one reference to him, and his riposte to Viollet-Leduc's proposed reforms of Academic art education.[50]

'Le dessin', Ingres once most famously insisted, 'est la probité de l'art' ('Drawing is the probity of art'). Listen to his formula in this background babel, the nineteenth-century discourse on art and industry. His voice surely rises on the word 'art'. Drawing is not a 'probity' as such or in itself. To emphasise the word, '*drawing* is the probity of art' is to hear a point that hardly needs to be reiterated by him. To raise the voice, angrily, on the one word *art* is to declare war on an industrial culture which, over fifty or sixty years, has set drawing free from art to turn it into its own genie, to serve its fantastic alchemy of the extraction of surplus value. From the military demands of the Polytechnique from 1797 to Dupin to Blanqui to the trumpeting of de Laborde drawing becomes divided, split, assigned in various forms and configurations to a division of labour that both turns it into a powerful vector of social difference and posits the need for a unity. De Laborde accomplishes this dense argument through an appropriation of the

grounds of Ingres' own formation. That is to say through an elaborate and violent denunciation of the artistic activities of the 1789 Revolution and the life and works of Jacques-Louis David. For de Laborde the Revolution destroys a process of harmonious and wise reform under the old Académie, when art and industry already worked in unison, and it 'breaks all traditions':

> Those of pupils by closing schools, those of masters by abolishing the academies, those of the workers by closing the royal factories, by disrupting the industrial family and, in a final mockery it proclaims the independence of art and industry, which were not enslaved.[51]

The industrial society of the new Empire will restitute this archaic condition and build a new kind of freely willed unity. Drawing, learned in the fragmented formulation of its different elements, and taking its authority from art, may be assigned to an industrial task as the specific 'language' of that task, each type of task requiring only its appropriate combination of fragments but never the whole. If for an artist of Ingres' generation it is rather the Revolution itself that systematically instrumentalised fragments of art for non- or counter-aesthetic purposes, then the fraud of an idyllic origin in the *ancien régime* is also and differently exposed at the time of the Paris Commune in 1871. When the Fédération Artistique framed its statutes this was done essentially to demand the restitution of an ideal wholeness of drawing itself to skilled artistic workers as a means of overcoming the division of labour in the craft industries and the deskilling of the artisan that had marked the Second Empire. It was a demand for a full education as much as one for the freedom of the artist. But, as Ingres realises in the continuation of his dictum, '[l]e dessin c'est encore l'expression, la forme intérieure, le plan, le modelé' ('drawing is also expression, interior form, structure, dimensional effect'), it was art alone that is now the privileged possessor of such an integrity – but, to Ingres' chagrin at a time when drawing had seldom seemed less important for art itself.[52]

If M. Eugène Pottier, fabric designer, author of the *Internationale* and the statutes of the Fédération, feared that he and his colleagues were condemned to an ever-diminishing terrain of skill, it was Senator Ingres who turned the fruits of their labour into art. Inès Moitessier's splendid dress, the decoration of her house, its vases, stuccos and mirror frames, constitute a veritable museum of industrial pleasures and artisanal production which Ingres painstakingly represents even as he grudges his own designation as the most disinterested and sublime category of the national culture – precisely because it is understood that he does not represent the *interests* or *finalities* of these things and baubles in any way at all. *Mme Moitessier* is an oddity amongst oddities in Ingres' work not just because, as I have already noted, of its outrageous reversal of values – its confounding that which endures with

this season's disposable if expensive fancies – but also on account of the reluctant passion with which he immerses himself in these details, in drawing and then painting all those ribbons and weavings that have already been drawn and coloured by men like Pottier, or figured in commercial pattern books. The relation of this painting to the probity of art may be figured as the invasion of Ingres' Rome by the carnival of Berlioz's article or the fantastic robes and dresses of Hoffmann's *Princesse Brambilla*. If the manifest subject's Arcadian pose wards off the present, this is only at the risk of its flooding in again here, in all her teeming fabrics and the unfathomable mystery of her mirrors. A disappearing princess, a Brambilla of the industrial world, art's image of a newly imagined plenitude, whose reflection shows that it is nowhere to be had as an ideal, nowhere at all, in that infinite regress of reframings, mirror edges and stucco decorations. Here Ingres' desire for origin falls into the abyss of an infinite regress, the tormented narcissism of a mythology that sees nothing but the enigma of its own passing into history. The portrait is negativity in its purest state, and at the same time an embrace.

Between *Mme Moitessier* and Ingres' great room at the Exposition, Ingres and industrial culture introject each other, one to claim art as its own supreme form, the other to claim it back. Ingres' great cycles of repetition and little repetitions alike begin to look like invasions of the industrial method into its distinguished other, a *system* of production or assemblage despite his academicism's refusal of all system or 'sterile imitation'. A detail of the table in the *Grande Baigneuse* survives to decorate the balustrade behind the *Odalisque à l'esclave*, eliding the space between an ideally learned archeological or ethnographic correctness, and the need of the half-educated artist anyway to look things up in one *recueil* or another. *Antiochus and Stratonice* catalogues the findings of Hellenistic scholarship. The use of the *recueil* is too much like the artisan's resort to some industrial pattern books for the good of its own integrity. And, as it happens, it is in the way that these processes seize on his work, despite intention, that these images of Ingres are drained of something we might easily call orientalism. It's not at all certain quite what they are pictures of, but one way or the other their oriental fantasy is only one of their signifiants.

Let us now see how this introjection might fall out for Ingres in another ninety years. Only if we take Ingres inside all the things he renounced do we see the relations of normality between him and them, and the really dense problematic of the classical gesture on the shifting surface of the consumer's world. Only then do we realise quite what his uncanniness reminds us of – our own fragility; shifting his angle to modernity, to render it rather more acute, also shifts the angle of modernity, strange and fatal concept itself, to its materials.

Start again: in 1944–1946

Cop: You sit for artists, for whom?
Garance: For M. Ingres, for example.
Cop: Never heard of him.
Garance: Oh, but you should, like you, he plays the violin.

Les Enfants du Paradis

Sometimes there are moments, like this, or points of confluence within the complicated, artistic structures of modern, urban societies which are quite surprising in their density, in their combination of references, of cultural levels, of formal rhetorical skills and of modes of address. That is to say, in their ability to display and to organise signs in a manner that pulls these materials out of their accepted meanings, turning them around each other, reconfiguring their potential, disturbing their usual framing. Manet's *Olympia* is accepted as one such instance in the history of art. Indeed, the extensive literature on this painting produced in the last two decades fabricates one of the armatures of the social history of art as a discipline, a register both of the historical complexity of painting and of its enigma. But just as *Olympia* manifests the intertwining of social discourse and aesthetic gesture in an almost unprecedented richness, an image such as Ingres' *Jeanne d'Arc* seems to be rather lacklustre. Its meaning is more readily available and its significance less weighty than a single asparagus spear chosen from Manet's oeuvre. What can one say of *Jeanne d'Arc*'s deathly surface, its reactionary and monolithic nationalism, its maudlin politics, other than that it seems neither to belong to modernity nor to mark a step in the evolution of modernism as the two critical pathways to our present? Unless, that it, fascism is eventually to be understood as part of modernity's canon rather than as its deformation, and the agonised interrogation of Benjamin's *Work of Art in the Age of its Mechanical Reproducibility* (1937) is to fall into obsolescence. Indeed, as we have seen, recent revisions of French modernity in the first half of the twentieth century have shown how deeply it is structured by social reaction, and how there is no easy narrative that escapes contamination. We will come back to Ingres' role on this in Chapter 3.

But, in a distantly analogous move, could we not bring together the shopping arcades of Paris, felt as a place for the realisation of historicity, with those of Leeds, Manchester, Southport or some other northern British city? In the first case we have a space patrolled by the Surrealists, who showed Benjamin how to collect the shards of history's self-destruction; a space where commodity culture made a mystery of itself and generated a tragedy of modern sensibility. By way of the person of the *flâneur*, worked through Baudelaire, his essay on Constantin Guys, his addiction to Delacroix and Wagner, the image of these arcades comes to structure a much broader image of the modern than the forms of consumption for which they were designed and their then sophisticated structures built. In the second example a distinct, provincial gentility effaces any sense of tragedy, and commerce appears as nothing other than itself, the rounds of middle and lower-middle class consumption, tea-rooms and fabrics, unconscious of its fragility, its place in an historical antiquity that it relays and effaces. Even if industrial centres like Leeds or Manchester were economically 'modern' when Paris was still but a capital of arti-sanal production, they appear only on the margins of a cultural modernity.

And this problematic topography of the very concept of the 'modern' should remind us that it is a construct. And that its dialectical images are shifting compositions of places and things, ideals and experiences, that can hardly be classified or named as a type of sign. Rather they might be understood as an ordering of the archive through a specific point of entry. If, then, those denser points or moments, *Olympia*, the Parisian Arcades, have been thought of as a dialectical image, while Ingres or the provincial Arcades have not, this contingent discrepancy itself gives permission for an arbitrary gesture of construction or invention, to choose some part of the cultural habitus, to make a new fetish out of it, to recover its problematic density that has lain elided behind its everydayness.

So this film clip allows us to take one canon inside another, museum painting inside the mass medium. An artwork of the Occupation, *Les Enfants du Paradis*, and no stranger to anachronism, could aptly have referred to *Joan of Arc*, somewhat in her element at this moment of history as a symbol of the right-wing nationalism that made its peace with Nazism (Figure 32). But the Ingres who is spoken here is the author of no particular work, rather just the idea of a spot-less and unmistakable artistic authority. If I have elsewhere used this film to design an angle of historical access to the Parisian writings of

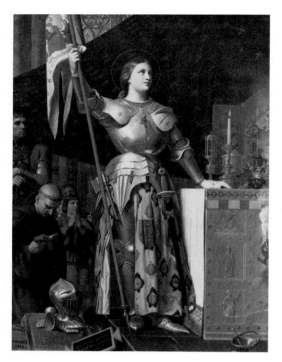

Figure 32

Walter Benjamin who, as we know, mentions Ingres only once in the *Passagen-Werk*, there seems to be almost more sense in using it to frame another staging for Ingres, whom it likewise names but once.

For if his name is only spoken once, he haunts the whole film as a visual presence, quoted as an ironic origin for its play of figures.[53] Several times the streetwise heroine, Garance, a figure more clearly out of Gavarni or Manet, appears as a kind of simulacrum of the Ingresque. As a nude cousin of the *Grande Baigneuse* when we first see her as the fairground allegory of Truth in a tub of water. Or she is the likeness of his bourgeois portraits, for example, in the episodes at her coiffeuse in the Baron's palatial mansion. Before he dies at the point of Lacenaire's knife, the Baron too is posed as an Ingres-like *baigneur* in the Turkish bath, even down to the way in which the edging of his gown echoes the drapings of the *Grande Baigneuse*. And so Ingres, Baron Turk has argued, appears as a mask for homosexuality in the field of Marcel Carné's unresolved self-vision, a negotiator for the director's sexual dilemmas. Maybe, in the complexity of his figuring here, this Ingres is nearer to that of Richard Wollheim's Freudian framing. Yet I cannot resist the reservation that such texts psychologise their artist, be he Ingres or Carné, reinvesting signs in the teleology of a life. Baron Turk's psychobiographic problematic is not mine.

Rather the film can be seen as a vehicle for thinking about its Other, naming and revealing it. That is to say, the systematically populist literary semiotics of *Les Enfants du Paradis*, in configuring within their space this sign of an indisputably 'high' culture, can force us to think anew about the interdependence of the signs of cultural distinction.

Viewed and reviewed his presence has a strange and ill-proportioned power. Subtract Ingres from the film, and it begins to look merely quaint, an exercise in unreflexive populism in the manner of Carné's previous *Hotel du Nord* (1939). In the company of Ingres its immanent diegesis is one of extraordinary richness, playing with the half-felt presence that is the substance of the chora, the disturbed background noise which frames a verbal quip, an effect of montage, a gesture within the shot. At the same time its easy quotation of his portraits and nudes alike within its idealised threnody of Parisian populism renders as nonsense all those careful art-historical distinctions, made by Ingres as much as by historians, between the genres of pictorial production and their value within the defined parameters of the Academic system. If Ingres himself feels these differences as an affect, and so as a torment, the film liberates him from them. In its free utterance of these genres within this other framework, their interplay with other modes of representation shifts from one of (a protective) indifference to one of irony.

What Baudelaire did for 1850s' Paris in addressing his 'Le Cygne' to a mythic woman – 'Andromaque, je pense à vous ...' ('Andromache, I think of you ...') Jacques Prévert and Carné now, almost a century later, redo for the cinema and its public. They integrate Ingres, this mythic trope of difference as expressed in an exclusive mode of address, as the substance of social distinction, the classical gesture itself, deep into the materials of the culture industries. In a twist of Baudelaire's own admiring distrust of Ingres, they beguile the poetic tradition of Parisian spleen into reliance on him as one of the conditions of its visibility within its own fabrication of the street as mythic. A similar infolding articulates the film's preoccupation with the popular transgression of authority. This unfurls doubly in the resistance of the dumb vaudeville to the real, spoken theatre on the one hand, and within the real theatre, on the other, through Frédéric's romantic, Shakespearian defiance of both conventional, academic gesture and locution and petit-bourgeois melodrama. That is to say through the play of class difference and of difference within a relatively unitary social framework, rather like the double contention of Ingres' early Salons, the unfixability of revolutionary and conservative. If the unexpected figure of Ingres nourishes the very *sèmes* that signify the need to overthrow the myth he represents as the never-to-be-finished work of cultural renewal, Ingres himself becomes elemental in the setting of

the film. As this is the first artistic and social bohemia of Balzac, the Balzac of *Un Prince de Bohème*, here he belongs to the *Revue de Paris*.

This is why I am interested not so much in the Ingresque imagery of the film as in that one brief moment when his name is spoken. For it is surely a passage, a change in his value as a sign of exclusion, including him as a term in the general system of the representation of popular knowledge as the essence of the nation. Ingres' name intervenes at the moment when the 'people' itself is represented as fragmentary, when the gallant parisienne, the cop, the master criminal and the landlady all stand together at a crossroad of narrativity, where their various humours, spaces and histories will separate out into the dynamic, grand narrative of the film, its headlong rush to tragedy and its static background of decorative types. Ingres is here taken back from Lapauze, surreptitiously lifted from the world of the Exposition Universelle of 1855 on the very ground of his introjection as a public spectacle. Now he is no longer that 'always and already' of cultural and material value, that which is at one and the same time industry's Other and its transcendent truth, but a figure once again; and a figure for, not a troping of, another industry of speech, of vision, of mass pleasure. Yet the passage is quite subtle and needs to read not against the grain, but for its graining. Here is the scene. Garance is arrested and questioned for one of Lacenaire's burglaries. Swiftly she battles with the constable, sparring against his brutal, lewd and loutish questions. 'Your profession ...', he insists. 'I've posed for artists ...for M. Ingres, for example.' 'M. Ingres? – never heard of him.' 'You should meet him ...', she fires back, 'You have something in common, you both play the violin.'

The point of congruence and separation is just here, and it seems to map out something like this:

'I have sat for M. Ingres.' Garance belongs to a higher level of culture than the street. Her body, which the men in the fairground stall will never see, has been seen by M. Ingres. M. Ingres sees the woman of the streets, and shares her with Frédéric, Baptiste and the Baron, with this strange difference: that while her lovers in the film project onto her, whether desire, anxiety or possession, he alone represents her, or makes her into the materials of representation for the gaze of others. Ingres' relation to the film's narrative is homologous to that of its authors', and in a sense, in all their wild cunning in the ruses of everydayness, they are more like him than they are like their charac-

ters. M. Ingres names authorship in its irreducible cultural authority, with a slight anachronism. The 'real' time of the film, 1828, is before he achieves his mythic status as Monsieur. Garance's title for him names what he is yet to become, eliminating the time between the time in the film and of its making. Ingres triumphs as the atemporal, once again, but in the street. Further, to pose for Ingres is not the same as to pose for Delacroix, whose sexual relations with his models were assumed. The irony of the cop's misapprehension of Garance's 'work' is the domestic chasteness of Ingres' studio, its tasteful musical evenings, its distance from the sex and violence of the film. The name Ingres sustains Baptiste's delusion of a pure passion even as his Monsieur is echoed in the film only by Avril's address to his master and master criminal, Monsieur Lacenaire.

'Never heard of him.' The cop hides this relation of complicity between Garance, the film-makers themselves, and Ingres. As an oppressor the cop stands outside the free, popular culture, of which he is, of course, a figure or a type, but not a subject as is Garance. At the same time he is invested with a popular indifference to bourgeois culture, an indifference that makes him truly of the people, and so immobile in his figurality. M. Ingres signifies that the people are not indivisible, and reminds us that the condition of their perception as art is the bourgeois gaze. By extension might not his own scenes of sex and violence, *Antiochus and Stratonice*, *Roger and Angelica*, *Paolo and Francesca*, belong to the narrative conventions of the film and its nineteenth-century predecessor, the serial novel? Might they not be read outside the aesthetic conventions to which he had devoted them, and now touch up against the *Mystères de Paris*?

The cop doubles Ingres, for his ignorance matches Ingres' own well-known obstinacy. Thus Garance can say 'You have something in common, you both play the violin.' She layers the most common of all Ingres' descriptors, his violin-playing, at once a sign both of his pretensions, his humanity and his hopeless commitment to repetition, onto the slang for a remand cell, which is also a 'violon'. The cop and the high artist both police culture, they try to constrain the people in the prison houses of convention. Yet at the same time the violin is a people's instrument, gipsy, street player, mastered in a mode utterly different from that of the symphony orchestra. The violin player is a liminal member of the city life, entertainer and outcast. The film was made at a time when Grappelli was a session man par excellence. The violin is a double figure of tradition, the tradition of bourgeois culture

and of street entertainment, and their merging in this moment is itself a moment in the commodification of culture as the condition of its visibility.

If Ingres' sudden appearance is bizarre, then this is in the order of normality. For in *Les Enfants du Paradis* the bizarre is indeed the ruling norm that captures a whole culture in its optic, as both the frame of chance and the incidents, scenes, performances that articulate its narrative. Presence, absence, disappearance are the grammar of the script and images alike, and if Ingres were, after all, a leading character who never appears, then this too should be no surprise. The implied exchange of gazes around Garance and the imitations of his work naturalise the classical gesture as another absurdity of the modern, in ever-constant exchange with its unlikely *semblables*, which should have been its Others. This too is an effect of the commodity system as Adorno grimly figured it, yet perhaps for Benjamin a redeeming moment.[54]

Moreover it is not so difficult to navigate from the poet Jacques Prévert, who wrote these lines, to the art critic and historian Jean Cassou, who shared a store of knowledges with him and also brought them to a figuring of Ingres. Importantly this bizarre situating of Ingres belongs to quite a different conception of the strange and the making strange from that which is manifested in Man Ray's famous photograph, *Le Violon d'Ingres*. Man Ray's reduction of this awesome mytheme to a monosemic eroticism must be thought of, rather, as representing the limits of the most vulgar and unproblematic aspects of surrealist masculinity. It is an appropriation that disarticulates ambiguity. In bestowing on Ingres the gift of the unremitting male gaze later to be discovered by feminist theory, Man Ray gives this theory its reason even as he puts the 1920s French Hoffmannists, like Jean Cassou, on guard for the need to insist on the alternative axis of the modern that was the germanic-bizarre, this choric presence in modernist narrativity.

This is the subject of Chapter 3, when I return to an extensive treatment of Cassou. But herein lies a conundrum of some consequence for my argument. The world of *Les Enfants du Paradis* is one element of what I call the nineteenth century of the Arcades. Although they nowhere appear in it, its mise-en-scène is the world of *flânerie* that they represent, the flicker world of fabrics, patterns, gloves, watches, chatter, the ensemble of consumer pleas-

ures. But the Arcades as an object of attention, as dialectical image, come into the theory of modernity in Walter Benjamin's writings from Louis Aragon's *Le Paysan de Paris*. This to say from a text that stands for Surrealism in its elemental state, in which the Arcades have already, in their decline, their 'bizarre and heteroclite' display, become an architectural form for the figure of the ragpicker. They are a repository of remains, of what remains. If their significance in history is an effect of what they have become, then the profusion of novelty that they once put on offer can only be recognised in its opposite, in the worn-out, the faded and the out-of-date, in the always second-hand classicism of their architecture. The value of the Arcades is in this infolding, this introjection of the desire to be at the end of history into what once stood for a new beginning. The conundrum, then, is that the Arcades seem to militate for the surreal view of history. The Hoffmannesque bizarre, far from being a figure for them, is nothing more than one of the stories that they put on sale. The answer, I think, is that this in itself is a figure for the structure of this book as a mimesis of Ingres and his choric evocation of the classical gesture. The apparently less adequate hermeneutic turns out to be more productive. The bizarre turns us towards a complex and frustrating history just as the surreal lures us to satisfaction, with history's reduction, its resolution in an image or a comic strip.

NOTES

1 'Homer and Phidias, Raphael and Poussin, Gluck and Mozart really said the same things.'
2 In Henry Delaborde, *Ingres: sa vie, ses travaux, sa doctrine, d'après les notes manuscrites et les lettes du maître*, Paris, Plon, 1870, p. 160.
3 Charles Baudelaire, *Les fleurs du mal*, in *Oeuvres complètes*, revised edition by Claude Pichois, Paris, Bibliothèque de la Pléiade, 1961; or *Baudelaire*, selected verse with an introduction and prose translation by Francis Scarfe, London, Penguin, 1961, p. 160.
4 See the introduction, note 13, for a number of books and articles dealing with these passages of French Academic history.
5 Ingres, *Écrits*, p. 29.
6 Jean Cassou, *Ingres*, Brussels, La Connaissance, 1947, p. 66. This book, one of the first that I read on Ingres and then ignored, has since become a key to understanding the question of the staging of the artist. See below, Chapter 3.
7 Ingres, *Écrits*, p. 22.
8 For a detailed insight into this interminable process of revision see chapters 6 and 7 of Norman Schlenoff, *Ingres: ses sources littéraires*, Paris, PUF, 1956 – both on the *Homère* – and the *Antiochus* in chapter 9.
9 For a useful and innovative discussion of the commodity status of the art-work in this period, see Nicholas Green, *The Spectacle of Nature*, Manchester, Manchester University Press, 1990.
10 Charles Baudelaire, *Curiosités esthétiques*, Paris, Garnier, 1962, pp. 453–502, for his essay *Le Peintre de la vie moderne*.
11 Honoré de Balzac, *César Birotteau*, Paris, 1837. See Henriette Vannier, *La mode et ses métiers: frivolités et luttes des classes, 1830–1870*, Paris, Armand Colin, 1960, for an account of the culture and journalism surrounding fashion.

12 See the dossier concerning *Mme Moitessier* in the National Gallery Archives, London, which contains this correspondence. Davies was planning his article on the portrait for the *Burlington*, which amounted to a justification of what he saw as a daring and pricey purchase – see his 'A Portrait by the Aged Ingres', *Burlington Magazine*, 68, June 1936, pp. 237–268.

13 'Un Effet David? Les mots de l'art et le statut de l'artiste', in Proceedings of the Louvre Conference, *David contre David*, edited by Régis Michel and Philippe Bordes, Paris, La Documentation française, 1993, pp. 1067–1091.

14 For a discussion of Ingres' relation with his artisan father see Richard Wollheim, 'Painting, Omnipotence and the Gaze: Ingres, the Wolf-man, Picasso', in *Painting as an Art*, London, Thames and Hudson, 1990, pp. 249–304.

15 See Schlenoff, *Ingres: ses sources littéraires*, and also his *Ingres: cahiers littéraires inédits*, Paris, PUF 1956, for an extensive account of Ingres' classical education and his reading of translations from the Greek and Latin. It's useful to go back to Bitaubé's classic Homer translation to see just how odd Ingres is in the way he assimilates it and, quite unconsciously, makes it his own. He remains marginal to the educational structures which he believes himself to have ingested.

16 For Baudelaire, see note 4 above, and for an important discussion of 'Le cygne''s problematic contemporaneity see Howard Caygill, *Walter Benjamin: The Colour of Experience*, London, Routledge, 1998, pp. 138 ff. Of course this poem too contains the crucial trope of exile, which is always and already invested in the figure of Ovid and in the imitation of him. Caygill writes of 'the rolling back and forth between the memory of the poetic tradition of exile and remembrance, the memory of Paris and the spectacle of contemporary Paris'. See also G. C. Spivak, 'Imperialism and Sexual Difference', in *Oxford Literary Review*, vol. 8, nos 1–2, 1986, pp. 225–240, for a rather different post-colonial reading of the poem and the instatement of a series of canonical tropings that arise from it, especially useful for thinking the historical grounds of the 'primitive' in academic rhetorics of representation.

17 Cassou, *Ingres*, p. 67.

18 Claude Lévi-Strauss, *La Pensée sauvage*, Paris, Plon, 1962, pp. 39–44, p. 42 for this reference.

19 Ingres, *Écrits*, p. 70.

20 Claude Lévi Strauss, *The Raw and the Cooked. Introduction to a Science of Mythology: 1*, translated by John and Doreen Weightman, London, Jonathan Cape, 1979, pp. 14–32, but especially pp. 18, 20, 24 and 25, for this and subsequent references.

21 Hans Naëf, *Ingres: Rom*, Zurich, Manesse Verlag, 1962. Of course if most of these drawings are now to be attributed to the 'Maître des petits points', the concept of *his* Rome shifts from one that Ingres made to one that he *collected* and reprocessed as a part of his own painting. In effect, although I remain resistant to Vigne's disattribution, I am very much aware that this notion of ownership is in line with my interpretation of the *cahiers* as being Ingres' thought, whether their pages bear what he thinks or what he copies out. Either way, the same process of 'subjectification' seems to be in play – see note 22 below.

22 'An example of the ego taking responsibility for the functions hitherto attributed to that "moral conscience" which enabled the ego to evaluate its relations with its ideal.' See Elisabeth Roudinesco and Michel Plon, *Dictionnaire de la psychanalyse*, Paris, Fayard, 1997, p. 476.

23 'Everything is debased; but, despite that, the heads are magnificent, the ancient works of art always sublime: the sky, the ground, the craftsmanship admirable

and, above everything, the dazzlingly beautiful Raphael, a being who truly came down to earth: which means that in the end Rome is still superior to everything. Paris follows behind' (Ingres, *Écrits*, p. 11).

24 Ingres, though enjoying poor relations with Quatremère de Quincy during the whole of the theoretician's tenure of the post of secrétaire perpétuel of the Académie, agrees with him quite profoundly on Raphael's status as an artist outside historical time. In his *Histoire de la vie et des ouvrages de Raphaël, orné d'un portrait*, Paris, Ch. Gosselin, 1824, Quatremère wrote that, in the 300 years since Raphaël's death nothing had happened to produce a painter of equal talent – and that the purpose of his work is to explain just this problem. He and Ingres, then, share the sense of a loss of recent time as time not filled by proper or valuable events, and both resort to the trope of filling it with the traces of a plenary and satisfactory origin.

25 See Carol Ockman, *Ingres's Eroticized Bodies: Retracing the Serpentine Line*, New Haven and London, Yale University Press, 1995, especially chapter 2, and Philip Conisbee, 'Rome, 1806–1820', in *Portraits by Ingres: Image of an Epoch*, edited by Gary Tintorow and Philip Conisbee, New York, Metropolitan Museum of Art, 1999, pp. 97–115 for a discussion of Ingres' Roman years. Also, for a general discussion of his career as a social and economic process, see Pierre Angrand, *Monsieur Ingres et son époque*, Lausanne-Paris, Bibliothèque des Arts, 1967.

26 Charles François Dumouriez wrote to Chaussard, when he was on Revolutionary mission in Belgium, in a tone of sending him up for his zeal, '[C]ome on, M. Chaussard, I'm no more a vizir than you are Publicola.' See Dumouriez, *Mémoires*, Paris, 1794, Book 8, chapter 4. That said, Chaussard was an interesting adherent of an egalitarian and democratic tendency in the Revolution, proposing radical income redistribution in a pamphlet in 1793; and his retirement to teach rhetoric and grammar in the French provinces was as much a sign of the times as of his failure. See P. Chaussard, *Le Pausanias français: état des arts du dessin en France à l'ouverture du XIXe siècle. Salon de 1806*, Paris, 1806.

27 This whole discussion depends upon the synthesis of a series of theoretical texts that bring together concepts of social dispersal and differentiation with notions of the instability or absence of semiotic reference. The most current texts are: Roland Barthes, 'The Death of the Author', in *Image, Music, Text*, translated by Stephen Heath, New York, Noonday Press, 1977, pp. 142–148; Jacques Derrida, 'Différance', in *Tel Quel: théorie d'ensemble*, Paris, Seuil, 1968, or in *Margins of Philosophy*, translated by Alan Bass, Chicago, University of Chicago Press, 1982, pp. 1–27; 'Cogito et histoire de la folie', in *L'écriture et la différence*, Paris, Seuil, 1967, pp. 51–97; Mikhail Bakhtine, *Marxisme et la philosophie du langage*, translated by Mikhail Bakhtine, Paris, Minuit, 1972. Also of major importance is Jean-François Lyotard, *Discours, Figure*, Paris, Klincksieck, 1971.

28 See P. J. B. Chaussard and Pierre Jean-Baptiste, *Héliogabale, ou, Esquisse morale de la dissolution romaine sous les empereurs*, Paris, Dentu, An X (1802). Chaussard's other satire of this period which I have used extensively in this chapter is his *Le nouveau diable boiteux, tableau philosophique et moral de Paris: mémoires mis en lumière par le Docteur Dicaculus, de Louvain*, Paris, chez F. Buisson, An VII (1799). His discussion on p. 273 ff. of the journalists of Paris is important for a notion of the commerce in ideas, which is germane to the understanding of the conditions for the splitting of hitherto agreed significations. Ingres gloated over Denon's death when it enabled him to take over his enemy's chair at the Académie in 1824, but for a more appealing image of Denon see a recent literary reinvention of this

period by Philippe Sollers in his biographical essay, *Le Cavalier du Louvre*, Paris, Plon, 1995.

29 See either the Abbé de Condillac or the Abbé de Mably, *De la manière d'écrire l'histoire*, London, 1789. In effect this text appears under the name of both these brothers, or Condillac, *De L'Étude de l'Histoire*, Paris, Ch. Houel, 1798.

30 Ingres, *Écrits*, p. 12.

31 For an overview of Ingres' repetitions, see *In Pursuit of Perfection: The Art of J.-A.-D. Ingres*, exhibition catalogue, by Patricia Condon with Marjorie B. Cohn and Agnes Mongan, Louisville, Kentucky, 1983. For an intellectually complex and challenging approach see Rosalind Krauss, 'Retaining the Original: Multiple Originals', *Copies and Reproductions, Studies in Art History*, 20, 1989, Washington, National Gallery of Art, and her very interesting discussions of Picasso and Ingres in her *The Picasso Papers*, Cambridge, Massachusetts, MIT Press, 1998.

32 Ingres, *Écrits*, p. 12.

33 See Carol Duncan, 'Ingres's *Vow of Louis XIII* and the Politics of the Restoration', in her *The Aesthetics of Power: Essays in Critical Art History*, Cambridge, Cambridge University Press, 1993. Ingres was highly anxious about the anachronism and lack of unity in the combination of secular and religious themes, and clearly I am arguing that the resolution of this anxiety was over-determined by the tendency to *étalage* rather than simply determined by political expediency.

34 Cassou, *Ingres*, p. 66.

35 See Samuel Weber, 'The Sideshow, or: Remarks on a Canny Moment', in *Modern Language Notes*, 88:6, December 1973, for a good discussion of this matter.

36 See Hoffmann, *Contes fantastiques*, Paris, Seuil, 1980, vol. 2, translated by Loève-Veimars, introduction by José Lambert, p. 13. See: Elizabeth Teichmann, *La fortune d'Hoffmann en France*, Paris, 1961; M Castex, *Le Conte fantastique en France de Nodier à Maupassant*, Paris, Corti, 1951; R. Murray Schafer, *E. T. A. Hoffmann and Music*, Toronto and Buffalo, University of Toronto Press, 1975; Claude Pichois, *L'Image de Jean-Paul Richter dans les lettres françaises*, Paris, Corti, 1963. This latter is in effect the most significant account of Germanic, romantic counter-cultures in French society up to and including the time of Jean Cassou.

37 In the first number of the *Revue de Paris*, 1829, pp. 114–115, Sainte-Beuve launches an attack on Boileau which adds up to an anti-Homerides. He finds all kinds of faults in Boileau's writing, especially in respect of his grasp of metaphor – a critique that amounts to nothing less than a radical assault on Ingres' form of Academic values. In a sense he picks up the Enlightenment attack on Boileau, exemplified in Condillac's insistent needling of the great theoretician in the *Traité de l'art d'écrire correctement la langue française par Condillac, précepteur de l'Infant de Parme* (1750), Nouvelle édition à laquelle on a conservé la même diction de l'Instituteur avec son Élève, Paris, Dufort père, 1812. Here Condillac goes so far as to rate Sévigné's use of periphrase above Boileau's, even preferring certain of Mlle de Scudéry's turns. Sainte-Beuve takes both Boileau and Malherbe to task for superficiality, for being writers who attack real vice, but only on its surface, and for having no principles and incomplete views – a nice underlining of the uncertainty of Ingres' enunciation in the *Homère*.

38 See Rensselaer Lee, *Ut Pictura Poesis* (1940), London, 1967, for an account of this classic history of the relations between the arts.

39 See Grétry, *Mémoires*, Paris, 1789.

40 Ingres, *Écrits*, p. 89.

41 One needs only to dip into the *Journal de Eugène Delacroix*, preface by Jean-Louis Vaudoyer, of the Académie française, introduction and notes by André Joubin,

Paris, Plon, 3 vols, 1932, to detect the differences and nuances of Gluck's and Chérubini's standing in contemporary intellectual circles. Delacroix is rather colder on Chérubini than is Ingres, but as cold on Berlioz. The peculiarity of these concordances once again underlines my insistence on the non-particularity of signs and tastes to individuals. See for example entries in the *Journal* for 4–7 April 1849 or 25 January 1857.

42 Joseph Ortigue, *De la guerre des dilettanti ou de la révolution opérée par M Rossini dans l'opéra français et des rapports qui existent entre la musique, la littérature et les arts*, Paris, Librairie de l'Advocat, 1829, p. 52. The war of the dilettanti is that between the Piccinists and the Gluckists, and Ortigue is carrying the debate into the early nineteenth century at the expense of Rossini and Voltaire – but in favour of Corneille, Racine, Mozart, Gluck and Méhul, especially the latter's *Oedipe*. Méhul, author of the great revolutionary *Chant du départ*, was also admired by Ingres, and his opera *Stratonice* (1792) was clearly an inspiration for Ingres' *Antiochus*. It would be hard to labour the point that the languages which Ingristes see as typical of Ingres hardly 'belong' to him at all. And nowhere more than in musical language, which so much interested him, is this made clear. The Bibliothèque de l'Arsenal in Paris contains a rich source of records for the musical debates of the late eighteenth and early nineteenth century.

43 Chaussard, *Le nouveau diable boiteux*, p. 136.

44 Ingres, *Ecrits*, p. 90.

45 See Schlenoff, *Ingres: ses sources littéraires*, for a detailed tracing of these vagaries.

46 That Ingres privileges the love story in the subject hardly needs underlining; but it does take on significance if we look at the political interpretation of the episode of ancient history in Ennio Quirino Visconti, *Iconographie Grecque*, Paris, Didot Aîné, 3 vols, 1811. Visconti, whose archeological and historical work was highly significant for Ingres (see Schlenoff, *Ingres: ses sources littéraires*, p. 165), devotes a few pages to the dynasty of the Seleucides. He records that renunciation of his young wife to his son by Antiochus's father, and his giving a kingdom to the couple, was an example of fatherly love 'heaped with praise by all of pagan antiquity' (vol. 2, pp. 277–278). He also goes on to recount that this self-same Antiochus Soter was a hopeless ruler and soldier, eventually being killed by a Gaul. Ingres' take on the material is very precisely not that of the historical, to which he aspires, but that of the wholly personal, which is what wastes his time in portraiture. His commitment to the 'dwarf' of a canvas is then, complex and tormented.

47 My thanks to Andrew Shelton for his generous communication of this text:

Les étoffes sont également bien peintes, et nous ne nous sentons pas le courage de faire un crime à M. Ingres d'avoir introduit dans sa composition de l'architecture tricolore. Nous avouons notre honte que nous ne sommes pas de ceux qui se paient de mots. Le style architectural préféré de M. Ingres existe-t-il ou non? Il existe. Et maintenant s'empare-t-il de la vue au point de faire oublier le sujet? Nullement. Il se fond sans crudité dans la gamme de l'ensemble. Qu'avez-vous donc à dire? Les préjugés politiques ridiculiseront-ils la couleur tricolore, comme ils ont ridiculisé la couleur blanche?

(The fabrics are equally well painted, and we don't have the courage to accuse M. Ingres of a crime for having introduced a three-coloured architecture into his composition. To our shame we admit that we are not of those who make their living by words. Does M. Ingres' preferred architec-

tural style exist or not? It exists. And now does it take hold of our vision so as to make us forget the subject? Not at all. Without crudity, it blends into the overall range. What have you to say then? Will political prejudices make fun of tricolour colour as they made fun of the colour white?)

([Anonymous] 'Portrait de M. Chérubini par M. Ingres',
Bulletin des Beaux-Arts, 10 March 1842)

The reference to the war of revolutionary red, white and blue on the one hand and Bourbon white on the other is obvious enough. Ironically then, as Ingres' own moment of being ridiculed for white took place at a time when the three colours were still just possible – see Chapter 2.

48 For a brief discussion of architectural and archaeological décor in Ingres see Robert Rosenblum, *Jean-Auguste-Dominique Ingres*, New York, Abrams, 1967, p. 146.

49 See J. F. E. Halévy, 'Ingres chez Chérubini', in *Revue et Gazette Musicale de Paris* 8, 1841, pp. 349–350.

50 The tracing of the languages of drawing and their delicate and complex position in making the relation between the different forms of art and commerce dates back to the discussions around the programmes of the Écoles Royales Protégées in the mid-eighteenth century. See my articles 'The Words of Art, the Artist's Status: Technique and Affectivity in France 1789–98', in *Oxford Art Journal*, 14:2, 1991, pp. 73–82; 'Un Effet David?', in Michel and Bordes (eds), *David contre David*; 'History, Time and the Morphology of Critical Language', in *Art Criticism and its Institutions in Nineteenth Century France*, edited by M. Orwicz, Manchester, Manchester University Press, 1993. See Édouard Pommier, *L'art de la liberté: doctrines et débats de la Révolution française*, Paris, Gallimard, 1991; Yves Deforge, *Le Graphisme technique: son histoire et son enseignement*, preface by Abraham A. Moles, Paris, Champ Vallon, 1981. For some contemporary discussions which appropriate what we might call the probity of drawing for non-art practices, see: Charles Dupin, *Géométrie et méchanique des arts et métiers et des beaux arts. Cours normal à l'usage des ouvriers et des artistes des sous-chefs et des chefs d'atelier et de manufactures*, Paris, Bachelier, 1826; *Enseignement et sort des ouvriers de l'industrie avant, pendant et après 1848*, Paris, 1848, where he writes that

> [t]he geometry of the Fine Arts is more or more generally the geometry of beauty in the arts and should not only form part of the professional education of artisans and artists, but of all men to whom one wishes to give a liberal education.

This appropriation of drawing to a broad range of social functions tends to undermine its authority within art as its privileged site, and the process culminates with the concept of drawing as a language of industry in L. E. S. J. de Laborde. That is, through the notion of drawing as a language for the illiterate, a language with a referent in terms of its use, but neither rhetoric nor grammar, or as a language of merely general knowledge. Thus de Laborde, in *Exposition Universelle de 1851, Travaux de la commission française sur l'industrie des nations, Publiés par l'ordre de l'Empereur*, in the 30th Jury of the 8th group, *Application des arts à l'industrie*, in his 'De l'union des arts et de l'industrie', Paris, Imprimerie Impériale, 1856, writes:

> [I] was only concerned with the arts, and yet I separate neither letters nor sciences from industry; in my sense the arts, letters and sciences are but

one with industry and the industrial edifice is threatened with ruin when these three supports of its base lose their solidity.

<div align="right">(p. 2)</div>

It is to this environment and not simply to Viollet's reforms that I believe Ingres to respond in his *Réponse au rapport sur l'École Impériale des Beaux-Arts adressé au Maréchal Vaillant, ministre de la Maison de l'Empereur et des Beaux-Arts par M. Ingres, sénateur, membre de l'Institut*, Paris 1863. See also Eugène Viollet-le-Duc, *Esthétique appliquée à l'histoire de l'art suivi de Viollet-le-Duc et l'École des Beaux-Arts de 1863–64*, edited by Geneviève Viollet-le-Duc, Paris, énsb-a, 1994. See Molly Nesbit's discussion of Marcel Duchamp and technical drawing in her *Their Common Sense*, London, Black Dog, forthcoming.

51 de Laborde, *De l'union des arts et de l'industrie*, op. cit., p. 164.
52 Ingres, *Ecrits*, p. 41.
53 See my *Street Noises: Parisian Pleasure, 1900–1940*, Manchester, Manchester University Press, 1993, chapter 1, for a detailed discussion of the historicity of the film. Edward Baron Turk, *Child of Paradise*, Cambridge, Massachusetts, Harvard University Press, 1989.
54 See my 'Total Ellipsis: Zola, Benjamin and the Dialectics of Kitsch', *Parallax*, 2, 1995, pp. 101–113.

2

ACADÉMIE, OR THE COLOUR WHITE AND THE CHILDHOOD OF ART CRITICISM

Moreover, in the phrase out from under the jaws of destruction, by forcing into an abnormal union prepositions not usually compounded he [Homer] has tortured his language into conformity with the impending disaster, magnificently figured the disaster by the compression of his language and almost stamped on the diction the form and feature of the danger – swept out from under the jaws of destruction.

Longinus, *On the Sublime*

However all these improprieties in literature are weeds sprung from the same seed, namely that passion for novel ideas which is the prevalent craze of the present day. For our virtues and vices spring from much the same sources. And so while beauty of style, sublime expression, yes, and agreeable phrasing all contribute to successful composition, yet these very graces are the groundwork no less of failure than of success.

Longinus, *On the Sublime*

Des croûtes de l'antiquité
Les érudits ne parle guères;
Le tems et des juges sévères
Vengèrent la postérité.
Messieurs, tâchez que l'héritage
Que de vous tiendront nos neveux
Mérite le culte et l'hommage
Que vous rendez à vos aïeux,
Et comme eux faites bon voyage.

Arlequin au Muséum, Salon of 1806[1]

I feel fairly certain that Ingres is an 'out from under' sort of painter. This leads him to some of those pictorial inventions which, falling right into the conflict of innovation and correct elocution, attract the most unenviable of critical attention. No more so than from those judges to whose admiration

he has a prima facie right, the Academics and their circles, those who do not remember that antiquity produced its own rubbish. And which attention, indeed, he tries so conscientiously to attract. Yet his critical reception at the Salons from 1806 to 1834 is unremitting in the declension of his rising fame with his notoriety for an extravagant cult of originality. But why should he, a young and ambitious artist, not try to innovate, to imprint his genius on the rhetoric of art? For Longinus is at pains to insist how it is the young Homer, the Homer of the *Illiad*, who is truly sublime. It is this Homer who is consistently able to 'magnificently figure' a moment in his rich materials or, to use Boileau's translation, represent 'as if in a painting'. The *Odyssey*, on the contrary, is full of narration, which is 'the genius of old age'. Now is the time to risk. If we watch Ingres carefully enough, from the good angle, his public successes and his failures are inseparable, even identical in their outcome. The ones are to do with his way of using a particular idiom of art, the others with his very acts of using it, his devotion to its cause. Their combination makes for a heterogeneous consistency, and for him a temporary sense out of the listings for listing's sake of his Odyssey and Illiad notebooks.

Ingres' painting *Jupiter and Thetis* (1811) is pre-eminently an example of his Homeric posturing, and also one of the great disasters of his critical reception (Figure 33). The crucial element in his annual *envoi* from Rome, together with a copy after Raphael, it was indifferently received at the Académie. As was the copy, thought to be competent but 'too dry'. The minute of 28 December, containing his judges' commentary, records the view that overall *Jupiter and Thetis* 'lacks contour and depth ... the colours are feeble and too much of the same value', while 'Thetis' head has a forced throwing-back and neither can one guess which leg is attached to the right thigh.'[2] Of course it is too late for Ingres to learn from this. He is a pensionnaire who started five years late at the Villa Médicis and the attachment of some leg to one or another thigh is no longer the order of his involvement with pictorial signs. With his *envoi* of 1811, already afloat in the unlimited potentials of making art, 31 years of age, he is not a teachable young artist, even if his masters must treat him as one amongst the many whose work they have under annual review. Their language and his work are pulled together by an institutional inertia, the necessity and the contingency of their relation being markers of the uneven historicities of the phenomena held together by the one word 'art'. This is of the essence of that pathlessness, that open sea of aporia of which I wrote in my introduction.

So the difficulty of Thetis' arms and head will haunt Ingres all his life along with so many other subjects and compositional devices which he invents throughout these years of retarded studenthood, to repeat, to rework and to resituate. *Roger and Angelica*, *Stratonice*, *Tu Marcellus*, the *Baigneuses* and others. Especially the Brussels version of *Virgil Reading*, this Virgilian painting in the mode of Homeric rhetoric, has its own particular registers of

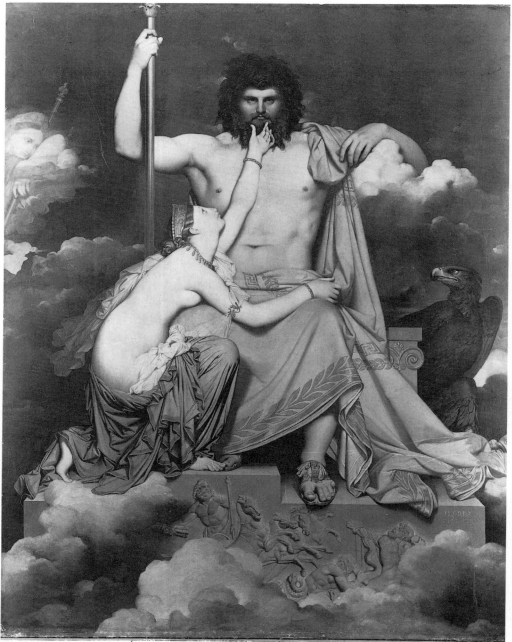

37158 Aix en Provence. Musée. Ingres. Jupiter et Thétis. (87).　Reprod. interd. Photo Giraudon (1940

Figure 33

'out from under'. There is the literally figured 'out from under' of the arm
under the body, the disconnected hand arresting the fainting body. And the
gesture of Augustus, heavy rather than graceful, out from under Virgil's
reading, which has provoked it and which it silences – here in
Virgil's absence from the frame; a figuration that we might indeed think of
as a despite of classical aesthetics, a gesture despite their desuetude and
expressing it; drawing attention to painting's dismaying silence in remaking
the very discourse from which it draws its authenticity, in making origin a
silence. History is broken on the anecdotal details of its making (Figure 34).

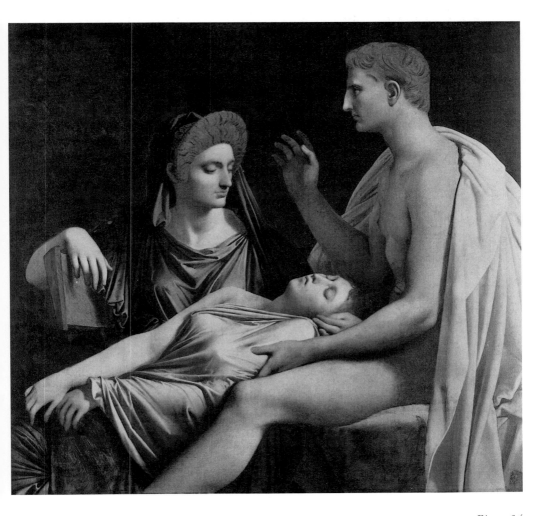

Figure 34

The repetition of such a subject, the search for variations and inclusions, could be seen as a pictorial stammer, straining to speak a disfunctional rhetoric of eloquence. But then also for Ingres, perhaps, the repetition of an inaugural problematic in his art, taken with the tenaciously held goal of its eventual resolution, might just be the key to the mystery of eternal youth. Ingres' tendency to repetition is surely more than fetish or is the sum of several fetishistic processes. Or rather, if it seeks to replace the penis, it is a penis that never was. It could well, as Wollheim argues, situate, instate and melt the father; it could be a fetish that wards off the uselessness of the dissimilar repetition endlessly enacted in notebooks, which do not repeat or invoke a meaning so much as re-enact the repertoire of cultural virtues as an artist's duty, and his panic in trying to fulfil it.

Yet his attachment to repetition is rhetorically authorised. Longinus allows as much for a perverse and fearful imagination, an imagination such as is Ingres', at once literal and absurd in its reading of a sacred text and attempting to repeat its lessons. An imagination that can hardly distinguish between the reinvention of an entire historical culture as an act of repetition and the individual repetitions that are the fruit of its own invention. For Ingres to repeat a particular is to imagine the unimaginable origin of a whole, to try for a finally accurate or fully satisfactory version of it, the idea of which itself is indeed the fetish. It's also more than a fetish precisely because the fetish cannot work, or because its invocation is also obedience to a rule which needs no other fetish to replace it.

Ironically, Ingres does not even know the lines from Longinus, quoted in my first epigraph, that are most apt to his problematic. In the translation that he does know and adores, the classic version of Boileau-Despréaux, from which he transcribes extracts in his notebooks, adding 'these are my exclusive opinions', they are missing.[3] Or rather, in translating the passage into correct French alexandrines, Boileau is obliged to eliminate all of their complexities. Homer's phrase 'out from under the jaws of destruction' becomes 'the troubled sailor ... believes that he sees encompassing death in each wave' (p. 70). And as for his commentary on Longinus' text, Boileau writes that 'I have passed over all that, as it is entirely a matter of the Greek language' (p. 203). In the very pretension of offering up the eternal, irreproachable archetype of the sublime, Boileau hides it from his reader. Homer's text, which should be so simply available on the printed page, becomes the stake in an argument over contemporary poetics, in the triumphant perfection of French over all preceding language.[4] In spite of its survival Homer's image turns into as much a mystery as the Greek sculptures or paintings by Zeuxis or Apelles that have never been seen, other than in their description on a page. If the true authority is over-present, or undermediated, then it must be rendered as if missing, nothing more than a 'matter of Greek language'. Ingres, it appears, adores and worships a deceit. Without reading Greek he is all too ill-equipped to fathom it. His good

faith is founded in another's ill, but his investment in a fragment is no more than a habit of his inherited culture. Boileau is already Ingres, or an outline of his possibility of being – Phidian as well in his syncretic purity. What is more, in a situation where we have become used to contrariety, Boileau, a figure rejected by Enlightenment, is not really one of Ingres' moment at all. The practical forms of rhetoric and ordering of knowledges that surround him are as much articulated through a Condillacian materialism as an outmoded debate on the virtues of the French language.[5]

For such a deceit or self-deceit is part of the scenery of his aesthetic habitus. Artistic memory and aesthetic criteria now, as in the early Renaissance, are riven by the uneven survival of different exemplars. Ancient buildings and texts are relatively complete, yet come to be known at different times through philogical and archeological development; paintings are unknown or to be guessed at from decorative materials such as vases; sculptures are doubtfully authentic, identical originals abound. Inevitably the abstract idea of the canon is ever more secure than the realities of its shifting substance in archeological discovery and antiquarians' manuals. And the surest canon, the most reliable, is that which is the least visible of all. The one that is only represented at a second order, as the record of a lost civilisation.[6] Even while Ingres paints his *envois*, a new crisis of the canon is preparing itself with the exposition of the Parthenon marbles in London. Yet if this sudden and unwilled presence of the true body of the canon should, on the surface, have been acclaimed as the revelatory confirmation of a discourse, the marbles never looked quite right. Quatremère, in his *Letters to Canova*, sidestepped the problem with an elegance and a rigour that left the marmoreal inscription of his aesthetics and that of the Académie intact.[7]

The position of an artist in all this ordered confusion was one, as we have emphasised, comparable to navigation. Obviously it was not just a question of getting things right for an academic lesson or critique, for an entry into the *loges*, a prize or a commission, but one of finding room in social spaces, in markets of increasing intricacy. Even in the relatively simple framework of the *ancien régime*, an individual artist, taken up by their work, could never, as Caylus had long ago recognised, be fully a connoisseur of art and litera-ture and antiquity as well as a painter. The poor painter must absorb prescriptions, formulae, ready-processed raw materials in the form of recom-mended subjects, and hope to integrate their abilities with this fabric on the one hand and that of their patronage on the other.[8] Their place was one of suspense in, floating over, a series of perceptions, and for things to work satisfactorily, what they have learned must be significant for their way of living out the rhetorics of painting. The problem for Ingres as for his gener-ation, and, indeed the half-generation before him of David's studio, is that no part of the equation is stable as the scholars, connoisseurs and archaeolo-gists cope with the new world of discoveries and taxonomies on one side of them, generating representations that undermine and relativise tradition

even as they deploy its language. As we have seen in the arcades, archaeologism confuses the relation between the décor of, say, *Virgil Reading*, the Passage des Panoramas or, eventually, the Gare du Nord.[9] And both the market and the languages of criticism begin to pullulate on the other side of them, in the new public realm of the Empire and the Restoration.

If then Ingres finds the gestures 'out from under', it is in the posturings of the very academic subject matter that he longs to subjugate; the attitudes of crowning, or supplicating, for example, all so important in the public sphere throughout his working life; getting an arm over from above, up from below to supplicate or to crown, or horizontally across without betraying the wrong degree of equality or superiority. So much depends on these kinds of *sème* in a visual world of fauns and muses, monarchs and subjects, deities and mortals, the great and the fallen or the humble, sinners and saviours, givers and the grateful.[10] In 1808, three years before the *Jupiter and Thetis*, Landon took up some entries in his *Annales du Musée* to turn his attention to the matter of stretched necks and raised arms, their attainable degree of precision in representing a subject. Ingres, in all probability, wants to contribute to the discussion and will continue to do so up to his great final composition of *L'Age d'or* and his reworking of the *Homère* and his *Apothéose d' Appollon* of the 1860s. But in doing so he runs into the unresolvable question of what is a pictorial sign, and where is it in the image – if it is not quite the image in itself. He makes a version of 'out from under', only for it to be regarded for its student faults. As his *envoi*, *Jupiter and Thetis* won't do. And this for perhaps no other reason than that to be a perfect student of the rhetoric of greatness is to fall into the gravest error – the error of illegibility, of an illegitimate enunciation of that upside-down ekphrasis that is a Homeric painting. To aim for the sublime is to gamble with producing an 'impropriety' or a 'weed'.

We will return to this problem of Ingres' with the Salon of 1806, but only after a detour around some aspects of French aesthetic theory in the century before this exhibition.

So, if I have cited these two passages from Longinus out of order, this has no other reason than to ask the question about the reading of this text, a text that more than any other was to haunt the aesthetic thinking of French Academicism in the eighteenth century. In its imagined purity it was rather more a product of the compromise of the Ancients and the Moderns than a defeat of one by the other. It was spun out between idealist and sensualist philosophies whose only site of agreement was the value of the Academic *séance* itself. This is perhaps not the customary view of Academic aesthetics. Normally it is recounted as the replacement of a hard-line, antiquarian phase advocated by Le Brun, with the triumph of de Piles' liberal, natural talent conception of creativity. If for Rensslaer Lee, in his *Ut pictura poesis*, the latter is so wholly associated with Boileau's influential translation of Longinus, this is difficult to reconcile with the Greek text itself, which is as insistent

on the learning of rules in the attainment of sublimity as it is on asserting
the precondition of talent or temperament. It is not hard to imagine why the
Pseudo-Longinus, as it is now known, should have appealed to a philosophy so
utterly eclectic as Academic Aesthetics.[11] The *Séance* brought together
artists of different skills and genres, connoisseurs, professionals and aristo-
crats on the unique common ground of their discussion, which was, one
could term it, a pseudo-Kantian space. Within certain parameters, which
might be caricatured in terms of 'le Brun/de Piles', what could be agreed
was the value of that ground – the pursuit of an eventual goal which might
be underpinned by Longinus in a section that Boileau did translate more or
less like this:

> To speak generally, you should consider that to be truly beautiful
> and sublime which pleases all people at all times. For when men
> who differ in their habits, their lives, their tastes, their ages, their
> dates, all agree together in holding one and the same view about the
> same writings, then the unanimous verdict, as it were, of such
> discordant judges makes our faith in the admired passage strong
> and indisputable.[12]

The order of reading and understanding of a text like Longinus was an
ordering of priority, a privileging of one term rather than another within the
singular but antiphrastic discourse that was the Academic theory of art. This
is to say that Academic discourse was neither unified nor without obvious
contradiction, but that division was rhetorically structured in terms of quite
immutable terms of reference: Vitruvius, Lully, Racine, Raphael, Poussin,
Zeuxis *et al.*, and in more recent times Piccini against Gluck or Vien against
Boucher. Although frequently thought of as deriving a real political and
market influence from its entrenchment in the Académie and its control
over the education of young artists, it was only occasionally and conjunc-
turally an effective voice of the French government and state under the
ancien régime. Many artists, including members of the Académie, ignored its
precepts in their practice while becoming respected members. Chardin, for
many years its treasurer, is an obvious example. And collectors, in the choice
of items for their collections, certainly paid little attention to the hierarchy
of the genres. Angivillier himself preferred Flemish landscape to decorate his
rococo walls. And the rise of the landscape and genre subjects that marked the
Salons of the Revolutionary period was a tendency the revolutionaries reluc-
tantly inherited from a corrupt monarchy whose attempted control over
the arts they soon sought to perfect in new and far-sweeping programmes of
prizes, competitions and festivals.[13]

This attempt to bring the now, temporarily Rousseauized, discourse and the
shape of society into line with each other, to construct an ideal image of
the *régime* of Liberty, Equality and Fraternity, was shortlived as a totalising

politic.[14] But it provided or disclosed ideas, threads and pathways for the organisation of the relation 'the arts + society' that we can trace quite formally up to a fragmentary but detailed summation in the *Exposition Universelle* of 1855 and Lapauze writing on Ingres in *Les Arts français et les industries de luxe* in 1921.

For not least important in this discursive heritage was the pliableness of its appropriation to different aspects of the interaction of state power, of whichever state power, with the social, political and economic institutions and forces.[15] Instances were the foundation of the École Polytechnique in 1795 and the mounting of the Exposition on the Champ de Mars in 1797. In these a delicate and sometimes brutal process unfolded of the layering of academic aesthetics into military training in the one and the taxonomy of industry as an interest of the state in the other. In some respects both these insertions had already taken place, and had a long-term unfolding in the practical work of the *ancien régime* Académies, in architecture and *ponts et chaussées*, for example, as well as in the Écoles Royales Protégées.[16] The particularity of the new conjuncture lies in the linking of the requirements of the state for the pursuit of war with the beginnings of the industrial economy that comes after the Revolutionary abolition of corporations and privileges, including those of the Académies themselves.

Thus if, in the Polytechnique, the state is committed to the idea that the drawing required by military engineers and generals must be justified through recourse to an aesthetic history that maintains the formal integrity of Academic rhetoric, the state itself must take on anew a quality of that rhetoric. The ground is laid here for the Napoleonic resuscitation of Academic status under Landon. And, as a repressed corollary, art must take on some of the qualities of this form of drawing. This second point has been amply demonstrated by various scholars in work on Napoleonic military painting and its relation to the battlefield sketch.[17] Moreover, in the detailed organisation of an industrial taxonomy, it is the state that will shape the outlook and self-consciousness of industrialists themselves, cajoling, bullying and harassing them into their participation in the long series of Expositions that do indeed reach a moment of epiphany in 1855.[18] And further, one of the integumentary links between these two ordering and structuring processes is the unfolding of a debate on the status and application of drawing in an industrial society. A debate on who shall do it and how they shall do it, on what it means for workers, artists or engineers, a debate that itself passes through a crescendo between the reports of Adolphe Blanqui in the 1840s and that of L. E. S. J. de Laborde in 1855, and which disembodies and re-embodies the aesthetic and moral affect of the languages that it deploys. A debate that progressively recentres the word 'drawing' in a position where it is still defined by Academic discourse, but no longer belongs to it. This, as we shall see, has some important implications for the

Ingrian aporetic, making for some strange connections between him and his Others.

Were I to designate an image for this process, it would not be one of the great military machines of Gros or Girodet, nor a landscape of the Levant or Egypt. More domestic, embedded in this intimate relation between state, social formation and genre painting as historical, it would be Isabey's painting of 1804, *Napoléon visiting the Oberkampf factory at Jouy-en-Josas*, preferably as the engraving from the *Annales du Musée*, where it did indeed compete with Ingres.

To conclude this section on a speculative note, it's worth thinking about the possible connections between Longinus and Kant, as what they are is yet another shadowy immanence for the history of art. Longinus, as I have argued, might be understood as a focus for a social agreement between right-thinking people, yet an agreement which leaves open the matter of talent versus learning as an appropriate object of contention. It is an agreement that then facilitates an endogamising disagreement within a social grouping and, at the same time, the appropriation of external discourse within its rhetorical structures. Longinus here, and we will think about him rather differently in the Cassou chapter, looks very much like a possible image for Bourdieu's negative version of Kant as the universalising mask of bourgeois particularity. And Bourdieu's critique of Kant is not too unlike the Voltairean critique of Boileau.[19]

This indeed makes good sense of Longinus, but by the same token, poor sense of Kant. For it seems to me that there are two dimensions to the emergence of the Kantian notions of judgement and the sublime that we can begin to outline in this context. One dimension is that of the need for an external measure of aesthetic and of ethical value in a society whose growing complexity puts the sufficiency of its endogamic institutions into suspense. That is to say, there is a need for a measure that is contained neither by idealist nor by sensualist discourses and the arguments concerning the differences between them. A site for judgement that is outside the boundaries of the known looks like a more convincing utopia than ever more dystopic or inadequate sites of the *ancien régime*, and is needed before Kant. The other dimension, which has been finely elaborated by Jacques Rancière, is that Kant, in opening up an empty space, invites the revolution to conclude itself in a form of equality that cannot be realised simply through political structures, but which can be imagined through the very failure to adequately figure it. Thus the Kantian sublime and the synthetic judgement, far from masking the bourgeois revolution, actually unmask its limitations.[20]

So, to return to the matter of judgement, so difficult for artist and public alike. In the *Observations critiques sur l'exposition des tableaux de l'an 1806, M. Vautour par M. Lambin*, we are treated to the pleasures and displeasures of a bourgeois at the Salon. It takes the form of a dialogue between the imaginary

M. Lambin himself, his servant Julie and art critic M. Vautour who is accompanying M. Lambin's Aunt Aurore to see the show. The run-up to the visit is an account of M. Lambin's toilette. He has ordered Julie to wake him at six in the morning 'in order to be ready at ten o'clock for the opening of the museum', a regal timescale for his levée that suggests the importance of the event as well as of the man himself. The first hour passes quickly as M. Lambin, his eyes on the uneasy barometer, anxiously chooses whether or not to wear boots or slippers with his 'violet jacket, crimson waistcoat and sky-blue breeches with silver garters'. His choice, for greater elegance over caution, is made by seven, and then he is in a hurry. No 'sans-culotte' is he, this Monsieur with a servant, a substantial wardrobe and the time to think about the one while talking to the other. His decision to take Julie with him follows an interchange between them that I will quote in full:

> Shall I accompany you, Monsieur? – Ah! ah! are you curious? – But
> yes, Monsieur, and I can assure you that I know it, because my
> father sold some of it. – And what did he sell, your father? –
> Pictures, Monsieur, and what's more he made some of them
> himself, and he didn't have to carry them to your Museum to sell
> them, I only had to hang them in front of the gate of our alley and
> in less than eight days he sold them for up to thirty to fifty sous the
> piece. – It is to be presumed, Julie, that these were nothing but
> *croûtes*. – Ah, no, Monsieur, they weren't *croûtes*. It's so true,
> Monsieur, that I'll tell you something true that will really surprise
> you. One day a gentleman came to order a picture from him that
> represented a galloping horse, my father spent more than ten hours
> making his sketch, but seeing that he couldn't make it gallop, he
> rubbed out his drawing and did another horse lying on its back, on
> the stampede with its four legs in the air. Two days later the man
> who ordered it came to collect it, my father presented it to him;
> after examining it he said to my father: But Monsieur, I asked you
> for a galloping horse, and not a sprawling beast; in consequence of
> which I don't want it. – But Monsieur, my father said to him,
> you're not thinking, understand that I've done more than you asked
> me for, because I've done you two, and this is so true that you only
> have to take my picture, where you see a sprawling horse, turn it
> upside down, and you see that the same horse gallops on its four
> legs. – Ah! there's a good story, cried M. Lambin, I can see that your
> father was a true dauber, because I've seen him illuminate more
> than a bum's game – Come, Julie, let's hurry …

Dressed for his visit M. Lambin looks very much like the men in Ingres' drawn portrait of his intended family, seated proudly around his fiancée Julie Forestier – the young painter who had copied Ingres' recent self-portrait and

who was to remain faithful to their hopeless engagement all her life (Figure 35). One of the determinants of Ingres' decision to break his engagement with this Julie is her father's lack of faith in him in the face of the critics in 1806. And without a shadow of doubt he, M. Lambin (or M. Forestier) must be a man of taste, with a cultivation of outlook that belongs somewhere in the murky area of cultural transitions where the old Enlightenment of Diderot and Greuze passes into the popular romanticism and common sense of a new bourgeoisie. Fragments of Academic rhetoric jostle with formulations of value that express the sense of individual judgement in the same breath as the 'gutter' press. M Lambin, to give him his due credit, in his own way is the whole tragedy of Kantian judgement in the imperfect world of the modern middle class, and during the entropy of the institutions of Longinian agreement. There are simply too many distractions. Arriving at the museum, he passes through the crowds of pamphlet hawkers and buys everything, every judgement, on offer, including M. Vautour's new publication. And when he bumps into the said M. Vautour with Aunt Aurore on his arm, they

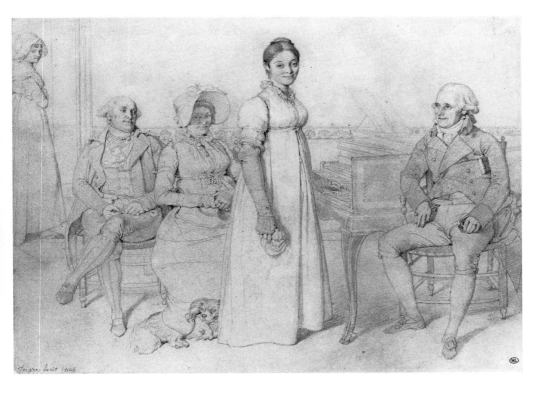

Figure 35

vow not to quit each other, but '[t]o examine the paintings and to say sincerely to each other what we think of them'.

For a young artist like Ingres this kind of critical discourse is both a part of his cultural environment and hard to take. For one thing it is terribly dissonant with the language of artists' aspirations and the exchanges of advice in the studios where they train. There, in the closed circles of masters and students, cliques of friends, of academic competitions, the words of art – words like taste, colour, drawing, composition, correction – are structured through codes as restricted as the societies they serve. They are used in a specially bloodless manner appropriate to the conserving of the illusion of Academic autonomy.

Girodet, for example, in 1816, advising the students of the École all these things: to avoid the rashness of Icarus – in ignoring the rules: to follow Prometheus's boldness in his modelling the perfect form of man out of clay: but nonetheless to recall that Minerva gave life to that clay, for the soul is still the 'sacred fire'. Here are all the old conflicts of passion and its regulation, unfolded in an elegant liaison of carefully chosen classical myths. The locution itself proposes a model for pictorial composition. A model that, as it happened, was hardly typical of Girodet's own risky career of flirtation with a violent and expressive sublime. One has only to look at the drama of his *Déluge*, or the maudlin but unclassifiable illustrations for Bernardin's *Paul et Virginie* or Chateaubriand's *Atala*.

Even so, quite crushing criticism more often than not may follow from such generalities. High-flown mythemes of the creation as an allegory of creativity lead to niggling points about the 'correction' of this arm or the joining of that shoulder. Yet they set a tone. Far from the market-place, they circulate like masonic nods or handshakes, confined to making sense only within their spheres of privilege. The language of art, before it arrives at a publicly legible figure, allegory or other form of meaning, is just so many articulations of arms and legs, trees and hillsides, backgrounds and foregrounds, colours and tones, lights and shades, choices of subject or narrative moment, the learning of all of which is saturated with a meaning prior to the meaning of their ensemble. For a true judgement there is no single point of repose, only a series of halting points appropriate to the interest in question. Landon himself is taken to task by a pamphlet for painting a nude with the 'thighs too long' long before Kératry was to verbally flay Ingres' Odalisque for its extra vertebra. If it was the latter denunciation that was to become famous, this was very simply because Ingres' supporters and his early historians understood what was happening to him no better than he did himself. They mistook the banality of the comment for the misunderstanding of genius, inadvertently situating themselves in an as yet unrecognisable avant-gardism far, far from their avowed theory of art.

But now let us listen to some of what our little party, well dressed and well informed, with their pamphlets and opinions, 'sincerely' thought of

Ingres when they arrived before his display in the Salon of 1806 (I should point out that not each stopping point entails a dialogue):

N.o 272 Ingres [Figure 36]

Full-length portrait of the Emperor: masses of red, whites, blue, grey, much gold, very rigid lines: Mr Ingres sees everything in white, even the faces.

N.o 273 The same [Figure 37]

More white on a canvas, a black suit, a white frock coat, and then a white handkerchief, a pale white face: all this put together makes a portrait of the artist.

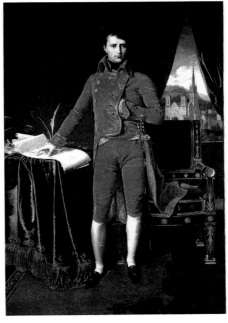

Figure 36

For sure, the self-image of the artist painting bears little resemblance to the highly coloured M. Lambin who is looking at it. Although there are no more words than these, this wild, duochrome image of what we would think of as Romantic man, is not a man as M. Lambin would see him made, as M. Lambin has made himself – albeit with the connivance of Julie. The asymmetry of the squint is perfectly misaligned. The artist, after all, does not make himself out of indecisions between boots and slippers, but out of lines, colours, clothing arranged against clothing, skin tones and background. This much is admitted by our critic in the radical misrecognition of the image that is implied by seeing and naming parts before the whole, that telling phrase 'all this put together makes a portrait of the artist.' There is a confusion here, an expertise

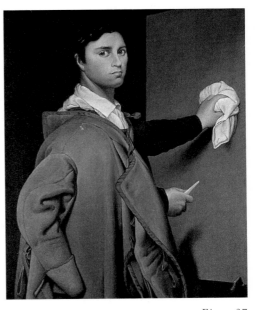

Figure 37

Figure 38

exercised out of place; the little party wants to teach Ingres, not to consume him, to step above their linguistic station in life. His self-image seems to encourage their social hubris. Ironically the image of this painting that does correspond to this description is the version made by the other, real Julie, Julie Forestier, who clumsily copied it, perhaps adding the tastefully embroidered 'I' to the cloth that Ingres holds towards the canvas (Figure 38).

N.o 442, *Portrait en pied de sa Majesté l'Empereur et Roi*, by Robert Lefevre, gets a much more positive response. The description of the 'golden laurel wreath' that crowns the figure's brow, the 'beautiful lace cravate, and the chain of gold eagles of the légion d'honneur', taken with the 'gold braided satin tunic', the ample, 'dark purple velvet of the cloak sewn with golden bees', and all the trappings of the throne, framed in gilt-bronze on its marble dais with a 'gold-fringed carpet', overcome one slight reservation. The face is no more than 'a good enough likeness'. But 'in general one can say: *voilà un beau tableau*'.

This Napoléon, it seems, in all his natural majesty, is more apt to such domestic consumption; his imperial excess is easily turned over into quantity. Here the artist sees like M. Lambin; Lefevre pulls off an elegant *étalage* of luxury.

The text belongs to a tradition, established since the 1760s, of more or less scurrilous and parodic Salon pamphleteering, a tradition that took the voice of criticism out of the high-minded writing of Academic discourse or Encyclopaedism. Instead the voice comes from the mouth of a motley collection of figures from Commedia dell'Arte or from the caricatured strata of a pretentious, new middle class, all of whom want to talk about art, to find themselves in its words. The pamphlet was capable of pursuing a nuanced range of objectives from a political polemic thinly allegorised in the already highly political languages of art, to getting sales in the market for entertaining literature – though these are not necessarily separable.[21]

By 1806, the year of the first Imperial Salon, the pamphlet had survived the Revolution and the counter-revolution, to both of which it had, arguably, contributed. It flourished as a kind of proto-critical discourse, a reification of art as the pretended object of attention before the modern press and the profession of art criticism were to form a common field in the 1820s and 1830s. And it flourished as the number of artists working and exhibiting and seeking access to public attention itself was growing. Pamphlets went with a progressive transformation of the public for art and of its art market, and a shift in the nature and extent of state control over the arts.

At the same time, the Salon of 1806, as Susan Siegfried has so cogently argued, marks a specific turning point in the state-organised exhibition of art in the post-Revolutionary decade.[22] The Napoleonic regime, represented at the Louvre by Vivant Denon, set out to achieve what had been little more than an elaborate state fiction under the preceding three kings Louis – that is to say the effective focusing of the whole exhibition on the political requirements of the moment. And, while the Salon that year saw an unprecedented number of pamphlets as well as artists showing, the beginning of the Empire was nonetheless marked by a range of restrictions on the freedom of the press that tended to push criticism back into the performance of political allegory. The tightening of controls over the organisation of the exhibition required by Vivant Denon's programme for the napoleonising of the art world tended to marginalise even those images of the Emperor that fell outside his programme. This meant that Ingres' own contribution to the genre, *Napoléon Enthroned*, eventually to be purchased by the Corps Législatif, was left quite unprotected by its idiosyncratically flattering image of imperial glory (Figure 39).

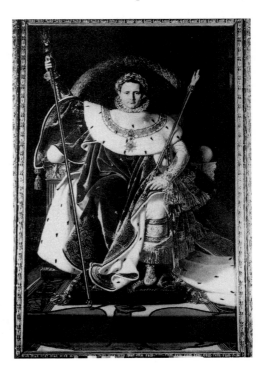

Figure 39

Parallel with this, in the Institut de France, the Classe des Beaux-Arts achieved a renewed self-confidence. Its control of art education was revived with the reopening of the School in Rome in the Villa Médicis. An event which made sense once again of the all-important Prix de Rome. And where Ingres, at 26 years of age, is to take up his five-years-delayed prize term just as the Salon opens. Academic discourse found itself renewed through teaching, commentaries on students' work, the commissioning of prize essays and reports, all of which directed the languages of art to meet its requirements. The Classe des Beaux-Arts consolidated itself as a social group, taking up its full range of traditional functions such as the editing of the *Dictionnaire des Beaux-Arts*, and came under the vigorous leadership of A. C. Quatremère de Quincy.[23] All this meant that the exhibition of art was now caught within an evolution of languages, at one limit ensuring their reabsorption into a real academic restoration, at another their dispersal into the pamphlet and

the very different institutions of the press. It is across this complex network of fissures and differences that the process of critical utterance finds meaning.

This suggests how radically the context of meaning could change even at a moment of relative political stability. It underlines how, as far as the pamphlets are concerned, what we call a development may be better thought of as a series of conjunctures and disjunctures that render the notion of a genre of criticism weak and minimally denotative. It hardly makes sense, then, to talk of continuity of function when meaning depends on an address from and to sections of a society in which the whole social topography of art is utterly unstable, and in which the role of art criticism is made out of interfering structures of its historical development. It is the tracing of some aspects of this problematic duration that will largely concern us here. The ways in which the pamphlet belongs to the institutions of the press on the one hand and those of art on the other are probably best thought of as framed by contingency and misrecognition rather than as representing a relatively transparent relation between art and critical discourse.

We have to attend to the registers of sense with which they resonate. Even though these are only partially and contingently related, they may, on a given occasion, conform to an acceptable and agreed standard of visual judgement. A judgement, for example, based roughly in certain expectations of the use of chiaroscuro as an acquired skill, demonstrating an ability to distribute light and shade in a proper way. This is the case especially when examining the work of a young artist who is showing the public his worth and potential, as, indeed, is Ingres. For it is also an expectation that skills have to be learned and that, through their effective application, a talented artist may achieve an effect of the sublime as an outcome of proper learning. This sort of assumption about the making of an image lies behind the comments of M. Lambin's little group, and their 'sincere' chatter makes up an essential element of the momentum it needs to circulate the knowledge of an artist's work. Indeed it is this kind of pamphlet, with its lack of any evident political programme, its jostling for attention in the market for entertaining literature, that probably pays the most disinterested attention to the works of art themselves – even while it may say less portentous things about them than, say, Chaussard in his *Pausanias Français*. But again this attention is conditioned by the institution of the press itself, the successive appearance of the reviews and their responsiveness to each other. What it, this or any other pamphlet might have to say is also influenced by judgements that, while they exercise themselves on the surface of a painting, derive their substance from a different urgency, that of M. Lambin's arrival through the babel of this commercial press, the sale of opinions.

Moreover this babel may generate common judgements, ones that come to appear natural and commonsensical. The reproach that Ingres was obsessed with whiteness was one of the truly common themes in 1806, just

as there was general agreement that Bergeret's *Death of Raphael* was a genuinely successful and moving painting. While the flock of Scapins, Arlequins, Lambins and Aunt Aurores danced attention on Bergeret and sang his praises, the artist who had already made himself the acolyte of the celebrated Raphael had to suffer all their taunts. For Ingres' *Napoléon Enthroned* the second of two Arlequins to visit the Salon sang this — 'to the tune of the march of the King of Prussia':

> De loin ce tableau paraît si blanc
> Qu'on le prend pour le Mont-Blanc.
> Puis fidèle au blanc
> Ingre (*sic*) s'est peint en blanc.

> (From afar the painting seems so white
> That one takes it for the Mont-Blanc.
> So, faithful to white
> Ingre (*sic*) paints himself white.)

No mention of his homage to Raphael in the details of the enthroned Emperor, the little Madonna della Sedia painted into the carpet. While for Bergeret, this couplet paid its compliments to the tune of 'Femmes voulez-vous éprouver':

> Bergeret dans ce beau tableau
> Que savamment ta main nous trace
> On voit que ton hardi pinceau
> Sait unir la force à la grâce.

> (In Bergeret's fine painting
> That his hand traces expertly for us
> One sees that his bold brush
> Knows how to combine strength with grace.)

High praise indeed to find strength and grace together, though the familiar 'tu', together with the tune, deprives the compliment itself of the social grace of teaching language. The other Arlequin also likes the picture. Though, with rather more political wit, he manages to note the figure of 'Napoléon (le-Grand)' by Raphael's corpse, strewing it with flowers alongside Leo X and the Cardinal Bembo. Actually this 'realpolitik' of misrecognition is far from ridiculous as a recognition of the Napoleonic programme for the exhibition, and the Arlequin's little study is almost a parody of the Comte de Gobineau's political melodrama on the life and death of Raphael written some thirty years later.[24]

To end up so utterly lost between the twin touchstones of Raphael and Napoléon is more than ill luck for the wretched Ingres. It represents nothing less than an inversion of the very structures of meaning with which

he has tried to locute his originality. It is rather as if the whole of his *démarche* has been nothing more than a slip of the tongue, as if he has said one thing, and another is being heard, as if he had painted a 'galloping horse' only for it to be seen as a 'sprawling beast'. In his letters from Rome he can hardly understand the critics. Gothic in the Rivières? – it makes no sense at all.[25] The more so as the notes already assembled for their *Dictionnaire* by the Academicians persist in depicting the gothic as being somewhere between the primitive and the decadent, but anyway as an abject style.[26]

So, while I accept the generality of her discussion on the changing structures of salon exhibiting and the analysis of its implications for the politics of art criticism, I must differ from Siegfried on the scale of the subject and the kinds of attention we need to pay to it. In turning to microstructures of cultural meaning I want to suggest that the presiding figure of the Salon is not only that of any individual artist or bureaucrat or political programme. Rather it is the figure of inversion. That is to say inversion as a rhetorical trope, but also as a wider discursive phenomenon in which we see a continual reconfiguring of the languages of art, and of who is their 'speaking subject'. If I try to limit my attention to a rhetorical notion of inversion, then this is precisely because it privileges the matrix over the hierarchical. Inversion as a figure or as a trope – and there is much debate about how to name it – occurs within the unfolding, horizontal distance of a printed phrase.

In French, if we take the model provided by Etienne Bonnot de Condillac, in his *De l'art d'écrire* (1767), perhaps the most immediate standard for the early nineteenth century, it may be as simple as the transposition of an adjective from the usual side of a noun to the other. Yet this choice is one that requires a complex and complete knowledge of the language, the exercise of an intense and structured control over the shape of the text as a whole. 'Pseudo-Longinus' insists on the matter, 'which consists in arranging words and thoughts out of the natural sequence, and bears, so to speak, the genuine stamp of vehement emotion'. The emphasis that inversion provides may only be justified by an appropriate underlining of meaning or sentiment in its relation to a whole complex of other rhetorical gestures or tropes. Thus the use, or especially the incorrect use, of the trope is loaded with significance.[27]

While this significance is certainly social, or may be referred to matters of social difference articulated through access to education, generation, institutional position, political allegiance or whatever, all of which are crucial at this time of transformation, this does not imply that the use of the trope, or its presence as a figure of the social, must be the invocation of a 'world upside down'. We may be looking at differences between the academic establishment, with all its weaknesses, and an Enlightenment critique, with all its adhesion to the monarchy. A truly liberal rhetorician, Condillac

certainly took pleasure in needling Boileau's version of correct locution. He would praise Scudéry, and, in certain of her turns of phrase, especially her mastery of periphrase, prefer Sevigné to Boileau himself. Yet between the informed use of rhetoric to draw attention to difference, to assert it, and the very rapid revolution and evolution of social relations, which make the correspondence of position and utterance absolutely unstable, it is difficult to assign a text to a role, or infer a situation from a text. Or doing so is at the best provisional. Julie's nutty horse story is as an accomplished an example of oxymoron as one could imagine, yet at the same time a parody of the over-elegant use of inversion. It is a sophisticated joke, but jokes, apparently, on behalf of a democratic and commercial commonality of art critical discourse, where these two terms are inseparable. It is invested in the playful and slightly ridiculous familiarity of the relation between the servant and her master. In their speaking to each other over the figure of the artist they absorb both the artist and the practice of art into a social space of their dispersion.[28]

One of the most influential counter-attacks on *Le Pausanias Français*, that of Boutard for example, first and foremost takes it to task for its wilful use of the trope of inversion – 'il ne sont partout qu'inversions inusitées, comme *paternel gouvernement, extraordinaires génies, septentrionales gothicités*' ('curious [French] inversions, such as government paternal, geniuses extraordinary, gothic northern, are everywhere').[29] This correction of Chaussard's grammar by Boutard takes priority over the somewhat competitive refutation of individual judgements and the satirical abuse of Chaussard's masquerade as an antique sage. He was, after all, known as one of those little-repentant men of '93 who liked to dress up and adopt classical pseudonyms – Pausanias, Publicola. To mock his rhetoric was also to undermine his project. If, then, the tendency to represent localised and highly specific contentions as general social inversion distances us from the density of inversion's matrices, what follows is a version of what such a mapping might well be.[30] Inversion, as the play between a formal figure of writing and a reversal of social proprieties, will be read as a potential symptomatology rather than a world upside down.

As I have already indicated, the criticism of 'whiteness' in Ingres is one of the most persistent of the innumerable criticisms of artists and art works to be made at the Salon of 1806. More than a mere whisper in the general clamour, coming as much from the popular pamphlet as from the serious critics, the remarks are quite dramatic for Ingres. They complete a general repudiation of his work across all the genres of his production. Narrowly, but precipitously, these range from the domestic portraits of the Rivière family, to the self-portrait and the historical portrait of Napoléon enthroned. Portraits all, but in different genres of affective and market value that range from the particular and private to the sweeping public generalisation of Napoleonic power. Like so much art criticism, the accusations do not make a

lot of visual sense, or the visual sense they do make lies in codes that are not fully present in the image. *Mlle Rivière* is indeed very white in her dress and fur stole, and the brilliance of Napoléon's silks and furs, his plaster face, are likewise difficult to deny (Figure 41, p. 121). If Ingres has avoided a difficult 'out from under' image here, he has done something far worse – he has neglected the educated distribution of tones and colours. So the quality of the shock is not radically different from that which some critics suffered, pretended or played out in front of Girodet's *Deluge*, which was singularly lacking in white tones and criticised for its greyness.

The critique of white in the self-portrait is something much more than a comment on how it looks, and goes much further than the dissatisfaction with *Mlle Rivière*. It suggests the presence of a deeply unsatisfactory procedure, and the ability to discern its presence. As a procedure for painting it is one that is both clean and dirty. The painting is white because Ingres wipes clean the painting he represents himself as making. White is as much an effect of removing paint as applying it. But in the slippage from the artist's legitimate duster to the 'handkerchief' with which the Lambin party see him wiping the picture in the picture, it turns into a dirty painting. It is improper. Whiteness becomes a means of articulating a dissatisfaction, or, should we say, the more or less adequate representation of a knowledgeable dissatisfaction with what the artist does. And while this in turn is enabled by a generalised field of rhetorical practices, it is the degree of correspondence of Ingres' procedures to those of art-rhetoric as an adequate vehicle that permits or blocks the process of recognition. Let us take the first of two pamphlets both entitled *Arlequin au Muséum*, here a dialogue between Arlequin and Scapin who dance and sing their way round the exhibition, in verse and prose:

INGRES 273. [Arlequin] Un peintre, oh! ici il y a du ridicule. Regardes, Scapin, cette tête à cheveux coupés et d'un noir tranchant, sur une grande toile blanche. Vois-le-donc, s'amuser à frotter avec un chiffon (le Moniteur a dit avec un mouchoir) très-blanc, parce qu'il aime la propreté ce peintre. Oh! oh! il est noir aussi; sans doute il s'est débarbouillé avec de l'amadou, pour trancher sur le blanc qu'il a mis dans son tableau. Comment peindre si froidement, lorsqu'on a une tête si chaude [see Figures 1 and 38].

(A painter, oh this is ridiculous. Look, Scapin, that head with cropped intensely black hair, on a great white canvas. Watch him amuse himself by rubbing a cloth (the *Moniteur* said with a handkerchief) that's very white, because he likes cleanliness, this painter. Oh, oh! He's black as well; no doubt he's washed his face with amadou, to stand out against the white he's put in his painting. How can one paint so coldly when one has such a hot head?)

Clearly the appearances that Arlequin describes have more to them than the effects of the more or less correct exercise of painting as specific skill; they are to do with the figure of the artist and the implication of an equivalent between his image and his physical or social presence. The signs in the painting make no sense in relation to each other, but only in relation to a man who is over-present in his self-portrait. As with the Lambin party, these signs break away from the picture and cajole the viewer into an intimacy with the painter, into feeling close to him. Their internal liaison is Ingres, an artist already noted for his desire to be original and who coldly represents himself as hot. What is felt is not what is signified and vice versa. Now with such a pamphlet the meaning of this is doubly structured.

First, it conjugates with the overall field of the critical rejection of the artist – referenced even in this short passage – 'the *Moniteur* said' is crucial to Arlequin's validity. It takes off from the most refined of academic aesthetics in its inability to see what is the liaison between the parts of the painting that derives from the codes of art as a form of rhetoric, for the relation between figure and linking of figure lies at the heart of Academic rhetoric. Here at least the inheritances of Boileau and Condillac run together. The contrast of light and shade, for example, normally a virtue if properly distributed, is seen as becoming oxymoronic rather than a binary complementarity. A cleaning off rather than a putting on, and in this a point for the slippage into scatology, for the word mouchoir contains the word 'mucus'.[31]

Second, then, the popular genre characteristically introduces altogether different orders of material as a means of generating discourse on the image. Materials that play with notions of emotion, pathos, narrative and so forth, but at the expense of the privilege of the image as the focus of either discussion or affect. The vaudeville surrounds the image with an accompaniment of extravagant displacements both of its meaning, and with equal importance, of critical language itself as the site of a possible Longinian accord. The second Arlequin, struck by the generally accorded mixture of frisson and revulsion in front of Girodet's *Deluge*, and accusing him of 'drowning himself in his subject', calls his own punning approach into question as 'a judgement of last resort' (p. 36). But despite this follows its logic to make 'several suggestions that are basically puerile, but nonetheless have the greatest weight for people who like to think of themselves as connoisseurs'. And then, in response to his question of just how all these people hold together, he calls the baby to life, which then pathetically rejects his criticism to the tune of 'nous nous marierons dimanche' ('we'll get married on Sunday'). Thus the vaudeville critique becomes a form of social 'papillotage', a play with language, writing a new space of social difference into the procedures of art criticism through its own relatively grotesque textuality.[32]

Moreover in the second instance the words themselves, interpolated into the already ambivalently dependent relation with academic rhetoric, in their history and other meanings, further decentre the site of sense.[33] 'Amadouer'

alone represents not only an interference in proper critical speech, but one that implies new ways of speaking about the artist. In modern French it means to coax or cajole, by synecdoche from the noun 'amadou' – tinder or kindling. But in the early 1800s the word 'amadou' seems to be in transition between different vernacular uses. One, dating back to Rabelais, 'the preparation with which beggars dye themselves in order to look ill and provoke pity', fits in here rather well and could flow into the use of the verb to mean 'flatter with pleasing words'. Yet the use for 'kindling' dates to the eighteenth century, and by analogy means 'easily inflammable', with a potential reference to a form of kindling made out of burning cloth. This too seems adequate to the fiery appearance of the artist, 'such a hot head', to his defiance of description and to his duster. I am not sure that we can resolve this matter, or that we need to. One way or the other the placing of the artist within a frame of reference that at one level makes sense in Academic discourse also pulls him into a figuration which is no longer contained by Longinian computations of the desirable proportion between âme and education. The vernacular both leans on the 'official' to be heard at all in the discourse of salon criticism, but suggests that the artist is something other than this official can account for. Not a temperament like that of artists found in Vasari – Signorelli, Raphael, Piero di Cosimo, Michelangelo – a neurotic, an exquisitely balanced temperament, a neurasthaenic or a fiery genius. But a beggar, a flatterer, a fraud or a sickly looking type, perhaps wanting to be loved, soliciting attention in the market-place that is the Salon.

If Arlequin and Lambin reject Ingres' romantic self-image, they also, if incidentally, denote it as an emerging social type with the strange and compelling accuracy of their somewhat literary vernacular. The relation between the critic and the painting is one between two subjects, one of whom, the artist, is becoming important for his being as well as for his responsibilities or skills. The critic as the *I* of his discourse designates the artist as the *he* in his, an emerging recognition that the work of producing the subject lies between the two of them. We may well feel that there is a discursive precipitate which, put into a teleology of the history of art criticism, is somewhere between Diderot and the work of a Thoré, a Gautier or a Baudelaire. This would, however, be an elision of what is better understood as an increasing density and complexity of the social structures and languages of aesthetic experience. Even if a major form of subjectivity appears to be establishing itself, it is not leading towards the playing out or completion of other models. Rather they will interact in differing states of continuity and discontinuity and continue to interact with each other through the production of critical and historical texts as well as art works. The miracle, if I may call it that, of Delaborde's work or of Longa's is to produce an Ingres with even the semblance of continuity, and to do so with

such power that the path to realising his plural subjectivities must continually pass through their illusion.

Once this is realised, materials change their sense. These pamphlet texts possess a richness and a complexity that emphasise the etiolated and entropic tropology of Academic criticism. That Ingres subscribes so fully to a theory of temperament made up out of Longinian soul and Vasarian art history is one of the ironic inversions of his relation with an art criticism that really does meet him, if in ways that, as yet, are outside its or his intention. In Élie Faure's appendix to Amaury-Duval's *Atelier d'Ingres*, he records an after-effect of this misrecognition many years later:

> Il [Ingres] disait: 'Le brun-rouge, une couleur descendue du ciel.' Quant au blanc, il eut voulu qu'on le vendît au poids de l'or, par crainte d'abus.

> (He [Ingres] used to say: 'Browny-red, a colour from heaven.' As for white, he would have liked it to be sold for its weight in gold, lest it be misused.)

(p. 200)

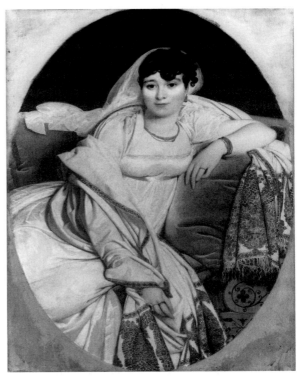

A fading of a leftover of an inversion, the earth colour of Ingres' anger falls from heaven, while the white of his unwanted filth is proscribed. This is the Chantilly version of the portrait (Figure 1) which he makes about this time, effacing once and for all the Salon of 1806.

Just as Ingres' self-portrait belongs too much to the artist, his *Mme Rivière* belongs more to the language of a middle-class social world of the sitter than to the portrait as a genre, which anyway the Arlequins pretend to despise (Figure 40). 'Rien n'est beau que le vrai / Le vrai seul est aimable' ('Nothing is finer than the true / Only the true is likeable'), sings the first Arlequin as his friend Scapin

Figure 40

109

tries to retain him in front of the painting. The bathetic descent from the 'beau' and the 'vrai' to the 'aimable' suggests that Mme Rivière herself, 'quoique cette femme soit dans une position voluptueuse' ('although this woman adopts a voluptuous pose'), is unlikeable. But what makes her unlikeable is 'blanc, blanc et blanc sur blanc, cela n'est pas naturel' ('white, white and white on white, that's not in nature', p. 17).

Again the unnatural makes the liaison between the physicality of the paint and a powerful social presence, and Ingres, as the butt of this critique appears as the focus for a concern with the whole genre of portraiture at the Salon. 'Passons, passons. Ce ne sont que des portraits' ('Hurry on, hurry on, these are nothing but portraits'), says the first Arlequin in front of the work of Capet, a response taken up even by the curious Scapin when Arlequin challenges him as to the identity of a man in an 'habit noir' by Devouge:

Scapin: Oh! c'est encore un portrait.
Arlequin: Et de qui?
Scapin: Je le connais bien moi, c'est Hypolite, comédien du vaudeville, qui étudie son rôle. Il est bien ressemblant.
Arlequin: Tant mieux pour madame Devouge.

(Scapin: Oh, it's another portrait.
Arlequin: And of whom?
Scapin: I know him well, it's Hypolite, the vaudeville actor, who is studying his role. It's a good likeness.
Arlequin: So much the better for Madame Devouge.)

(p. 12)

If it is hardly necessary to underline that if the process is here one of identification in the fullest sense of the word – the vaudeville approvingly evokes itself in the painting – its partner is one of a *blasé* distanciation. In the second Arlequin, after a witty summary of the weird conjunction of the higher genres at the Salon, with all their posturings and facial expressions, he sets against the portrait:

Ajoutez … tout cela des milliers de portraits, qui ne sont par malheur que trop ressemblants, Air: Combien je suis frais et dispos.

Portrait rouge de monsieur B,

Puis portrait bleu de madame M,

Puis portrait gris de monsieur P,

Puis portrait blanc du petit N.

A voir de ces plaisans portraits

Les grotesques enluminures,

On croit que nos peintres français

Ne font que des caricatures.

(Add up ... altogether thousands of portraits, which are unfortunately only too lifelike. With the air how fresh as a daisy I am.

Red portrait of Monsieur B,

Then a blue portrait of Madame M,

Then a grey portrait of Monsieur P,

Then a white portait of little N.

Seeing these pleasant portraits,

The grotesque illuminations

One could think that our French painters

Only do caricatures.)

And so on, and so on, all this sameness which at the same time is differentiated by colours, tones, postures, 'ridiculous positions' that 'are the most difficult to hold' (pp. 15–16). Ingres, then, is far from alone in his attraction of an unfavourable critique for portraiture. But as its principal target he is even further from being consigned to oblivion, as one of the Arlequins jokes that he would like to be – so great is his resistance to success; on the contrary, it is the beginning of his being rendered tropic, but precisely on the ground which he himself has aesthetically renounced through Academic rhetoric. The ground of what we would now call visual semiotics, of the relations of mark to sign and sign to the split predicate of referent and signified, and of the relation of these to the artist as a presence in his work, and which, in Academic propriety, are only to efface each other. To accept any other propriety would be to desire to breed 'weeds' out of the passion for 'novel ideas'.

Or, worse still, it would be to accept the utter banality of one of the fundamental myths of representational art, one often represented at the Salon and repeated as the figuring of infantile genius for a succession of canonical artists from Giotto to Picasso. This is, of course, the tale of Dibutade, the Grecian maiden who outlined her departing suitor's shadow on her wall and so invented the art of copying nature and of treasuring this copy as affect. Or, even worse, to give equal place to Julie in the languages of art, she who so nimbly masters and so subverts the relation between the image and the sign in the story of her father's inverted horse. Or it would be to realise that the other Dibutade, Julie Forestier, in making

a copy of her fiancé's portrait, perhaps knows more about it than it knows about itself. The ruling figure of inversion is no more or less than this figure from the social comedy; not a world upside down as much as a world of upside-down locutions, and the slow tilting of this gradual social inversion, through which the 'simple girl', instead of remaining the chaste originator of pictorial art, becomes its self-willed critic or consumer. In this tilting of art criticism to become a new art of writing, let us commemorate the servant Julie as its Dibutade, and Arlequin and his Scapin its Pliny or Herodotus. As Scapin says to Arlequin, when he speaks of history painting, 'how strange it sounds in your mouth'. As indeed it does; strangely natural that the second-order codes of the Academic genres, these meta-descriptions of all that which, as Arlequin rightly observes, can never exist, should be sung and danced in a market-place as a matter of choice and of personal enjoyment. This childhood of art criticism is a dream of codelessness, of the direct medi-ation of art by language, which is also the dream of origin in classical aesthetics and, in its way, the relation of consumer and commodity. Poor Ingres recognises his own dream only in its absence: in its ingenuous pres-ence, he experiences it as his nightmare. The nightmare world of the Arcades.

NOTES

1 Of the daubings of Antiquity
The erudite hardly speak:
Time and severe critics
Avenge posterity.
Sirs, make the legacy
Which our nephews will inherit from you
Worthy of your worship and homage
To your ancestors
And, like them, journey well.

For a general survey of the emergence of Salon pamphlets see Richard Wrigley, *The Origins of French Art Criticism, from the Ancien Régime to the Restoration*, Oxford, Oxford University Press, 1993, which includes a fine bibliography, and for the most complete list of the salons see Neil McWilliam *et al.*, *A Bibliography of Salon Criticism in Paris: From the Ancien Régime to the Restoration, 1699–1827*, Cambridge, Cambridge University Press, 1991.
2 See in the Archives de l'Institut, this dossier.
3 For a discussion of the positioning of Boileau and Longinus in Ingres' pictorial universe, see Norman Schlenoff, *Ingres: ses sources littéraires*, chapter 6. See Nicolas Boileau-Déspréaux, 1636–1711, *Oeuvres diverses du sieur D*** : avec le traité de sublime, ou du merveilleux dans le discours, traduit du grec de Longin. Et les réflexions critiques sur ce Rhéteur: ou l'on répond aux objections faites contre quelques anciens*, Amsterdam: chez Antoine Schelte, 1697.
4 On this matter of translation and the French language see Julia Kristeva, *Le langage, cet inconnu: une initation à la linguistique*, Paris, Seuil, 1981 (1969), and

Joan Dejean, *Fictions of Sappho, 1546–1937*, Chicago, University of Chicago Press, 1989.

5 Etienne Bonnot de Condillac, *De l'art d'écrire*, 1767.

6 See my 'History, Time and the Morphology of Critical Language', in *Art Criticism and Its Institutions in Nineteenth-Century France*, edited by M. Orwicz, Manchester, Manchester University Press, 1993.

7 A.-C. Quatremère de Quincy, *Lettres écrites de Londres à Rome et adressées à M. Canova, ou les Sculptures du temple de Minerve à Athènes*, Rome, 1818.

8 Comte de Caylus, *Tableaux tirés d'Homère et de Virgile, avec des observations générales sur le costume*, Paris, 1757.

9 The most complex manifestation of the gestural universe on which Ingres depends for *Virgil Reading*, which is also, through the text–caption relation, an example of the exaltation of Racine as a source of pictorial affect, is the great Didot edition of Racine's work of 1798.

10 For some good examples of this look through the reliefs done as *morceaux de réception* into the Académie by sculptors of the seventeenth and eighteenth centuries now on display in the Richelieu wing of the Louvre.

11 It is useful to check through both the *Procès Verbaux* of the Académie Royale de Peinture et de Sculpture as edited by Anatole de Montaiglon, Paris, 1875–1909, and the archival dossiers left over from them in the Institut de France, to get a sense of this eclecticism and the pragmatism of the procedures of the *séances*, the regular meetings of the members of an academic body.

12 Longinus, *On the Sublime*, VII, pp. 140–141.

13 See Édouard Pommier, *L'art de la liberté: doctrines et débats de la Révolution française*, Paris, Gallimard, 1991.

14 What I meant by Rousseauised is the series of prize essays which deal with the causes of the greatness of ancient art and the systematic analysis and reflection on these causes as the foundation for progress in the arts. See, for example, T. B. Toussaint Bernard Emeric-David (1755–1839), *Recherches sur l'art statuaire: considéré chez les anciens et chez les modernes, ou mémoire sur cette question proposée par l'Institut National de France: Quelles ont été les causes de la perfection de la sculpture antique, et quels seroient les moyens d'y atteindre?*, Paris, chez la veuve Nyon aînée, 1805. See A. D. Potts, *Flesh and the Ideal*, London, Yale University Press, 1994, for the most important overall discussion of these historiograpical questions as well as other significant themes in this chapter, such as that of Quatremère's positions.

15 See my 'Un Effet David? Les mots de l'art et le statut de l'artiste', in Proceedings of the Louvre Conference, *David contre David*, edited by Régis Michel and Philippe Bordes, Paris, La Documentation française, 1993, pp. 1067–1091.

16 See my 'The Words of Art, the Artist's Status: Technique and Affectivity in France 1789–98', in *Oxford Art Journal*, 14:2, 1991, pp. 73–82, and Pommier, *L'art de la liberté*, for discussions of this history of Academic functions and their transformations.

17 See Susan Locke Siegfried, 'Naked History: The Rhetoric of Military Painting in Postrevolutionary France', *Art Bulletin*, June 1993, 75:2, pp. 235–258.

18 On this, see a series of documents in the Archives Nationales, Paris, amongst which one gets a glimpse of this quite dynamic and forceful intervention by a succession of governments from the Directoire to the Restoration monarchy, for example, in the series F4 and F12.

19 See J. R. Miller, *Boileau en France au dix-huitième siècle*, Baltimore and London, Johns Hopkins Press, 1942, for an assessment of the importance of his writing and a discussion of Voltaire's rebuttal of him. Also, for what is now the standard, modern critique of Kant see Pierre Bourdieu, *La Distinction: critique sociale du jugement*, Paris, Minuit, 1978.

20 See his critique of Pierre Bourdieu and re-evaluation of Kant in his *Le philosophe et ses pauvres*, Paris, Fayard, 1883.

21 Bernadette Fort, 'Voices of the Public: The Carnivalization of Salon Art in Prerevolutionary Pamphlets', in *Eighteenth-Century Studies*, 22, 1989, pp. 368–394.

22 See her PhD dissertation, 'Ingres and His Critics, 1806–1824', Harvard University, 1980.

23 See my 'Ingres and the Academic Dictionary', in *Art History*, Summer 1983, pp. 154–170; Tom Holert, *Künstlerwissen: Studien zur Semantik künstlerischer Komptetnz in Frankreich des 18. Und fruhen 19. Jarhunderts*, Munich, Fink, 1998; and the dossiers of the Commission for the Dictionary of the Fine Arts in the archives of the Institut de France.

24 Comte de Gobineau, *La Renaissance: Savanarole – César Borgia – Jules II – Léon X – Michelange*, Paris, Plon, 1903 (1876).

25 See Henry Lapauze, *Le Roman d'amour de M. Ingres*, Paris, Lafitte, 1910.

26 See both the word Gothic in the Dictionnaire des Beaux Arts and the dossiers in the Institut de France.

27 My argument here is that the Academic discourse, largely through the exhaustive denotativity of its terms and phrases, was readily able to absorb Enlightenment thinking into its textual production without realising the need to rethink, or suffering from incompatibilities. This hegemonic process constantly tends to reinstate the powers of texts such as Boileau's through a sustaining rhetoric, even as they undergo critique.

28 At its most extreme, Condillac's form of liberalism, which finds its echo in Caylus's archaeologism, leaves behind the possibility of making more than one choice at once, something that chimes quite perfectly with the conditions of utterance facing an artist in the early nineteenth century. This is why I must also take issue with Bernadette Fort's article, despite its groundbreaking work in breaking the taboo on the serious analysis of popular criticism. If it misses the nuances of rhetorical difference even when they were at their most loaded in the *ancien régime*, it is even less appropriate a framework for the period of the Empire.

29 *Journal de l'Empire*, 8 December 1806.

30 I will here take a rather different line to Bernadette Fort and others, who tend to use Bakhtin's concept of carnival rather freely, anachronistically and optimistically to align literary and revolutionary inversion, contrary to Kristeva's equally Bakhtinian but more complex conceptualising of poetic revolution.

31 A reading of Condillac's *De l'art d'écrire* reveals an astonishing dependence on visual imagery and the analogy of pictorial narrative and painterly techniques for verbal constructions and rhetorical procedures which underlines the profundity of the relation between rhetorical or critical comment and the appearance of a painting.

32 Papillotage is the technique of rapidly making paint resemble something, like the foliage of trees; Diderot both criticised it and in effect practised it as writerly means of representing paintings – see Marian Hobson, *The Object of Art:*

The Theory of Illusion in Eighteenth-Century France, Cambridge, Cambridge University Press, 1982.
33 See the *Robert Etymologique*, or other French etymological dictionary.

3

A FILAMENT IN THE TISSUES
OF MODERNITY

Thinking is quite comparable to the drawing of pictures.
Ludwig Wittgenstein, *Philosophical Grammar*

Là-dessus je sais deux choses, la première est que la couleur efface le dessin; la deuxième est que le dessin combat toujours la couleur.

Cela sera évident si vous considérez les deux gestes du dessinant et du peintre, si profondément différents: le premier tire des lignes; le second pose des touches. Sur ce sujet, bien caché, je trouve un aveu dans les *Pensées* d'Ingres sous la forme d'une règle qu'il a donné à ses élèves, et qui étonne. La couleur, dit-il, ne doit pas être déposée le long du contour, mais sur le contour. Où l'on voit clairement que la couleur détruit le dessin. Je ne veux pas dire qu'Ingres pensait à de telles choses; mais je dis qu'il les faisait telles. Et cette séparation, cette opposition, je veux la nommer la pensée d'Ingres.[1]

Alain, *Ingres*

It is 1950 and the new director of the Musée National d'Art Moderne in Paris, Jean Cassou, brings out a volume in the collection *L'Homme et la machine*, directed by Georges Friedmann for Les Éditions de Minuit.[2] This is an influential collection, representing the cultural adaptation of an important sector of the Left intellectuals and the literary Resistance in France to the post-war world. Cassou's contribution is entitled *Situation de l'art moderne*, a subject wholly in line with his status as an experienced novelist, poet and art critic who, politically and aesthetically speaking, has been steadfastly on the good side of modernity and has established the authority to think through just such an ensemble of problems. In the title of his book the apparently insignificant lack of the definite article, 'La', before the word 'Situation' indicates something of the nature of his project, and perhaps more than he allows for. Cassou himself does draw attention to this little absence, – but only to the oddity or inappropriateness of the word 'Situation' rather than to its nudity. For him 'situation' implies 'je ne sais

116

quoi de stable et de configuré que l'on considérerait avec une sérénité toute objective' ('A certain indefinable sense of stability and shape which one would consider with a quite objective peace of mind', p. 114). Yet, he continues, ought one not to add the word 'disquiet'? With modern art everything is a matter of perpetual movement. Modern art is a disquiet that 'aspires to a possible situation', and to suggest that it has one already made for it is to foreclose on the discussion.

For us, I suspect, it is perhaps more rewarding to note that the missing article before 'Situation' turns it into a noun of process. This means that it is a gerund as well as a space, a disguised imperative as much as a place to be located or discovered. Situating modern art is a primary task or an obligation of the critic. To situate is to unsettle, to shift from one position to another, testing for effect, for decorum, for truth. It is to dis-locate. It must then follow that it is as much the critic who is the subject of disquiet, for it is the critic who can never fix a situation for modern art. Ineluctably, as if by a reflex, Cassou locates himself in that singular, unsettled tradition of romantic modernity which itself begins in disquiet, in that historic realisation of the uncertainty of semiosis which emerges in a nexus of texts where the short stories and musicology of an E. T. A. Hoffmann interweave with the aesthetic writings and disturbed urbanity of a Baudelaire. A nexus of dis-locations, as we have seen with Ingres' classic signs in Chapters 1 and 2.

Yet Cassou's reflex is conditioned not just by this tradition, which he has learned and introjected over three decades of critical thinking, but by the dense complexity of the political situation that he faces. At this very moment placing or situating modern art precisely is his major problem. He has a museum to fill with it, a new National Museum of Modern Art and, to put it plainly, none of these words, 'national', 'modern' nor 'art', may be used without contention. For Cassou, who is signalled a 'yid' by L.-F. Céline in his *Bagatelles pour un massacre*, this situating of modern art in a new museum may even be understood as a final phase of the Resistance, a cultural resistance to the chauvinism inherited from Vichy France and its deep history in the phantasmatic structures of a reactionary national culture – for which, as it happens, the name Ingres is such a crucial signifier.[3] Cassou has a museum of modern art to fill, and what he puts in it will become a history of modernity, situated in the Museum, in the Museum's own situation of France after the Resistance. His disquiet is a national disquiet about what should be seen in a National Museum of Modern Art, and also an historical mode of critical perception.

No less problematically, Cassou continues in *Situation*, spacing, being spaced or placed in modern, industrial society, is itself a process which for art founders on a double contradiction. Modern artists, he argues, do indeed have conditions of production and distribution. That is to say they work in a market, furnished with galleries, surrounded by followers of fashion,

immersed in snobbism. But it is not such an economic and social dynamic that sustains the production of art. Rather, he writes, it is out of the 'pulverising of bourgeois society by capitalism that the artist finds support and outlets, not in this society's spirit and in its coherent will' (p. 111). Michel Thévoz seems to be on the same trail thirty years later in his *L'Académisme et ses fantasmes*, though in a very different context. Writing of Gleyre's painting *Le Soir, ou les illusions perdues*, Thévoz understands this canvas as triumphing with the public even as the artist himself confesses his absolute failure in the face of that public, and even as it is his very defeat by and submission to that public which he represents in the making of *Le soir*. Thévoz, in order to delineate Gleyre's situation, refers this terrible impasse to Sartre's classic exposition of Flaubert's situation in his *Idiot de famille*:

> What Sartre said of literature applies exactly to this painting; 'one must write the work in order to miss it and to show that the greatness of literature is in its unreality: that consequently the greatness of the poet and his aristocratic character comes from his real failure and his non-realisation as the imaginary author of an impossible masterpiece, from the dissatisfaction and the passage to the imaginary, here so inseparably linked'.[4]

In this subtle location of what, at first sight, looks like a conformist art, as itself subject to and suffering from the rule of capitalist ideology, Thévoz enables us to reassess the complexity of Cassou's speculations and Ingres' eventual role within them. For in directing our attention the problem of how an Academic artist, or one who aspires to a certain conventionality, might nonetheless endure the same social aporetics as a Flaubert, he shifts our concentration from the narrow specificity of modernist art-historical conceptions of the radical to broader problematics of art's ontology. And it is precisely his rather easy assumption of such matters as a starting point that might make Cassou's choices seem rather quaint. So, Cassou asks, if his argument is on the right tracks, then how can it be that the styles that a modern art offers to society may be held to satisfy its needs if this society, as an ensemble, cannot recognise itself in these styles? Yet artists, in the very act of offering society their art, and especially to whatever newly emerging social configurations might follow on the convulsions of the post-war world, put themselves in the position of denying the conditions of modern art itself. They risk contradicting the contradictions which make for its freedom to produce. Stalemate. The ideal of an artist like Rubens, as being at one with his society and at ease in its systems of order, is no more than a dangerous myth. 'It isn't fatal that the artist be an outcast poet. On the contrary it is fatal that he aspire to harmony and to feeling happy in a happy society' (ibid., p. 113).

Cassou's discussion, which has by now shifted from analysis to a prescription as to what art must be, is a complex and fascinating account of the

growth of the belief in art's autonomy and its progressive detachment from and conflict with bourgeois values during the nineteenth century. It is very far from being a socio-ideological reckoning of the evolution of the double configuration of bohemia and avant-garde as the site for some self-deluding belief in an inherent antagonism of artist and society. Nor is it a belated version of the defence of art for art's sake as a necessary social relation, with the artist depicted as the member of some fifth estate, oppressed by all the other four alike. For, oddly akin to cultural theorists whose work is more commonly appropriated in modern art and cultural history, such as Theodor Adorno, he insists on the significance of a process of negation in defining what it is that art is as the representation of a relation of social forms and structures. The not-being-understood is constitutive of art as such, but only perceived insofar as it becomes socially symptomatic. This is to say that negation registers art's refusal of bourgeois social forms, but that it does so on the grounds marked out and forced upon it by that society. Quite unlike Lukàcs' notion of a socially replete, critical realism such as that of a Balzac or a Tolstoy, the art of the modern epoch is typically and rightly a displaced counter-affect of what has formed it.[5]

It is hardly surprising then that, also like Adorno, Cassou takes musical modernism as a crucial paradigm of the reworking of relations between means, procedures and affects in art. Though here, in distinction to Adorno, he places Stravinsky at the heart of a discussion on the contradictoriness of the modern implicated in the ways that its sense of reality is estranged from common meaning. In Cassou this echoes or re-sounds with the musical matrix of the modern that we find in the early nineteenth century, a matrix strung out between the overlapping classic spaces of Haydn, Mozart, Gluck, Kant and Beethoven on the one hand and the romanticism of E. T. A. Hoffmann, Mozart, Bellini, Berlioz and Beethoven on the other. But refracted through the perverse refusal or reworking of any such categories that is the writing of Hoffmann, this 'heroic' moment of modernity disclosed, as we have seen, at its most intensely ambivalent in the the *Revue et Gazette Musicale des Paris* and the *Revue Musicale de Fétis*.[6] And it is a stratum in the discursive histories of Cassou's own cultural situation and attitudes which marks his modernity as always and already cosmopolitan, Germanist and French at once, or as French only by virtue of its very eclecticism, and hence as bizarrely appropriate to the task of post-war cultural construction. Through all of this Cassou is riven to Ingres, who dwells in that same world of new combinations, and plays there on his violin some of the same tunes that Berlioz admired, if for what he, Ingres, at least hoped were a different reason, for a sublime beauty rather than for dissonance or disquiet. A beauty which, however, Cassou recognises as being of 'of a distinctive order'.[7]

It would have been possible to begin this chapter elsewhere in Cassou's history, then, to restage him and Ingres through each other, to show the difficulty in staging either. Indeed it could have begun with an exchange

of letters between Cassou and Edmond Jaloux in 1925 in which they decide to form a club for the diffusion of Hoffmann's and Richter's work in France, which will be called the *Brambilla Club*.[8] In their letters Cassou and Jaloux plan to instate Hoffmann at the centre of a radically other and yet central French culture, and Jaloux notes the curious combination of the Latin and the German that Cassou's fascination with Hoffmann represents. The significance of this moment would be its conjunction with the development of Picasso's neo-classicism, favoured by Cassou, but in a spirit wholly unlike that of the conservative critics such as Lapauze who saw in it the retribution of tradition for modernism's hubris. We could trace in this correspondence the separating out of a position on the relation between modernity and modernism that establishes in the disruptive and labyrinthine subversions of the Rhenish bizarre from either Surrealism or conservative modernism. And in doing so we would formulate a Cassou and an Ingres who encounter each other on a terrain of potential misrecognition that is to enable Cassou both to see Ingres' myths and to see through them – as an optic of modernism, that is to say, and so to generate a new figure, a third term, out of their encounter. In his *Ingres*, Cassou, distancing himself from Amaury-Duval's dislike of the painting, regards *Mlle Rivière* (Figure 41) for the structure of her oddity, sliding from the phrase I have just cited, 'a beauty of a distinctive order', to seeing her as somehow extinct as well as distinct:

> At first sight, there is a kind of frozen silliness in that face with the elongated eyes, the fixed smile, in the little head that evokes some kind of reptilian bird from prehistoric times. Concerted oddity has blended the face of a romantic keepsake with the artifice of the boa wrapped around the shoulders and the yellow-gloved hands. But our final impression is dominated by just this chord (combination). Then an extraordinary grace flows from the entire image ... so that we admit that this singular person might have been ravishing and that she appears even more ravishing to us through the taste and the will of the poet who reinvented her.
>
> (pp. 69–70)

Here, quietly, the Phidian reinvention and the Hoffmannian contamination slip together into a mesmerising unity or unexpected harmony of making art at a tangent to the kind of artist one is supposed to be.

Cassou, then, is out to discover adequate reasons for a belief in art as being at one and the same time a specific function as the very integument of social transformation at particular historical moments, and as what remains the recognisable and irreducible situation subtending processes of change. That is, as something both tied to and characteristic of a historical moment and transhistorical as the representation of a form of being yet never the

120

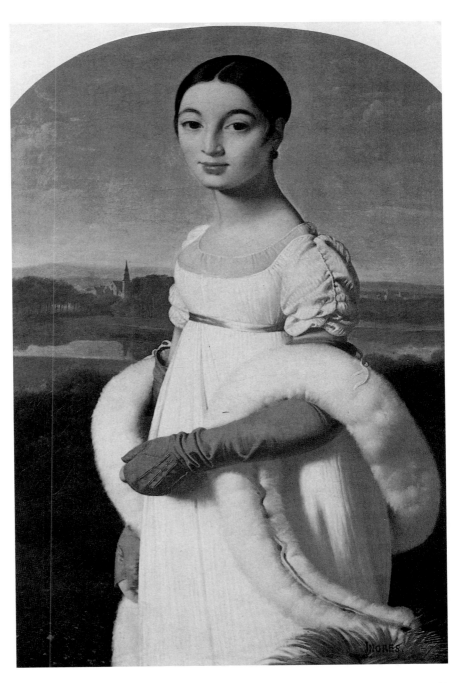

Figure 41

same as itself as a phenomenon. This is not quite the same as the couplet of the ephemeral/essential in Baudelaire's *Peintre de la vie moderne*, although it might share a theoretical space with Kristeva's belief in the sacred role of art in a secular society.[9] But it is to do with the relation between the condition of art as something which is physically made and the conditions of this making as what an individual does. The philosophy of Merleau-Ponty is, then, an unsurprising reference for Cassou in the anchoring of his text – even if he does not develop the connection. Ponty's left-wing and subtly rela-tivisitic materialism – his seminars made the headlines in the Parisian academic world of the late 1940s – is of the essence of Cassou's moment. And his capacity to rethink a being of art in the world, of and in perception, as in his classic essay on Cézanne, was paradigmatic for thinkers such as Jacques Lacan himself. But here I will have to leave the comparison in suspense, as does Cassou.[10]

Rather my purpose is to invoke its presence in Cassou's situation and then to pursue the traces between *Situation* and Georges Bataille's little book on Manet of 1955.[11] Bataille, as I have already suggested, wants to make Manet's indifference or negation to his subject the hallmark of his and our modernity – 'C'est la dureté résolue avec laquelle Manet *détruisit* qui scan-dalisa'; or 'Le *Déjeuner sur l'herbe* était lui-même la négation de ce *Concert Champêtre* [of Giorgione]' ('What scandalised was the rigorous resolve with which Manet destroyed ... The *Déjeuner sur l'herbe* was itself the denial of that *Concert Champêtre*', p. 59). And in this he establishes Manet's clear distance from what he sees as the ongoing pollution by tradition of Ingres, Delacroix or Courbet, to find 'l'*humanité* sans phrase' (p. 56). All of these others remain haunted by the pre-secular value of the object, the things and figures that used to make up a subject in the work of art for church and court. While for Bataille Manet's work is a paradigmatic passage to emanci-pation from the dead weight of conventional meanings, Cassou, on the contrary, has already found a form of supreme indifference, but it is in Ingres. If this is an indifference to all but the search for style, it is nonethe-less a true indifference, for such a search is also an escape from connotation, from the excess symbolisation of extrinsic value that is entrained by each and every conventional gesture, even though these gestures are none other than utterances in the vocabulary of the style he seeks. If, then, it seems to be valuable to bring together these two writers, Cassou and Bataille, it is in order to rework the grounding of the concept 'modernity' on a linking of Ingres and Manet not so much through what is gained in their work for some teleology, such as one of stylistic 'unities' or 'historical progression', but through what might be thought of as becoming lost in it. That is to say, a historical, or, as Bataille insists, *impersonal* process of the diminution of art's semantic functions. Or, better still, a displacement of the semantic to different matrices of the sociability of signs than that of manifest or conven-tional content.

One way for us to activate this relation, as I began to argue in my Introduction, is to deploy a broad and specifically geared concept of negation or of negativity. This, then, is to argue for a negation that falls outside the motions of an Hegelian dialectic. One that is neither wholly an active resistance, nor the effect of a passive dejection to the margins of legibility, nor indeed simply located on an axis between these poles. With Adorno in his *Aesthetic Theory*, to take but one formulation that might meet up with this requirement, the relation between art and nature and meaning manifests as just such complexity:

> Hegel's thesis, that art beauty originates in the negation of natural beauty, and thus in natural beauty, needs to be turned around: The act that originally gives rise to the consciousness of something beautiful must be carried out in the immediate experience of it if it is not already to postulate what it constitutes. The conception of natural beauty communicates with natural beauty: Both want to restore nature by renouncing its mere immediacy.[12]

If, with Bataille as with Cassou, we extend the concept of nature to include the 'natural' environment of art, which is 'society', negation's character is that of an ascesis, even anaesthesis, a cutting away from a situation to produce not a synthesis, but an unmeaning which in itself is a situation – of the very communicativeness of signs in modern society. Conceptually negation may be enlarged, as I have already proposed in my Introduction, by attaching it to the early Kristevan notion of the semiotic chora. This is done so that negation will now become not only a point in the syllogism of dialectics, nor just indifference, refusal or resistance, but a despite of intention, a lapsus, or an over- or an under-signifying, born of utterance out of a complexity so highly overdetermined that the outcome of its disturbance is never to be guaranteed. That is to say the negating gesture may, involuntarily, entrain its own denial, as if one had trailed one's hand in water and, raising it to find it cupped and full, were to see only the droplets coursing down its back. What Ingres or Manet accomplish is grounded in an excessive and highly fetishised immersion in what 'holds back' Courbet or Delacroix. Except that with the first pair what we can now call indifferent negation may flatten or attenuate the vigour of the symbolic in a kind of bulimic resistance to its full digestion, a fanatical persistence in the naming things *as if only surface*. With Ingres this might be recorded in either his classicising or archeologising detail, his following of rules so hypostatised in their immanence that they amount to a liberty from law that allows the truly bizarre to infiltrate his working. In Manet it merges across an isomorphically balanced or polarised excess of either populist or historical citation and improvising skills in the imaging of things.

These two artists imagine mutually complementary fetishes of the 'permanent' and of the 'transient' perceived through a process of obsessional denotation – a refusal of the laws of the symbolic in a singular, oxymoronic relation where Ingres does so in favour of an imaginary or mythic system, Manet in favour of the denial or the ironising of any such system. Curiously, in Longinian or Kantian terms such a rhetorical desublimation of the choric into form might well be thought of as the sublime, as an affect that passes by the controls of symbolisation without yet becoming allegory. What Ingres' and Manet's paintings are *pictures of* – in the sense of a form of thinking, implied by my opening quotation from Wittgenstein – is not quite the same problematic as it is with Courbet or Daumier. For we can argue that Ingres and Manet make pictures which think the unnameable kind of 'thing' that is a denotation or a situation in Cassou's meaning, whereas these other two painters persist in representing modern life as if it could be named. In Ingres and Manet, then, sublimity and desublimation differently coincide.[13]

While Cassou's writing now seems to be almost without any self-conscious theoretical perspective or meta-discourse – and I am anyway remaking it as I go along, translating it – it needs to be read as a 'period style' of cultural commentary. It belongs to a committed mode of art criticism which, as I have insisted, finds its roots in Heine, Hoffmann and Baudelaire. Rather than an analysis that takes a distance from its subject, it can be understood to represent an aspect of modernism's self-reflection from within the conflicted play of its situation – something all too difficult to envisage in the moment of total meta-discourse or vulgar deconstruction that we name 'postmodern', that often disingenuous master discourse of an altogether other mode of indifference.

In 1968 not only is Cassou's situation not out of date but it is even in tune with Situationism. Invoking Marcuse in his piece for *Art et contestation*, the famous collection of essays that characterises and sums up leftist cultural resistance to Gaullism in the 1960s, he goes on to develop his comprehension of art's *being* into a powerful attack on consumer culture as totalitarian in its invasion of human values.[14] Understanding art as the name for the contestation of *convenances*, and critique and imagination as identified with each other in the making of art, he sets himself apart from a reconciliationist or reparatory view of creation. In this he distances himself from an Academic stance of that very moment which reflects on how the sharpest differences in the history of art can be historically overcome precisely as a means of repairing historical trauma and healing difference in the present. Thus Emmanuel de Bondeville, *Secrétaire perpétuel* of the Académie des Beaux-Arts, in his address to the *Séance publique* of 29 November 1967, on the very brink of the great upheaval, called for a reconciliation of Baudelaire, Delacroix, Ingres and Wagner in the name, of all things, of the common ideal of a well-formed *métier* and a high level of

craft.[15] If, in the interests of dispensing with stereotypes, de Bondeville restages Ingres as the unexpected innovator and Baudelaire as the unexpected prophet, then he repeats the trope of their supposed differences, while really making a plea for the elision of any kind of difference in the name of a *métier*. Ironically he demonstrates the force of a system of connections that delude Ingres himself and that Ingres' name cannot but reactivate. While for Cassou it is making strange or rupture alone that offer a permanence of value for what we give precisely the name of art.

This is a critique that indeed puts him in a similar position to that of other theorists who have situated the problematic of art and cultural affect at the centre of their social critique, such as Herbert Marcuse and Guy Debord. In insisting on an irreducible ethic of capitalist society, which art must either humbly serve or set out to subvert, *Situation de l'art moderne* represents a significant passage in post-war reactions to newly emerging elements of mass culture that have been both disrupted and technologically transformed by war. As such it both accompanies rather than merely follows the crucial rethinking of everyday life that we find with a theorist such as Henri Lefebvre, and suggests something of an alternative dimension to the tortuous conversion of traditional cultures into capitalist modernisation.[16] Yet if Lefebvre brutally rejected the Baudelairean and Surrealist social critique, derived from what he understood as a system of Baudelairean insights into the mysteries of the modern city, as nothing more than an assault on the value of the critical concept of the everyday, seeing it as a pseudo-subversion that wishfully imagines itself onto some other shore of modernity, in the cloudy realm of the marvellous, Cassou both shares and refines his refusal. Lefebvre's contention may be read both as philistine, short-circuiting a complex problematic, and as rightly insisting that social transcendence can be neither fabricated nor willed through the desire to cross over to the other side. While Cassou, who was reluctant to acknowledge Surrealism from its very foundation, in part for a related suspicion of its voluntaristic Freudism – he wrote only one article concerning it, and that very late in his career – already represents this subtly other and rather special vector of modernity that is worked through Hoffmannism. It is one that engenders the pre-Freudian valorising of the uncanny out of Freud's own sources of inspiration and is, at the same time, a profound recognition that this condition is also the condition of commodity production and of industry. Or, in my own reworking of the problematic just outlined, the unconscious may be more or less identified with any utterance that does not intentionally seek it, and this hatching ground of the bizarre is of the greatest importance for our Ingres.

Ingres' name indeed crops up in the book on situating modern art, but only a very few times. Though it is just three years since Cassou published a monograph on him, a monograph in which the character of his descendance in modern art is an all-important figure, and Ingres has been at the

centre of his aesthetic thinking since the late 1920s. Here, in *Situation*, Ingres appears once to fill in the rather conventional-looking genealogy of great, modern French art, quite acceptable to a de Bondeville, as an element of origin along with David and Delacroix (see p. 195). And again, in a finely controlled passage of situating, to separate him from what we may conventionally think of as being pre-eminently his situation, that of bourgeois taste in the early nineteenth century. Or rather it is not Ingres' name that is spelled out on this occasion, but that of one his sitters, *Mlle Rivière*, whose image, whose portrait, Cassou tells us, is not an identity photograph. The matter at issue is the bourgeois attitude to what exactly is to be seen in painting, and the commonly made reproach that modern art has deprived itself of reality. For Cassou, nonetheless, reality remains modern art's secret and constitutive substance even in its absence, and whatever the individual work of art's appearance. The bourgeois, in confounding reality with resemblance, is unable to see this and voices the stock objection that 'l'art moderne ne fait pas ressemblant' ('Modern art looks like nothing we can recognise'). Cassou strikes back at his straw-man bourgeois:

> Resembling ... what? Reality. Let us be clear: reality as the bourgeois imagines it to be. In the bourgeois image of reality. Because one can only compare one image with another image. And art produces images. Would it therefore be with reality that the bourgeois claims to confront these images? Yes, that is what he claims. He claims, I repeat, to compare his aunt with the portrait of his aunt, a cow in a meadow with the image of a cow in a meadow. In which he is mistaken, since one can only compare an image with another image. Unless of course the image has been produced deliberately for the object represented to be recognised, as for example with a road map or an identity photo. This is not the case with a painting entitled *La route de Pontoise*, which is not a road map, nor with the portrait of Mlle Rivière, which is not an identity photo.
>
> (p. 54)

These days, as I have suggested, this may well appear a little simplistic. For we now know very well how to argue that a route map is a representation, cartography ringing with economic, cultural and political resonances, and that a police mug shot may as well have a punctum, a Barthesian thrill of unexpected and undercoded pleasure as might any other photo, as well as being an effect of any number of discursive formations of criminality and surveillance. And, even if Cassou knows all about Renault, 1950 is not that far from Barthes' discovery of the meaning of the Citroën DS, – another major turn in the relation of art and its meanings with industry and its affects. We also know from his book on Ingres that Cassou could not have

reached this formulation without him, yet, at the same time, that there are indeed some strangely direct resemblances between Ingres' work and the social classes whose destiny is to misunderstand it. Clearly we need to retain the problematic nature of resemblance, rather than reject it. But Cassou wants to inhabit a particular space of the modern and so to unravel a philosophical conundrum in the split between the bourgeois individual and social form on the one hand, and art's progress on the other. And he wants to locate this at the level of system and convention, the reality of signification, if not quite of language, as ontological. We are again reminded of the debates surrounding Merleau-Ponty.

What the artist does, Cassou suggests, is recognisable up to a point, and for the bourgeois, looks just as it should. A Corot or a Cézanne lugs all his equipment out to the 'motif', which makes for a very satisfying spectacle of artistic comportment. They set out to get experience just like you or me. But after that, similarity breaks down as the artist 'abandoned himself on canvas to an exercise with which we were no longer in agreement' (p. 55). The artist may, like you or me, be moved by the sunset, but for all that:

> what differentiates him from you, from me, from our concierges, is that he is a painter, and one who paints. Picasso summed up this problem in a very profound phrase: 'It is one thing to see, another thing to paint.'
>
> (ibid.)

Painting makes seeing unlike common experience, the artist is a painter *and* who paints. Art, in its transhistorical quality, and bourgeois society, work from diverging ontologies so that its appropriate specificity must go unrecognised. In an easy two pages, then, Cassou shifts us through what looks like a formalist reading of art's autonomy – albeit one situated in the wider ambiance of 'man' and the machine, and gets us all the way through from Ingres to Picasso. From an image by Ingres to a phrase of Picasso's. Not from one formal invention to its successor, but from one moment in the negation of a bourgeois idea of reality to another. Indeed this movement Ingres ↔ Picasso, as Cassou knows, is one of the major tropes of French modernities, conservative and radical alike, then and now.[17] Though, as we will see, Cassou deploys it only to twist its rhetorical functions in favour of Resistance and anti-traditionalism.

Now, then, it is 1947, and Jean Cassou, who has been director of the Musée National d'Art Moderne for just one year, publishes a book on Ingres. *Ingres*, it is called. 'Ainsi Ingres', he writes towards the end of the book, 'demeure-t-il un des noms capitaux de la pensée humaine, un lieu de pensée, un départ qui définit et explique' ('So Ingres remains as one of the great names of human thought, a place of thinking, a beginning which defines and explains', p. 128). A considered claim for the nature of thinking itself in

what after all is but one of Cassou's many books in differing genres from literary fantasy, novel or poetry to the theory of modern art. And between the two, *Ingres* and *Situation*, in 1949, he publishes a little picture book on Picasso where, in six pages of text, Ingres, with his 'disdain for the outer world' and his search for 'his ideal in excentric schools', figures as the master of Picasso's drawing:

> This time [1920s] it was Antiquity that inspired him [Picasso], or it was engravings from romantic magazines, or M. Ingres. This last meeting is worthy of notice, for it explains certain profound aims of modern art, which announcing the voluntary imitations of Picasso, acknowledged the supremacy of M. Ingres. Modern art placed itself under the influence of this man, who disdained the outer world, nature, reality, and colour, devoting his one passion to the search of style.[18]

Picasso's ranging over the sources of the modern is here subtly elaborated. Antiquity inspires him, for it cannot but inspire a modernity that belongs somewhere in Europe since the Renaissance or Enlightenment. The classic is tropic, always and already, no matter what quite it might denote, whether rejected or embraced. No doubt this echoes back to the problematic modernity of Ingres. But Romantic magazines themselves are specifically modern, and to be inspired by them is to belong to their world, which is also the world of the newspaper collage, the world of everyday life. To be inspired by them is to render them a figure for a making of art which is more than merely classic, which is also to renew art, both by lending them to its discourse and it to theirs. Ingres puts a stop to this movement and intention, imposes a limit which is a means to acknowledge and to realise the true objectives of the very process of art. For Ingres, because of his disdain, belongs neither to Antiquity nor to reality, but alone to the singularity of their synthesis into style. Ingres' study is the negation of learning, the outcome of the splitting embedded in Picasso's own phrase, 'autre chose est de voir, autre chose est de peindre'.

To introduce a more dramatic dimension, the particular affirmation of art that this entails, we might argue, brushes along the grain of the Faustian renunciation of moral good. For to engage in style is to renounce a literally moral relation with the world in favour of one with the surface, with the logic of art itself, an end to pursue irrespective of what the painting will eventually look like — a mythology, a scene from history, or a bourgeois sitting in his armchair. Recall that not only is *Mlle Rivière* not an identity photograph, but she is so white that she can represent nothing if not the artist's desire for originality. This originality is manifested in one way and one way only, in the application of white paint, and if this looks like an insult or it's been done with a duster, originality anyway finds its figure in

this white with its mucus undertone. 'A painter, and who paints', is what Ingres might have been in 1806, and given this history the phrase is emphatically one which does not mean the same kind of thing as 'art for art's sake'. Of course, then, in Bataille's terms it all adds up. An artist like Courbet, extolled and condemned precisely for his ensnarement in morality, for this very reason cannot be fully modern, for all that he wanted to be 'a painter, and who paints'.[19]

In this account of mine, my abuse of Cassou's, Ingres is pre-inventing Adrian Leverkuhn's modernity of the great chapter 22 in Thomas Mann's novel *Doktor Faustus*. Sickly and systematic at once, Ingres' repetitions both at the level of cycle or theme, and of details (at the level of surface) come to look like the work of an artist impelled into the purest of meta-discourse; an artist no longer responsible for his own status as an effect of some set of social relations that embody themselves in his intention, but working at a limit where his procedures, however they are intended, may not necessarily make sense of such relations.

Baudelaire's Delacroix can hardly approach this order of indifference, concerned as he is with the correspondence between making art and the sensuous reality, with the conservation of a transcendent essence in art's making, rather than by its (re)invention through the laws of art. Baudelaire's sensual correspondences might, as I suggested in Chapter 1, after all be read as a philosophical restatement of *Paragone* as synaesthesia; a Wagner-inspired discourse on the specificities of the arts unified in an overriding, sensory relation to some kind of a hypostatised nature – rather what makes Adorno fret over Hegel. This image may be thought of as regressive or even as fatuous precisely in that, taken at the letter, seeing and painting would become one and the same thing, just as would any other sensation and its expression. Baudelaire's desire to recognise a material and indissoluble relation between sense and representation is, perhaps more than the codes of recognisability, likely to please the very bourgeois whom his bohemianism so deeply offends – and indeed the duplicitous coupling of simple analogy with social alienation has left Baudelaire at the conventional origins of modernity. I have already cited a caustic passage in the 'Overture' to his *The Raw and the Cooked* where Claude Lévi-Strauss destroys the philosophical pretensions of 'musique concrète', a passage which might perhaps enable one to read Baudelaire without his redeeming irony as an author, ironically enough, overinvested in reality and insufficiently in the abstraction of myth. Perhaps, then, when Baudelaire reads Ingres as dry or 'maladif' it his own lack of or desire for dryness that he senses rather than the painter's. Ingres' dryness may then be thought of as nearer to Schoenberg's difficulty than to Stravinsky's desire to please. There is no irony in this, for it happens that the 'desire to please' is amongst the most vilified and passionate of Ingres' hatreds, seen by him as a sure sign of the departure from ancient models and

of an inappropriate submission to appearance. Thévoz again produces a formulation that we can draw into our argument:

> Ingres does not escape the generalised double-bind that we have demonstrated, but he knows how to play the terms off one against the other. He cultivates his style as revelation of a latent reality, so as to divest appearances of their ontological weight and to restore their original secondarity.[20]

This rather Lockeian relation between materiality and its sense-data is something which Thévoz sees as especially true of Ingres' portraiture. His insight, that the cultivation of style as ontologically dense relieves appearances of their material weight and restores a secondarity proper to appearance in itself, which is anyway already discursive, ineluctably leads us to the irony of Ingres' immersion in the real and the inseparability of the terms 'real' and 'nature'. Insofar, that is, as Ingres seeks a latency that is wholly an effect of discursive interactions, then his being as a subject of those discourses is itself profoundly material and highly specific. His being as an artist belongs to the ontology that Cassou so deftly draws from Merleau-Ponty as surely as does that of Cézanne. Cassou's figuring of Ingres' indifference has positioned him in a different kind of nineteenth century from that to which we are habituated – so now we are reading Cassou as if we were Cassou reading.

Let us for a moment let us try to get closer to what this might mean, and to why, within this generic construction of the modern, Jean Cassou might have been both more bold and more accurate in his tracking towards Ingres than was Georges Bataille in his turning from him – a confrontation which is at the same time what I see as an exploration between the pre- and post-Freudian theory of the uncanny. And, as another starting point, let us take what Thévoz calls the 'apparently most *ressemblant*' of all Ingres' portraits, that of *M. Bertin* (1831), an image to which both he and Wollheim dedicate some eloquent pages (Figure 42). We will not spend even a moment with the anecdotal history of the work, so essential for a psychoanalytic reading, the story of the complicated reversal of power between the miserable, cautious and unsatisfied artist and his calm, almost motherly patron-sitter, who sees him through the ordeal of yet another unsought-for engagement with the sociabilities of modern life, the travails of doing portraits when he would rather be at the major themes of historical painting.[21] After all, it is by now to be expected that an artist who rejects the *Revue de Paris* and a worldly, bourgeois editor – the *Journal des Débats*, M. Bertin's review, also translated Hoffmann – at the heart of the modernity of publishing, will find it difficult to see eye to eye even in that most regularised of professional situations that is the sitting, and that the balances of power between them will be terribly unstable, despite their friendship.

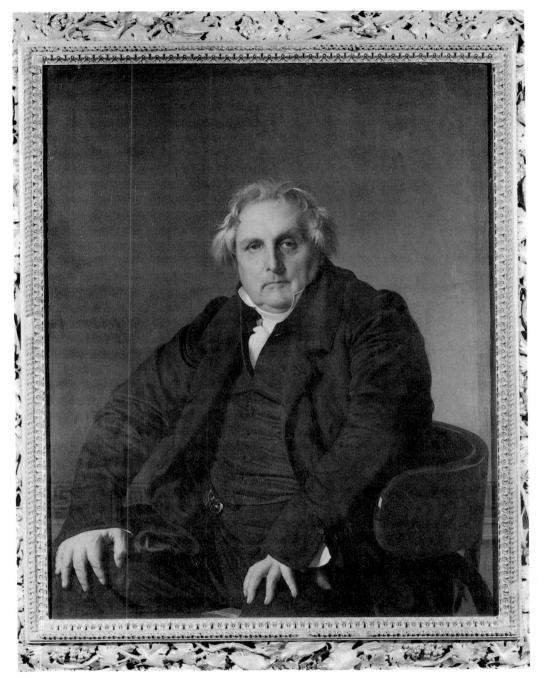

Figure 42

But I am far from certain of this strategy of mine. I want to restage the problematic once again, of readings and lives, lives of artists and of viewers, projecting Ingres and his painting into a wholly contemporary ontological problematic. This is an ontology of differential subjects and identities that follows from identity politics in our time, and the mode I want to use is one of what we call queering or gaying as the episteme of this mode of being. But these must now be queer or gay readings that are themselves tainted by Cassou's problematics of looking and of being, already trapped in histories that are not quite theirs but which nonetheless *are-differently* in the spaces of cultural history. What now follows is an excursus within a chapter, an essay in such situating. It has its own title and reworks some of the materials I have already developed – not to produce a gay reading of Ingres or his work, but to see what becomes of our problematic in the light of this wilfully anachronistic projection, this gesture of welcome at the shadow of the archive, this speculation in ana-historesis.

The High Window (parable and excursus)

this same thing I would want today I would want again tomorrow.
<div align="right">Bob Dylan, Boots of Spanish Leather</div>

Our undertaking will have two aspects. In the first instance we will study the status of the poetic signified in relation to the signified in non-poetic discourse (the discourse of everyday, oral communication will be considered as the type of non-poetic discourse). At this level, which we will define as intertextual since it is a matter of comparing types of different text, we will try to show how the relation of true–false, positive–negative, real–fictional is realised in the poetic signified.
<div align="right">Julia Kristeva, Sémiotiké</div>

It was only when it began to appear to me how desolately my endless work around the artist Ingres had been lacking in gay issues that I embarked on this piece of writing. Alas, the means of gaying Ingres are either terribly obvious and not very interesting, or if they are interesting, they have already been rather well dealt with by Carol Ockman and Wendy Leeks. Anyway, did he or didn't he sleep with his friend the sculptor Bartolini, with whom he seems to have spent much of his time during his first stay in Rome, and to all appearances at the expense of his wife? And if he did, does this make his numerous male

nudes, painted or drawn, homoerotic in the making as well as in the reading? And anyway, if we accept the theoretical propositions of the critique of the author function outlined say, by Barthes, does it matter? And then again, why should such an interest only arise in the presence of the male nude such as that great camp-kitsch icon of the nineteenth century, Flandrin's *Figure d'étude*?[22] Or the figures in Ingres' own *The Envoys from Agamemnon* (1801)? To cut a long story short, I decided to take a painting by Ingres where such an interest is far from evident, and to do two things: to tack a gay approach onto it quite arbitrarily and to see what happens.

Of course this is neither disinterested nor without some preconception of how things will turn out, although the writing and the initial, live deliveries of the 'story' yielded a number of surprises. I can't escape a growing conviction there is nothing more interesting than a mystery that remains closed to resolution. The most dismal form of iconology is that which offers us nothing more than the final solution to some problem of meaning, a hermeneutic of exhaustion and closure. While a Derridian take on the problem of meaning, even if it should not be abused as an alibi for meaninglessness, constantly reminds us that decoding and framing cannot be taken apart from each other and that there is no end to the problem. If I have borrowed my title for this excursus from Raymond Chandler, it is to insist on a particular value of his writing, which is invested in the emotional inconclusiveness of his mysteries, of their *dénouement*, their residue of profound dissatisfaction left over by the always unresolved anxieties of the narrative, even when the crime is fully revealed; and to engage with a viewpoint as a point of falling, as if from a high window.

Clearly this is at the same time a technique for the practice of *différance* in the Derridian sense, which I try to work through the repeated comparison of one problem or problematic to an apparently illegitimate comparator. As far as this strategy of planned misrecognition goes, you may argue that it has more to do with paranoid criticism than with the social history of art. Nonetheless my enticement is with the construction of analogies between materials that don't appear to belong to each other at all as far as the orders of their production, articulations and sites of reception are concerned. The allure is polymorphous: the strategy allows materials a quasi-aleatory interaction with one another rather than through the hierarchical exercise of a given authority, of theory over experience, for example; or of history over anecdote. And it tests and undermines method's virtuosity in

allowing it to work on, speak of or through materials that refuse it, so leaving it with a quite peculiar sense of its integrity, its flexibility or its undoing.

So this excursus involves a story about three men styled around the model of a gay pornography, who get muddled up with looking at Ingres' portrait of *M. Bertin*. If the argument deploys a sexual top/bottom coding as the analogy for other elements of analysis, this is because of its significance in pornography as the site of a fracture between certainty and uncertainty, of an undoing or a self-composure which is the finding of a true or other self, the (in)stability of role, the knowing construction of desire. That is to say, it provides a happy conjuncture of the banal with the theoretically elaborate, and, incidentally, in this conjunction, a model for the relation of the poetic and the non-poetic that is both in the space between pornography and art and in that between an artist and a model as the painter paints.

Thus we are largely concerned with a relation between the sign and something that we might signal as an unconscious, which is at the same time the very sociability of the sign itself, and here I intend to deploy the Kristevan notion of a semiotic chora as a baseline, as an analogy for the whole ensemble of social and of psychic forces which in their invisible interaction form that which is the repressed of a given form or instance of representation. As Kristeva puts it:

> If the theoretical description of the chora that we are pursuing, follows the discourse of representation which gives it as evidence, the chora itself, insofar as it is rupture and articulations – rhythm – is a precondition of evidence, of spatiality and of temporality.[23]

If she convincingly insists on the chora as that which is only known by its symptoms, which are identified with modes of consciousness, nonetheless I want to start out in discrete conflict with these profound and difficult passages, cited here and in my epigraph, essentially by taking my materials the other way round. I begin with a clear and striking example of her theoretical problem, but one that is very much an instance of the non-poetic, a little sample of everyday, verbal communication, and then proceed from this to a more general theoretical analysis of the relation of the non-poetic and the pictural via the construction of anachronistic juxtapositions that are the lifeblood of identity politics.

And at the same time I want this example to be as far away as possible from the central figure of my discussion, which is *M. Bertin*, who was one of the most distinguished of a new generation of a

powerful bourgeoisie at the time of the post-Napoleonic restoration, editor of the all-important *Journal des Débats*, and hence in his own way every bit as important for the articulation of modernity as Baudelaire the poet. Michel Thévoz, in *L'Académisme et ses phantasmes*, signals this when he compares the Ingres portrait to the first volume of Karl Marx's *Capital*. My comparison will be both more modest and more distant from this figure of middle-class manhood than *Capital*. As I have just suggested , it has more to do with my trying to elaborate a subject position from within a critique that one could call 'gay-regardless', an exemplification of the 'and if ... and if' technique of discourse.

Brad and Scott, in a brief conversation about desire; Tyler listens in

This conversation takes place in a gay leather bar, and from the names Brad and Scott, you will recognise that the narrative is one typical of a certain genre of American gay pornography, especially that published by Bad Boys Books of New York. I will set the scene, the story so far. Brad and Scott cruised each other several months before, and since then, after an initial, backroom session of interesting, pretty rough sex, have had a kind of uneasy friendship punctuated by one or two desultory attempts at a full scene. Brad is a fairly committed top, if sometimes a perplexed one, and Scott is a bottom, – they wear the same colour handkerchief in opposite pockets. But Scott is one of those very powerful bottoms capable of remoulding a top in his own image, and this has disarmed Brad who has, as a result, possibly of projective identification, made the mistake of falling for him. He feels, if not defeated, then at least disrupted by the encounter, which, and we have to face up to it, has been something of a 'failure'. Or rather, and it is here that pornography, with its treating in stereotypes and their boundaries, can be so good at tracking the innervations and irritations of identity, it has been not so much a failure as a failure of nerve, of self-realisation, of projection. If Brad is apt to such a radical investment in the suffering that his encounter has caused him – and I insist on the encounter as the cause, not Scott, who really is the kindest of men – can he still think of himself as a top? Should he even wish to cast himself in this position? Has he not revealed, at least to himself, his capacity for suffering in a mode that enslaves him to another, and is his open symbolisation of his identity not now out of line with what he feels? 'Dorian Gray had an easy life compared to this', he inwardly

remarks, reflecting that he and Scott seem to have got into a real double-bind, but with no one left to untie the knots that they have made for themselves.

Anyway, this is the disturbing chain of thought – for Brad is an intellectual as well as a porn-star – that obsesses him when he bumps into Scott quite by chance, or rather not by much chance, because if either of them goes out to one of the three leather bars in the city where they live, there is a one-in-three chance that they will meet. By accident, or not quite by intention then; and he knows from his own network that Scott has been offering himself to some of the best young operators on the scene and has commented freely on their various skills. And he, Brad, is beginning to fantasise about this, but with each wandering of his fantasies, it turns out to be Scott's experience that he wants to have. So not only has Scott, or rather the meeting with Scott, been a cause of the beginnings of Brad's self-questioning, but Scott has now become for Brad an image of his own, new-found sense of lack. Brad is beginning to want to become Scott, and Scott is the cause of this desire.

They talk, pleasantly nonetheless, fluently, in the darkened bar, casually leaning against the cage. The usual stuff, a new singer at the opera, a startling revision to the theory of avant-garde cinema, some gossip concerning someone else's sexual history. Then Brad says this:

BRAD: I want to make a proposition to you.
SCOTT: Uh uh?
BRAD: If we ever have sex again, Scott ... if you feel like it ... and it's entirely up to you ... and when you feel like it, now, next week ... or in ten years' time? I want you to top me.
SCOTT: No, I'll never do that for you ... nor for anyone else, ever.

The reply is immediate, sharp, definitive, yet Brad does not recoil. In a half-formed insight he begins to sense that the condition of becoming Scott is indeed to become himself, different and same, same and different, that the self is an indifferent matter insofar as it is nothing but difference. If I had written this novelette rather than plagiarising it, Brad would have put his thoughts into terms that play with the relation between the two rather technical philosophical terms of negation and denial, and we will come back to this. But now I have to tell you that these two guys are with a third man, Tyler, who, as luck would have it, is also an intellectual, a high flyer from art history or cultural studies, I imagine – after all this is just a story that I have poached and chosen to comment upon. Tyler is an addictive listener-in, well used to

hearing other people's unguarded slips and confessions, yet he is so struck by the intensity of this brief exchange that he begins straight away to reflect upon it. Tyler's reflections form the basis for my own.

It's not so much the surprise of Brad's confession that takes Tyler's breath away. He had been waiting for something of the kind to happen, certainly for longer than Brad himself. After all, as a good post-Freudian, he recognises the compulsion to metonymy that drives all sexual desire, and as a good post-Jakobsonian he knows that metonymic slippage powers the chain drives of language. Tyler notes that Brad's obsession with Scott indeed has all the makings of a projective identification, that ultimate refinement of the metonym. Tyler also knows that to bring these two forms of knowledge together, Freud with a communicative theory of language, is probably the greatest of Julia Kristeva's achievements in the earlier stages of her work. As an admirer of *The Revolution of Poetic Language*, he is prepared to read deeply into any semantically and rhythmically complex utterance, be it poetic or non-poetic. What now takes his breath away is the triple density of Scott's expression in his brief reply, the semantic chain, and with it, the grammar, the grammar's rhythm.

Did or didn't Scott think to lighten the blow? Scott says, ' No, I'll never do that for you', and then there is the slightest of hesitations; perhaps he realises that he might be hurting Brad for whom he has real affection; and in one of those lightening connections that we make, he recuperates the damage – 'nor for anyone else'. But this might or might not be the case; he might just mean what he said. Either way it's too quick to be intended, planned or reflected, and so the sentence is emphatically dramatic, its drama embodied, physically present in its incantatory yet broken rhythm, the 'never' to the 'ever', the sweeping recuperation of Brad's more stammering, rhythmically free and so more strictly, in Kristevan terms, modernist proposition. If Scott denies Brad, it is so as not to negate himself, and the tension seems to be quite understandable. Dramatic too because it takes Scott across the abyss from the particular to the general, from a simple assertion, refusal or marking of a personal desire, to a legislation; from 'never for you', to 'nor for anyone else, ever.' In insisting on his own being as a bottom, Scott assumes that of the top both in his refusal of the other's expressed desire, as well as of the desire of any other who might express it, and in his forbidding of himself to be other than he is, denying the possibility of his own negation. In one short breath Scott both denies that great discovery of the poet Rimbaud, 'I am an other', and he professes it anew, 'I am what I am', and 'I will be

what I am', with all the rigour of the god of Abraham; and, in saying this, I will make myself be what I am, I am another to myself in enforcing the exclusion of another self.

This is, if you like, a conundrum of identity; identity is nothing if it is not difference. But identity fragments into pathology if its founding in difference is acknowledged. And this pathology is nothing more or less than the fracturing of the imaginary Cartesian or Kantian coherence that is the self-willing bourgeois subject, itself the presiding demon of cultural theory in the period since Althusser and Foucault shamed it into silence. Scott holds together an identification (with being a bottom) in face of the radical difference between his and Brad's identification (with being a top), as if to acknowledge difference were to undermine what difference indeed secures, and this crisis is precipitated by Brad's offer to switch the position or direction of identifications. Kristeva, in *Sémiotiké*, offers us a gloss on this scene: 'So, whether it is constitutive attempt at the process of symbolising, or an internal operation of judgement, negation in the universe of speaking (of the sign) banishes the denied itself (the other) from discourse' (p. 189).

Now I, that is me, as distinct from Tyler, find that this short extract from a pornography – for, as you will imagine, in this kind of book, there will be sex within the next two or three pages, every seven pages to be precise – I find this extract to be a perfectly luminous example of the motions of desire in language, or the relation between the materials of consciousness and their rendering as semantic. Like chora these materials are only known as symptom, this is to say as *sèmes*. There is whatever these men have become; this has evolved through complex relations between the drives and the histories of their nurture, their disciplining, their flowering and their frustrations; the men's families and their schooling; the evolution of social mores and their various identifications within and through what we call the politics of identity and all the distinctions made between each other and themselves and other groups of gay men, the various modes of symbolising desire; and through this, over this, under this the motions of desire as that which is overdetermined, as that which is overdetermination, a motion undetectable except in utterance. There are the possibilities and the constraints of utterance, in Scott's case he responds to Brad with a highly complex performative that, in pointing to himself, to what he is, actually contradicts itself and, at the same time solves, if only for a moment, the relation between singular utterances and universal moral law. A self-contradictory performative is, we might say, Scott's truly creative contribution to language, his breathing against the choric

remnant so that for a moment we hear the babble of subject forma-tion. Kristeva thinks this through in terms of Mallarmé rather than pornography. For example:

> One could suppose that the syntactic function comes into play as soon as a break manifests itself in this infinite and free semiotic rhythm: a break that we have evoked in speaking of the thetic, and which introduces the division between the drive and the sign, the *censure* (caesura) between the signifier and the signified, and the possibility of denotation.[24]

But I have here chosen pornography to stand in for what we call expe-rience as an Other to theory and literature, to see if this exchange at the level of the everyday is capable of sustaining an evaluation comparable to that of a poem.

If it is, then my parable can work.

BRAD: If we ever … have sex … again … Scott, if you feel like it … and … it's entirely up to you and when you … feel like it … now … next week, or in ten years' time, I want youtotopme. [free verse, everyday speech, Mallarméian, vernacular]

SCOTT: No, I'll never do that for you, nor for anyone else, ever. [Classical rhythm, pre-modern, in the mode of Racine]

To forbid oneself to be another, but to be an other of one's veto is the aporia that signs both the emergence from chora and the immer-gence in chora. The interdependence of these two desires is like a lighting effect where the source and the object are identified with each other, the double structure of the Lacanian gaze as the object and the subject, the illuminated eye that sees the light from behind it as if it is an object before it. Thanks to Tyler's insatiable appetite for theoretical diversion, we can now take a sidestep to the Louvre, halting only for a brief reflection on the history of art.

The high window

When we speak of reading paintings, how can we, can we read them like I've been reading this exchange? Or is it better to think of listening to them? These are the thoughts in Tyler's mind as he listens in, the intellectual on the margins, distracted by paintings when he tries to think about men, by men when he looks at paintings. His eyes scan

the scene, the reddish light casting shadows in the leather, the serially arrested gestures in the stroboscopic beams. The gestures are visual expostulations from some genre painting of the 1830s. But they are scarcely framed or even unframed by the curious warping of the bar space; a distortion that derives from the sexual cruising of his eye – which now prioritises a distant figure over the friends he drinks with, now prefers the periphery to the centre as he scans the *étalage*. Tyler feels as if he were floating in a warp as sometimes he does in an art gallery, negotiating the difficult spaces in and around a painting. With what, he wonders, is the painting an exchange, or is it always and already an exchange, but still with what and at what moment? And what in it is an exchange, articulation in complex difference of the signs through which a never truly existing nature, as a sign, is transformed into human culture? For example!

His thoughts, my thoughts, drift to Richard Wollheim's chapter on Ingres in his *Painting as an Art*. Here Wollheim brings together three bodies of material concerning:

- Ingres' biographically established relations with his artist father and his declared feelings for the man.
- The Kleinian notion of projective identification, and Ingres' way of taking a part of what he constructs in his works in substitution for his desire.
- The consequent very strange spatial distortions of Ingres' work which mark different compositions and subjects and which cannot be accidental, so carefully does the artist seem to plan them and vary them (Figures 43 and 44).

Wollheim comes to see this spatial tearing, taken with the thematic elements or story-lines of the paintings, as what he calls the *melting of the father*, a complex psychological process of simultaneous assimilation and destruction. *M. Bertin*, Tyler remembers, is one of these images; so, as he looks back, or sees Brad and Scott again, beautiful in their leather and latex layers, he notes how their bodies are as encased as was Bertin's in his worsteds and batistes. Briefly in his mind's eye he tracks the folds and overlappings, the elaborate seams and textural contrasts, and strangely, the three men, Brad, Scott, Bertin, begin to melt together ...

Yet what troubles Tyler is the nature of Wollheim's dependence on the whole image, on its eventual narrative integrity, a structure of argumentation which he shares with most historians and theorists,

reactionary or radical, feminist or queer. Why, he wonders, is the painting taken as eventually the sum of its parts, or its parts as metonymic shifters between the social and the image? What if the painting were less than its parts, or one of its parts, just as Brad and Scott, however lovely, are momentarily less than the strange syntactic rhythm of their little conflict and its floating in the microcosmos of sexual choice? Art history, he worries, in its concern for the whole-ness of an utterance has, perhaps, confined the level of semanticity to being articu-lated in whole signs or stories. If these can be assigned to referents, however complex, we are stuck with semiotics as iconography. Yet we know also that all kinds of drive or of desire can be otherly symptomatised, and that an aesthetic or an obsession with an aesthetic may emerge as form through signs that bear no resemblance to its conventional figurations.

Figure 43

Along with Ingres' *M. Bertin*, then, Jacques-Louis David's *Mme Récamier* or *Marat* spring to Tyler's mind at this moment. While the

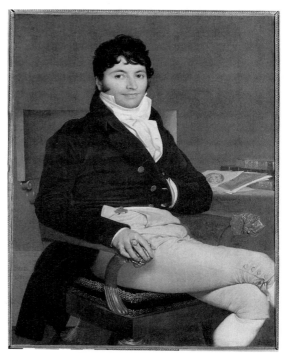

Figure 44

latter two, art-historically speaking, prepare the painterly possibility of the former. With their great, richly vacant backgrounds, their myste-rious Lacanian light, in which the subject, you or me or Mme Récamier, seems to be the source, glowing in the dark, it's ridiculous to think of that light as falling from some hypothesised outside of these images,

or from some unified direction. In this they are not at all like their successor. And this unlikeness is not just a matter of the subject, of the revolutionary hero or Directoire woman reduced to bourgeois man, but it's rather more syntactic, or rather it is more disclosed in a syntactic failure or exaggeration of *M. Bertin*. A failure in the painting, as we will see, and a fissure in Ingres' lightlessness, which we have already seen in *Paolo and Francesca* or *Antiochus and Stratonice*.[25]

For in *M. Bertin* the light has a shape that is altogether more formal than Ingres' usual effects, an attempted reality effect we might call it, and it is here that it fails or fissures. So let us take the apparently most 'ressemblant' of all Ingres' portraits. My attitude to it has recently undergone a change. A few paragraphs above I wrote like this:

> We will not spend even a moment with the anecdotal history of the work, so essential for a psychoanalytic reading, the story of the complicated reversal of power between the miserable, cautious and unsatisfied artist and his calm, almost motherly patron-sitter, who sees him through the ordeal of yet another unsought-for engagement with the sociabilities of modern life, the travails of doing portraits when he would rather be at the major themes of historical painting.

Of course now the parallel between Ingres and Brad makes the anecdote more interesting. And now I suspect that, in the light of the relation between Brad and Scott, that of Ingres and his sitter might be adduced as an element of evidence – evidence in the Kristevan sense of presence – in our reading of the portrait. So let us resume it. In a first version Bertin was depicted standing, with one hand lightly leaning on a table, a more Napoleonic pose, even a domestic form of Ingres' own *Napoleon as First Consul* (1804) (Figure 36, p. 99). In the event, dissatisfied with this and wracked by doubt, Ingres substituted and completed the seated posture, which we can see as being both closer to a figure such as that from the ancient *Hercules in Arcadia*, like *Mme Moitessier* herself and as an even more radically domesti-cated rendering of *Napoléon on the Imperial Throne*. 'In itself' and 'in its context', then, the painting authorises some quite specific and some rather general versions of its author, that are only tangentially of him, if only because they are tropes made flesh.

In the earliest writing on Ingres, such as Amaury-Duval's *L'Atelier d'Ingres*, the mise-en-oeuvre of *M. Bertin* puts into motion an inconsis-tency between the artist as being in full possession of a transcendental

accomplishment and the artist as merely a (hu)man before the awesome nature of his work. In Amaury-Duval the narrative of Bertin's making contains two short scenarios, Ingres' own account of its making and that of M. Bertin himself. In the first Ingres, brushing aside his wife's remark that 'he always has to start over again', tells Amaury that despite Bertin's wonderful quality as a model he had to inform him that the sittings were lost – 'I was desolate, but I had that courage.' Bertin kindly tells him not to worry, to relax, that he will be at his command, and this puts Ingres so much at ease that he finds the pose. Later Bertin, who has invited Amaury to dinner, confirms the broad outlines of the episode, adding that 'He [Ingres] wept and I spent my time [in the sittings] consoling him.' They agree that he will begin again. Then:

> One day Ingres was dining here and, as today, we were taking our coffee outside in the same spot; chatting to a friend, I was, it appears in the pose of the portrait. Ingres got up, came close and speaking almost in my ear said: 'Come sit tomorrow, your portrait is done.'[26]

The residuum of these scenarios is not so much the betrayed secret that Bertin is positioned to reach his coffee cup, but rather the reinventing of a conflict that we might see as being a dominant trope of the writing of the artist's personality over a very long duration; the trope of frustration of inspiration caught in the mesh of a quotidian (the coffee cup) that it must transcend. But as a story about this artist, it is also an unresolved conflict between an Ingres who both invents a moment in the history of pictorial style and yet conserves the great, Davidian tradition of portraiture in French art, and an Other Ingres who belongs to an altogether much lower genre of social comedy. For while the first is set to become the living master and memorial of the ideal of a national, classic style, the second is a figure of childlike and impetuous simplicity. Bertin, with an almost motherly concern, sustains Ingres through his crisis, until he becomes at once both man and artist. And then there it is, this supreme image of our modern world in its unfolding.

But still, rather than concentrating on the social history of the image, which could be perfectly constructed on the model that Carol Ockman has so well executed in her study of the *Baronne de Rothschild*, let us engage with Thévoz's notion of the ontological weight of appearance, but reduce its immediate scope. Thévoz sees the wild empiricism of Bertin, the detailing of the clothing, its representation as symptom of

the body, as being almost 'soft art avant la lettre', and above all an opposite to the 'effect of the real' which is the requirement of academic art with all its redundancy of detail. On the contrary:

> Ingres explodes the device of redundance and uses this public persona to reveal all the subterranean forces which shake his own historical and social space. We will willingly situate the effigy of M. Bertin with regard to Marx's Capital as an enterprise analogous to a 'symptomatic reading' conducted in the plastic register.[27]

Of course this claim is as attractive as it is excessive. For its conviction it depends on the traditional and generalised acceptance of Balzacian realism as a precursor of Marxism at Marx's and Engels' own word in their reflections on that author. My own argument around the *dispositif* of *étalage* makes the same kind of claim at a different order of representation of the bourgeois world on the one hand, and its interference patterns in art on the other. At the same time the idea of the painting as itself a symptomatic reading returns us to Cassou's and Merleau-Ponty's materialism, Ingres working through and against a restrictive *dispositif* as a material for the actualising of his image. While it also reminds us of how Tyler listens and looks in the bar, taking all as symptom and symptom as actuality. In the paragraph Thévoz himself also goes well beyond his preceding yet eventually more radical argument that Ingres, in seeking the final form for Bertin *before* he can finally and successfully sit him, – and here the anecdote of the making is crucial evidence – reverses the relation of reality and image in this portrait:

> [he] reactualises in a certain way the 'mirror stage' which requires the subject to model himself on his own image as perceived as other by others – for which it merits more than ever the name 'model'.
>
> (p. 153)

Truly convincing, this suggests how we might go into a different envisioning of *M. Bertin* as representing painting's aporia, which is also its condition and its means, and also a conundrum like Brad's and Scott's interference of identificatory processes. We will begin with a more or less formalistic regard on the distribution of a few reflections. In fact these are an effect of what we have already problematised as the source of light in the picture. The two most striking reflections are those on the edge of the chair to the right of the image, and in the eyeglass at M. Bertin's fob. This is a reflection which occurs in a

Figure 45

Figure 46 *Figure 47*

number of Ingres' male and female portraits, making it appear as an accident of fashion and necessity. *Mme Marcotte de Sainte-Marie* of 1826 and her husband, *M. Marcotte* (1810), are conjoined across time by just such a reflection, so maybe, if it is a matter of fashion and necessity, it is one of their long term, and is not just a matter of moment nor quite a matter of social class. Robert Rosenblum, who is attentive to these appearances, whereas neither Wollheim nor Thévoz in their more epic discussion of the psycho-spatiality of *M. Bertin* are not, has this to say (Figures 45, 46 and 47):

145

> Not only is the replication of wrinkles, hair, and folds of clothing astonishing, but, as in Napoleon I on His Imperial Throne ... even the mullioned window of the room is reflected in the edge of the chair back. Once again Ingres has harmonised the polarities of abstraction and realism, and has created as well one of the most vivid personalities in the history of Western portraiture.[28]

This is to say that for Rosenblum the reflection embodies, at the level of the redundancy of the observed in the schema of representation (a different redundancy from Thévoz's academic reality – Thévoz uses the word to refer to the structuring trope of a discourse, Rosenblum to an excess of detail), the apparently bizarre heterogeneity of Ingres' work. And this is in turn to be disclosed in the social and aesthetic complexities of his epoch. So far so good, but Tyler is unconvinced by the phrase 'Once again Ingres has harmonised ...', and feels that Rosenblum has fallen into the trap laid once by Delaborde himself. For the redundancy may well hold secrets of its own, one of which just might be the secret of the social history of art, that mysterious, old relation of text and context, of text and detail. The reflections are not quite the same, and how they are different weighs heavily in our own discourse, and its investment in the image.

Or, the opening out of the window, onto the nothing that is outside it, other than the signifying presence of light, which it admits, could be called aporia. In the chair back, light becomes an object, one with an object, which is the showing of a real thing, or two real things, the window and the image as a whole (Figure 48). And so it obeys the laws of classical aesthetics, of truthful imitation, like Zeuxis painting grapes or Dibutade outlining her lover's shadow on the wall. The window is like the origin of art carelessly inscribed in the conventions that follow on from origin. We could try to look out through the window in the chair back, although what there is to see will be only on the painting, and only a glazing over of the chair, the represented object which is slightly flattened as a result of the superposition. It becomes less real, less accurate, the wood takes the flat form of the window. The very woodwork of the window itself is nothing more or less than a leftover, fragile trace of the chair's mahogany colour, rectilinear

Figure 48

rather than slightly curved, a stain that has not been effaced by the glaze of brilliant light which in effect has, at this point only, failed to form the chair. The effect is so powerfully real that the absence of an outside becomes something of a shock, an uncanny revelation of the light source as an abstract idea at the point of its most material embodiment as object. But let's for the moment call this a Cartesian light, pure, in itself an assurance of the reality of viewing itself, of being. A light that precedes a knowledge of the object, rather than a light with an object that are only knowable together.

Not so on the eye glass (Figure 47). Here it, the light, does not merge with a represented thing in its transcendental effacement, but enables a thing, or a presence, to be represented at the level of a proposition about representation; perhaps in a purely Lockeian, or, more appropriately, Condillacian sense of being that datum which tells of substance's presence. Yet through doing this in translucence itself, it reminds us of representation's mere propositionality. And so an interval opens up between the light and that which it enables us to know of, gently but definitively breaking the general illumination of the image as a secure and unproblematic pictorial convention. To the left of this tiny reflection, which is much more complicated than in many of Ingres' fobs and eyeglasses, there is a distorted oblong or a rhomboid which passes back into the lens to give it a rotundity, but which, as brushmark, also rhymes the flatness of the window frame, oxymoronically, as reflection rather than as trace (Figure 48).[29]

Between the two, then, light's representation both explores the conflicting spaces of materialist philosophies, the irresolvable differences of direct and conventional representation; and it illuminates the frame of idealist conventions that are Ingres' laws of art, which he tries to obey and which he disobeys, as a Cartesian subject in full command of his intentions. As in an old debate of the time of Revolution, when Ingres came to Paris, an obscure disagreement between the artists Neveu and Gérard, the unwitting painter uses signs at once conventional and natural.[30] Yet if the two reflections appear natural, should we not really see them as nothing more than accessory? After all the analogy of the image is really M. Bertin, director of the *Journal des Débats*, and, even though they confirm his presence and the pictorial space of this presence, he could be recognised without them. But here redundancy is structural, it is of the structure of aporia. The difference between the two lights is that which permits a discourse on the validity of representation as the fixing of a

signified. The image of Bertin is both actual and ready-made, a modern bourgeois and a classical referent, for, as we have noted, it is he as much as *Mme Moitessier* who has the right to claim a descent from the *Hercules in Arcadia*, and it is in the tension or suspension between the rhetorics of the observed and the known that Ingres makes his way. The window in its status as a white mark on the mahogany surface draws attention to what so many of the painting's marks obscure, facture, it demonstrates or betrays the very thing which classical technique sets out to hide, which is technique itself. If attention drifts then from the figure of Bertin to his portrait as a painting, it is this final impossibility of reference that obtains the effect of magic, a magic which points to or shows through chora as the unintended of that historical moment. That is to say, as that archive of rhetoric and society, of identifications and identities that manifest the modern artist. And if Ingres has destroyed a father, it is the hermetic paradigm of Davidian portraiture with its indivisible lighting, that merging of nature and culture into each and every detail of the surface-narrative, which he shatters with his twin episteme of light. The ontology of art is an always and already vehicle of modernity in this configuration of aporia. If light is nature and Bertin culture, but the source of light as the means of its figuration is conceptual and built, the realisation of this aporia as figure shatters art's delusions more thoroughly than Brutus' renunciation of private good in David's painting. Crazily enough Ingres, the artist on the wrong side of the barricades, seems to do the more violence to art's histories, and Cassou is the one to notice this.

While he is apparently so imposing then, *M. Bertin* is an almost unavailable form of masculinity, rather as the Odalisque escapes the oriental. For if he is one, his mediation is one diffused and curiously suspended in a problem of pictorial being. In this case a problem of being-as-paint and being-in-light, and this problem is a punctum which is embodied in the reflections, even if the reflections are not the punctum. It is not the reflection, the high window, but in the caesura between it and its different and identical other in the fob, and here, I might be tempted to argue, Ingres finally achieves his great ambition: rhetorical sublimity. But he achieves it not in the distorted, the broken or the classical image, but in the very texture of everyday life that stretches the rhetoric of classical procedure to the point of the impossible, this double-bind of light. This is the semiotic lesson of the

meaning as not embedded in the system of references or in its narrative relations; of the problematic matter of deciding what, at the level of the pictural, actually does constitute a sign.

Part three: three men in Paris

My story, for it is a story, does not have a very happy ending, and to get there I have allowed myself to take some terrible liberties with my three heroes. Tyler, Brad and Scott are on a long weekend together in Paris, where Tyler has a *pied-à-terre* – and it is here that I am perhaps muddling it up a little too much with my own desires for narrative ... Anyway, even for these three sophisticated guys there is such a lot to admit and such a lot to hide that it has been easier to spend whole nights out, which is what they wanted to do anyway, than consciously to decide who will lie with whom in the intimate confines of the little Parisian apartment. When they do sleep, it is the involuntary rest of the exhausted.

On the last day, weary but contented after a largely amusing visit to the baths, they find themselves trailing round the Sunday afternoon Louvre. And, of course, probably as a result of the manipulative Tyler's superior knowledge of the place, they end up in front of *M. Bertin*. Will the experience of looking at him help them in their dilemma? Tyler is concerned about this, for he believes passionately in art, and he wants to see it have an effect, whether it be one of breaking or of healing. And a dilemma they do have, the very dilemma proposed by the Bob Dylan epigraph to my excursus, one not resolved by the easy yet evasive pleasures of the baths. They will desire again tomorrow what they desire today, but desire (in language) is never the same as itself, even today. It's only by unconsciously balancing the tenuous rationality that strings language across chora with the irruption of meaning and its repression through that rationality that they, or we, can afford to mingle such superficially separate yet radically and intimately belonging to each other experiences as looking at a painting and desiring to be oneself. Their dilemma is not then, quite as unlike that of Ingres as you might have thought ... the emergence of their desire, like his, is not in the semantic units apt for its visibility, its recognition. It emerges in spite of their intentions to express it, elsewhere, in the poetic of hesitation, of breath, of pain.

The referent of Scott and Brad's exchange was neither the handcuff nor the whip, nor who is going to use them and on whom, nor was it

the specificity of desire; rather it was the production of desire as a series of shifting and unsettled cathexes, whose *semème* is in this sense representative of chora, in its incoherence in coherence, rather than of the desire they feel and figure for themselves.

In bringing these three men together, Scott, Brad, and *M. Bertin*, Tyler has hoped that he will be able to confuse the relation between the referent, 'a man', and the signified, 'his masculinity', in such a way that they get to be lost in each other. For this reason he likes to think that his two friends, who, for reasons of which their own troubled relation is only a single element, are right now not very happy, will begin to project their perplexities onto the painting and finally see them as something outside themselves. In fact they are struck by the image, they laugh, and they recognise M. Bertin's dress, comparing his layers to their own, leather, denim, cotton t-shirt; Scott notices the high window; will he fall through it? Yet no; mobile, intelligent, but far too restless to follow all the traces, half-way across the tract of M. Bertin's expansive belly to the fob, he loses interest. At this point, at this moment only, just as he steps away from the painting, the back of his hand grazes against Brad's. And for that moment alone, they both feel, if not quite happy, then somehow better. *M. Bertin* is one utterance in another of Ingres' repetitions, something in the order of a 'no, I'll never do it for you, nor for anyone else, ever', that he anyway does do it, one genre after another, over and over again, despite himself.[31]

In Ingres, then, we can begin to apprehend the crazed, at-any-cost exclusion of the metaphoric which, in Adorno's words, is 'precisely what we see in works that are genuinely avant-garde. They become objectified through unqualified monadological immersion in their own formal laws, that is, aesthetically, and thereby mediated in their social basis as well'.[32] Yet it is here precisely, in this coolly socialised formality, that the social history of art, like Baudelaire and Delacroix, who represent its origins, turns out to be enmeshed in an aporetic of representation, in wanting an image of an art to correspond if not to an aunt, then at least to an ideology of the family. Ingres, as I have argued, resists this in his very occupation of crowded signs, whose histories overdetermine the impossibility of either a singular execution or interpretation.

The adventures of Brad, Scott and Tyler with *M. Bertin* dream another introjection of Ingres' signs into a historically current yet anachronistic framework of identifications. In their very capacity to reveal or to register the choric murmurs of the painting these adventures render it uncanny in the history of its canonicity, matching Hoffmann's otherness that we have already established as Ingres'

sense. They show us once again how the archives of the image coming into sense and those of its coming into being fold in a form that can never be again unfolded.

With Cassou's *Ingres*, then, one hundred and sixty-seven years after Ingres' birth, he (it, I suppose. In English signifiers have no gender ...) happens on what I have come to think of as possibly the most important biographical event in all his history. It is one of the weighty kind which, just because it can turn up in the life of any sign, is hardly as such special. But here it comes at the point when the sign can get switched into a fresh set of meanings, twisted to stand for something other than its traditions would have it signify. In this case, the case of *Ingres*, for things that are both new and not quite national. For, after all, the Museum is to be not only national, but also modern, which – at least in Cassou's understanding – far exceeds the national. Ingres is made to testify for and on behalf of some things that are recognisable in the social and political world of pre- and post-war France, but not as the proper referents of such a sign. Despite their Ingrisme, Picasso or Modigliani, he, Ingres, belonged to France. And as a result this, *Ingres* does these foreign things the service of pulling them into its spaces of meaning, offering them respite and hospitality.

And why should an idea of progress(iveness) come to be signified by such a sign as Ingres? Or rather why should a particular construction of progress in modern art get to be routed through Ingres in a subtle yet crucial shifting of the ways in which this had been done so many times before? Ingres and this meaning become a disguise for each other in Cassou's text, and this in turn has an effect on the history of art, reinforcing old problems and making new ones for it both at once. Expansion and closure, the two together in one gesture. The idea of an artistic genealogy is reinforced, although in its reconstruction Ingres now exceeds it. But all in a good cause, for a political ruse. The no-good ahistoricity of the idea of being-an-artist is now 'résistant' to the sleazier side of French cultural nationalism whose horizons Cassou's Museum must challenge. After all the pretension of Ingres' historical critical acclaim, the future and the past get into step, get to look more like each other, the new and the conservative at each other's reasonable disposition. And all without even a whisper of scandal.

It is 1947 and the scandal of old and new is all too easy to evoke in the bitter-sweet taste of post-Vichy culture, the time of rebuilding a nation in the only available images of its own foul taste. Never had modern art needed Ingres more, to wear the lurid allure of cosmopolitanism in the garments of old France. Joan of Arc to the rescue of a bunch of Catalans, Communists and Jews. Cassou is able to work inside this situation if only to say that Picasso took Ingres as his

master, that Picasso affirmed and confirmed Ingres, rather than that Ingres got there first. In Cassou, Ingres allows for modern art, he does not trounce it.

Yet it is not an event that has gone unprepared, though much of what has already happened may well leave us unready for its singularity and even reluctant or unable to see it. It has always been on the cards as a possible condensation of art's modern narratives. As a possibility implicit in the idea of Ingres the modernist, that he might one day stand on the side of the modernisers, and, I might go so far, of the Resistance as well, as something French in ways that he had not been. *Joan of Arc*, rather than a dreamer of minor, classicising utopian erotica, and maybe it has always needed someone who figures, as Cassou does, as a Jew in L.-F. Céline's *Bagatelles pour un massacre*, to accomplish the slippage. For what Cassou succeeds in doing is to turn the tables on a process of conservatising Ingrisme that unfolded in the years after the first world war – something that Kenneth E. Silver has described in his book *Esprit de Corps* – 'Ingres was not only the symbol of sanctioned French art but was also seen as the antidote to everything that deviated from the path of France', he comments of post-war Ingrisme.[33] But this had long unfolded on the back of Louis Blanc, Teodore de Wyzéwa and Ingres' very first biographers. It goes back to 1834, to Ingres' departure to direct the national school in Rome, to 1855, his coronation, alongside Delacroix, at the Exposition Universelle with Courbet waiting at the gate.

Silver refers, albeit dismissively, to an Ingres-event of 1921, the publication by Henry Lapauze of his special number of *La Renaissance de l'art français et des industries de luxe*, a publication that we should best read as a tastefully institutionalised after-effect of the introjection of 1855. It is dedicated to Ingres and to the exposition of his presence not just as a precondition of, but as an already-in-advance of modernist painting. Its texts are largely old ones, reprints of Balze and Gautier, Amaury-Duval and Maurice Denis, the direct heritage of the artist's name, and Lapauze's own intention is to say nothing new. On the contrary, he asserts, 'I've covered Ingres and anyone who looks for him will find me on their way.' The metonymic slippage between the historian and the artist, to find him you find me, suggests the identity of history and tradition, that singularity of Ingres as an artist on whom history has no effect other than that of perpetuating the non-eventuality of his having always been that which was always there before the modern, the 'novateur qui annonce le temps nouveau' ('the innovator who heralds the new age'). 'Thirty years ago', Lapauze is boastful, 'I sent Signac to Montauban, and Maurice Denis went, and Degas and Bartholomé', then Cézanne loved Ingres and now Picasso, Lhote and Bissière. 'The artists of today have been preceded in their admiration of Ingres by the revolutionaries, who have learned wisdom.' To find Ingres is for revolution to gain wisdom in the self-discovery of having already happened, 'That's the rule nowadays: everyone bides their time to claim Mr Ingres for themselves.'

If then Ingres is the atemporal of artistic progress, he becomes for a modern

morality of the arts what Raphael had been for his own epoch, a breath in the vacuum of history. Cassou stumbles upon the conditions that answer the puzzle that Ingres comes to represent. The secret of the loop is not that it can be cut – the gordian solution – but of its moebian structure in the articulation of French culture. Read from one face it is a limit, but curving round on its other surface it is a margin; and these two characteristics are continuous.

Figure 49

NOTES

1 'On that subject I know two things, the first is that colour effaces drawing, the second is that drawing always fights against colour.

'That will be obvious if you consider the two gestures of the drawer and the painter, so profoundly different: the first draws lines, the second places strokes. On this subject, addressed at length, I find an acknowledgement in the *Pensées* of Ingres in the form of a surprising rule which he gave to his pupils. Colour, he said, must not be placed along the outline but on the outline. This clearly shows that colour destroys drawing. I do not mean that Ingres was thinking about such things, but I do say that he acted like this. And that separation, that opposition, I shall call it the Ingres viewpoint.'

2 See the essays of Georges Friedman and Jean Cassou in a volume to celebrate the nationalisation of the Renault car factories after the last war, *L' Automobile de France*, Régie Nationale des Usines Renault, 1951. The aesthetics of the factory as a form of socialist modernity might seem an irony for an Ingriste of Cassou's

stature, but his commitment to them seems to underline his general attention to strategies for the liberal modernisation of a reactionary France, amongst which Ingres is one element. The most complete survey of Cassou's life and work is *Jean Cassou, 1897–1986: un musée imaginaire*, Bibliothèque Nationale de France/Centre Georges Pompidou, 1995. This generous catalogue of a great exhibition traces all the aspects of Cassou's complex career through a variety of documents, letters, art works and analytical essays, giving an essential basis for the study of his life and work.

3 For the most complete analysis of Céline, Alice Y. Kaplan, *Relevé des sources et citations dans bagatelles pour un massacre*, Tusson, du Lérot, 1987; Laurence Bertrand Dorléac, *Histoire de l'art: Paris 1940–1944. Ordre national, traditions et modernités*, Paris, Sorbonne, 1986.

4 Michel Thévoz, *L'Académisme et ses fantasmes*, Paris, Minuit, 1980, p. 110 (citing Sartre's *Idiot de famille*).

5 For a summary of the differences of the Lukacsian aesthetics of Realism versus Adornian negativity, see T. W. Adorno, *Aesthetics and Politics*, London, New Left Books, 1977, translated by Ronald Taylor with an afterword by Frederic Jameson.

6 See T. W. Adorno, *The Philosophy of Modern Music*, New York, 1973, and *Quasi una fantasia: Essays on Modern Music*, translated by Rodney Livingstone, London, Verso, 1997.

7 Cassou, *Ingres*, p. 69.

8 See Chapter 1, note 36 on Richter and Hoffmann in France, for a bibliography, and this discussion drawn from Claude Pichois, *L'Image de Jean-Paul Richter dans les lettres françaises*, Paris, Corti, 1963, pp. 393–396. On 17 September Cassou writes to Jaloux in reply to his friend's asking if he has read Jean-Paul's *Titan*:

there is also in Jean-Paul this hysteria of the Romantics which one also finds in Kleist, and even sometimes in Goethe, and in any case in Schiller, and which is so full of curiosity for us who are imbued with Dostoïewsky and Freud. We must republish all of that.

(Pichois, p. 395)

9 See for example extensive discussions in her recently published seminars, *Sens et non-sens de la révolte: pouvoirs et limites de la psychanalyse I*, and *La révolte intime: pouvoirs et limites de la psychanalyse II*, Paris, Fayard, 1996 and 1997.

10 See Maurice Merleau-Ponty, *Phénoménologie de la perception*, Paris, Gallimard, 1945.

11 Georges Bataille, *Manet* (1955), Geneva, Skira, 1994.

12 *Aesthetic Theory*, newly translated, edited and with a translator's introduction by Robert Hullot-Kentor, Minneapolis, University of Minnesota Press, 1997, p. 274. On post-Kantian concepts of beauty, Kant–Burke differences, etc., see the work of Philippe Lacoue-Labarthe, for example *Musica ficta (figures de Wagner)*, Paris, Bourgois, 1991; Rainer Rochlitz, *Le désenchantement de l'art: la philosophie de Walter Benjamin*, Paris, Gallimard, 1992; Jean-Marie Schaeffer, *L'Art de l'âge moderne: l'esthétique et la philosophie de l'art du XVIIIe à nos jours*, Paris, Gallimard, 1992; J. M. Bernstein, *The Fate of Art: Aesthetic Alienation from Kant to Derrida and Adorno*, Cambridge, Polity, 1992.

13 Of course, and here I return to a theme of this book and reiterate on a rather different ground, this argument entails certain difficulties for a social history of art. Especially for one that has worked on and through the relative completeness of paintings as utterance or semantic practice, so that while different from each

other, a 'real' stonebreaker is as adequate in its potential to signify as a 'mythological' Endymion, provided proper orders of evidence are invoked in each case. Or the revelation of a common substrate 'prostitute' beneath an orientalising beauty and an urban courtesan, in different kinds of painting, is the guarantee of their mutual relation to the field of the urban, male gaze. For if the site of meaning is shifted from the thing and its surrounding discourses, such as art and its criticism, to a system of gestures or signifiers of which the very 'essence' is incompletion in their possible articulation with the signified as a concept, then these procedures begin to look narrowly positivist. And if the thetic gesture which entrains disturbance, whatever its level of being-intended, is also a trawl in or reflection on the unconscious as a social space and as the space of historicity, then the relation of artist and art work shifts to one that Cassou calls *situation* in its gerundive function. In this historicity the artist figures on the surface of the work, readable not as a cure for the loss of meaning, sought in the analysand's discourse of the image, but as an effect of the impossibility of staging the finality of overdetermination. Moreover in the practice of art history itself the artist becomes a figure or a trope of *and* in that practice, associated with and enabling types of reading. Just as meaning escapes from the imaginary completeness which occurs at the level of the whole image, so also there are then no essential artists of or for the process other than those established in the conventions of our discourse in author functions, and in our reflections on its modalities. And this, if you like, could be the aim of a modernist art history – situating the object in an infinite series of relations which, disturbingly enough, can hardly be translated into each other, in which no author function is finally quite the same as itself.

14 See *Art et contestation*, Brussels, La Connaissance, 1968.
15 Emmanuel de Bondeville, *De Baudelaire, prophète du présent, à Ingres, novateur imprévu*, Paris, Institut de France, 1967.
16 For Henri Lefebvre's criticism of Baudelaire's conception of the everyday see his *Critique of Everyday Life*, translated by John Moore, London, Verso, 1991, pp. 120 and 141.
17 See Rosalind Krauss, *The Picasso Papers*, Cambridge, Massachusetts, MIT Press, 1998.
18 Jean Cassou, *Picasso*, London, 1949, non-paginated.
19 The conflict between realism and morality on the one hand, and art with its morality on the other, a conflict which has haunted this entire century, cannot be reduced to a matter of art for art's sake against social art. It is rather more to be thought in the possibilities of imagining art as moral.
20 Thévoz, *L'Académisme*, p. 153.
21 See for example Amaury-Duval, *L'Atelier d'Ingres*, Paris, Charpentier, 1878, new edition by G. Crès, Paris, 1924, under the direction of Élie Faure, p. 96ff.
22 See Whitney Davis, *Gay and Lesbian Studies in Art History*, New York, Haworth Press, 1994 for an overview of this field.
23 Julia Kristeva, *Révolution*, p. 23.
24 Ibid., p. 215.
25 I have remarked from time to time on the oddity of Ingres' light, and the strangeness is quite widespread in his work. See for example the *Baronne de Rothschild*; not only does the upper background transform from Davidian scumble to contemporary wall covering in a passage that both asserts and denies the representability of the real, but some of the shadows in her dress, painted flatter than the highlights, lie, optically speaking, slightly above them on the surface.

26 Amaury-Duval, *L'Atelier d'Ingres*, p. 97.
27 Thévoz, *L'Académisme*, p. 157.
28 *Jean-Auguste-Dominique Ingres*, New York, Abrams, 1967, p. 137.
29 See Michael Baxandall's great chapter on Chardin in his *Patterns of Intention: On the Historical Explanation of Pictures*, London, Yale University Press, 1985.
30 See my article 'The Words of Art, the Artist's Status: Technique and Affectivity in France 1789–98', in *Oxford Art Journal*, 14:2, 1991, pp. 73–82, for a discussion of this question.
31 Amazingly, some two years after writing this I went to a rather seedy gay nightclub in London. Decorated with cyber-pop images of what once might have been thought of as futuristic machines and space effects in the style of a post-pop Dan Dare, quite well painted on unstretched canvas, one of the great brick arches was dominated by the gigantic face of M. Bertin. There he stared out, beautifully copied, but now amazed as a pink arrow penetrated his left ear, and little bundles of his hair flew off, spinning into deep space.
32 T. W. Adorno, *Notes on Literature*, New York, Columbia, 1991, pp. 230–231.
33 *Esprit de Corps: The Art of the Parisian Avant-Garde and the First World War, 1914–1925*, Princeton, New Jersey, Princeton University Press, 1989.

INDEX

157